PHOTOGRAPHY
ESSENTIALS

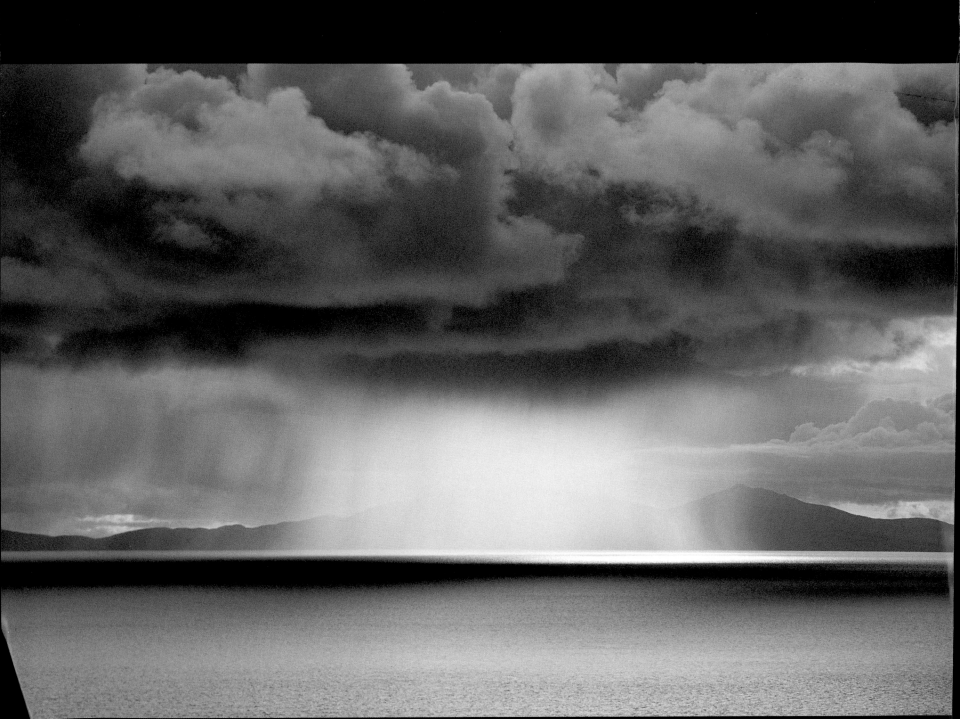

**PHOTOGRAPHY
ESSENTIALS**

WAITING FOR THE LIGHT

DAVID NOTON

D&C
David and Charles

To my wife
Wendy, for all
the love, life
and laughs,
while waiting
for the light.

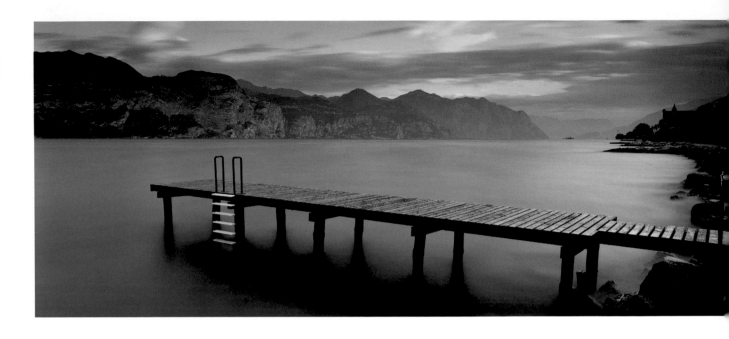

A DAVID & CHARLES BOOK
© F&W Media International LTD 2008, 2009, 2011

David & Charles is an imprint of F&W Media International, LTD
Brunel House, Forde Close, Newton Abbot, TQ12 4PU, UK

F&W Media International, LTD is a subsidiary of F+W Media, Inc.,
4700 East Galbraith Road
Cincinnati OH45236, USA

First published in 2008
First paperback edition published in the US in 2008
This paperback edition first published in the UK in 2009
Reprinted in 2009, 2010 (twice), 2011

Text copyright © David Noton, 2008, 2009
Images copyright © David Noton, 2008, 2009

David Noton has asserted his moral right to be identified as
authors of this work in accordance with the Copyright, Designs and
Patents Act, 1988.

A catalogue record for this book is available from the British Library.

ISBN-13: 978-0-7153-2819-4 paperback
ISBN-10: 0-7153-2819-0 paperback

Printed in China by Toppan Leefung Printing Limited
for David & Charles
Brunel House, Newton Abbot, Devon

Commissioning Editor: Freya Dangerfield
Editorial Manager: Emily Pitcher
Art Editor: Martin Smith
Project Editor: Ame Verso

F+W Media publishes high quality books on a wide range of
subjects For more great book ideas visit: www.rubooks.co.uk

Contents

Jetty near Brenzone, Lake Garda, Lombardy, Italy
In the cool light before dawn the clouds are scudding across the sky, driven by a brisk wind from the east. The distant hulk of the Dolomites to the north east is capped by dark, angry skies, and the waters of Lake Garda are choppy and restless. There will be no warm Mediterranean light this morning. So, I pile on every neutral density filter I've got to slow the exposure down to a tedious ten minutes, open the shutter and wait. In five minutes I'll take another exposure reading, but for now I've just got to let all that movement in the image do the job. I would turn to crime for a caffe latte right now.
• **Fuji GX617, 90mm lens**

(page 2) Cloudburst over the Isle of Harris from Neist Point, Isle of Skye, Scotland
I'm huddling on the cliff tops on the western tip of the Isle of Skye, wind-battered, sodden, and despondent, waiting for the light. Will these clouds ever part? Looks like another fruitless vigil. A faint lightening of the sky far out to sea over the Isle of Harris rouses me from my musings. There's yet another downpour rolling in off the Atlantic, I'll get another soaking, but behind it the sun is threatening to break through. I'm scrabbling in my bag to get the filter on my 70–200, fumbling with the adaptor ring with cold fingers, glancing over my shoulder at the ever more dramatic sky. For just seconds a heavenly shaft of sparkling northern light backlights the rain. I expose, do a few brackets, and it has gone; a scene never to be repeated.
• **Nikon F5, 70–200mm lens**

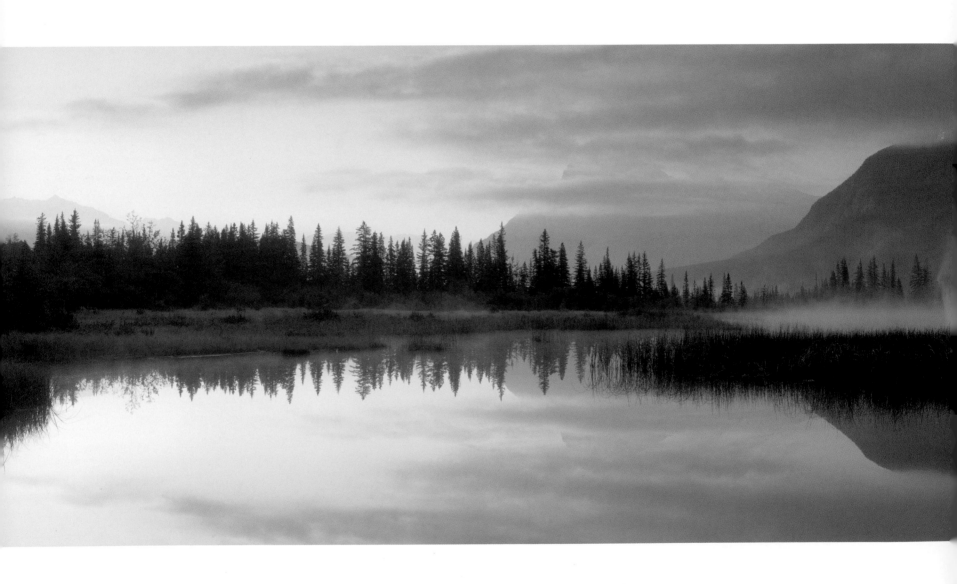

The Waiting Game

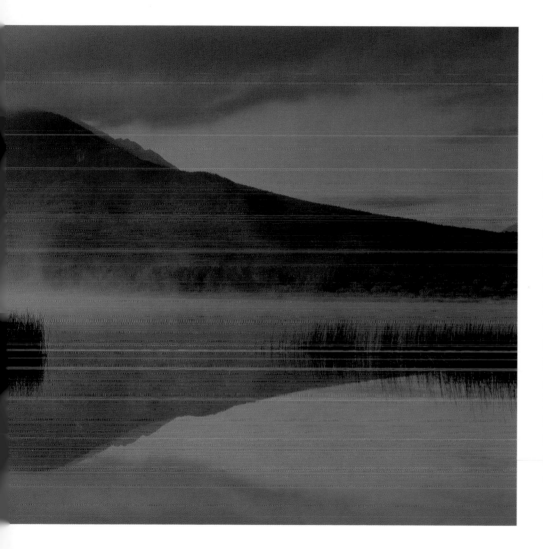

I'm standing by my tripod, my default setting, waiting for the light. Watching the dawn break over a Rocky Mountain lake is an experience to stir the soul. Mist seeps across the flat, calm waters, diffusing the perfect reflections of the jagged peaks. The call of a loon echoes; a beaver surfacing briefly ripples the water; the first light of day seeps through the sky tingeing the clouds clinging to the mountains with pink. This is my eighth morning waiting here by the tripod and finally all the elements are coming together. This location was found on the first day; under grey skies with a chill wind whipping the water it looked a very different scene, but the potential was evident. Three mornings later, after several fruitless dawn patrols, the day started calm and clear with strong sunlight but … not a cloud in the sky – no mist, no drama, no mood. So, we stayed on, waiting for the light. Now, after eight days our persistence is rewarded with clouds draped over Mount Rundle and a layer of mist over the still waters of Vermillion Lake. As always, this image is a fusion of the elements Mother Nature chooses to offer – light, clouds, mist, reflections and the landscape itself – and my input; being there, pre-visualizing how the scene could look in the right conditions, persistence and lastly, technique. In short, this picture was made by a marriage of nature's perfection and photographic vision – these are the elements that are the *making* of a photograph.

Mount Rundle reflected in Vermillion Lake,
Banff National Park, Alberta, Canada
• Fuji GX617, 105mm lens

INTRODUCTION | THE WAITING GAME

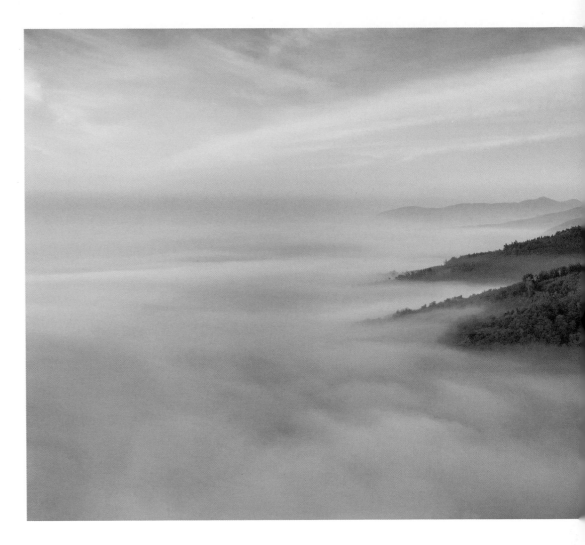

Let's cut to a grey, windy February day, 1981. I'm up a ladder cleaning the windows of an office block on a trading estate in Watford … sounds tantalizing doesn't it? Photography has just taken over my life, with my payoff from the Merchant Navy I've just bought my first SLR camera and life will never be the same again. I now know I want to be a professional photographer, but haven't got a clue how to achieve that. As I work my squeegee I'm dreaming of far horizons, the Himalayas in particular. My friend Pedro has just returned from backpacking through Nepal and I'm so jealous. Last night I was drooling over a travel feature on Annapurna. Surely, if I could scrape together the cash to get there, great images would just fall in my lap, right?

Wrong. It's a popular misconception that's easy to fall into – a belief that just turning up somewhere epic will be enough, that great shots are just there for the taking like ripe fruit off a tree. But the really unique, striking, achingly subtle, perceptive images are made, not taken. They are the product of an idea, a vision brought to reality by persistence and sound technique. This is the crunch – the difference between the 'taking' and 'making' of a photograph. This book is all about that difference. There's the arty bit – the development of a photographic vision, and the practical bit – how to work in the field, or up a mountain, or in the jungle. And in the process we're going to see the world. So, let's go.

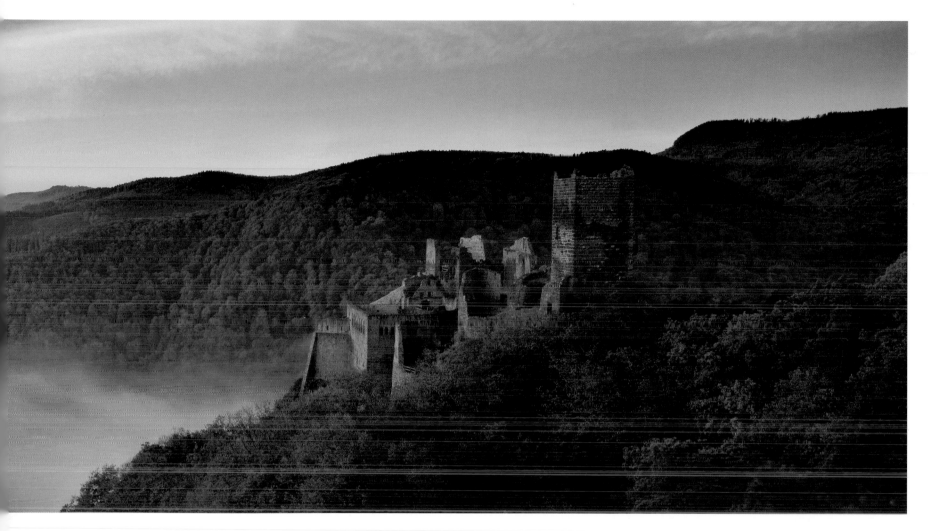

Château St Ulrich, Vosges Mountains, Alsace, France

We started trudging up the mountain by the light of our head torches through mist-shrouded woods. Directly overhead the stars were visible, we just had to get above the low-lying cloud. As the twilight tones spread through the sky from the east, we emerged panting from the swirling fogs to our chosen viewpoint. Some sights stay with you forever – this is one.

• **Fuji GX617, 105mm lens**

PHOTO ESSAY

Hot Wok Exposures

Some places are all about the big views, but for me, the essence of South East Asia can be found in its markets. They are such a cultural overload and a riot of colour – a world away from sterile supermarkets – that it's difficult to know where to look first, or to train the lens. They are crowded and chaotic with difficult lighting but in amongst the piles of chillies and lemongrass there are stir-fried photographs to be made – quick, instant and sizzling straight out of the wok.

Strawberries on the move, Hanoi, Vietnam

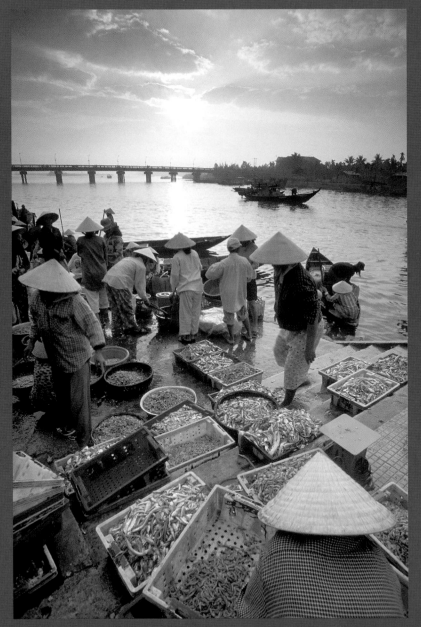

The fish market at dawn, Hoi An, Vietnam

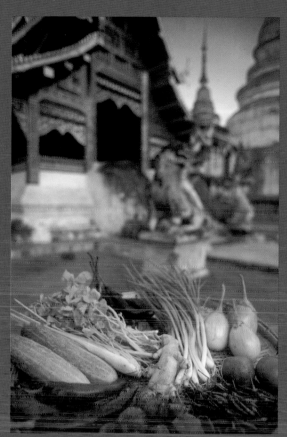

A platter of Thai ingredients at Wat Phra Singh,
Chiang Mai, Thailand

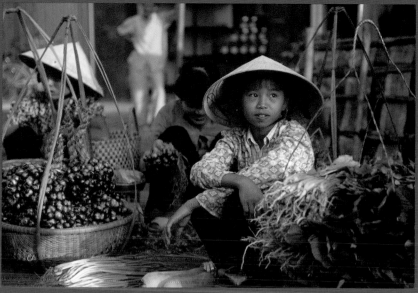

A young girl selling vegetables at a market in
the Mekong delta, Ben Tre, Vietnam

Cash being exchanged at Wase market, Er Hai Lake,
near Dali Xuang, Province, China

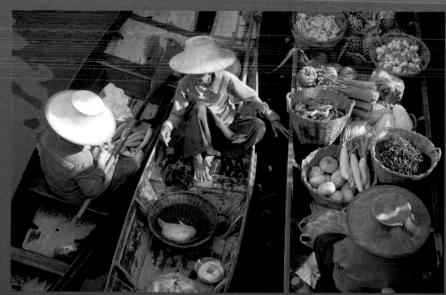

Chilli dealing at the floating market,
Damneon Saduak, Thailand

Part One: Vision

Before a camera is even touched much of the hard work of photography is done. The elements that make a photograph – those of location finding, pre-visualizing, composing and planning – all come before a lens is fitted. The only equipment needed for these crucial steps are a pair of photographer's eyes. Training those eyes to see the potential in a location, envisaging how a scene could look, appreciating the nuances of light, motion, colour, perspective and composition, is what photography is all about. Developing that vision is a journey that never ends.

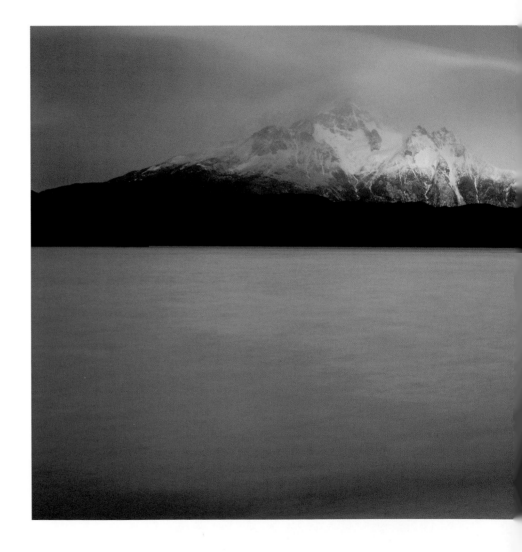

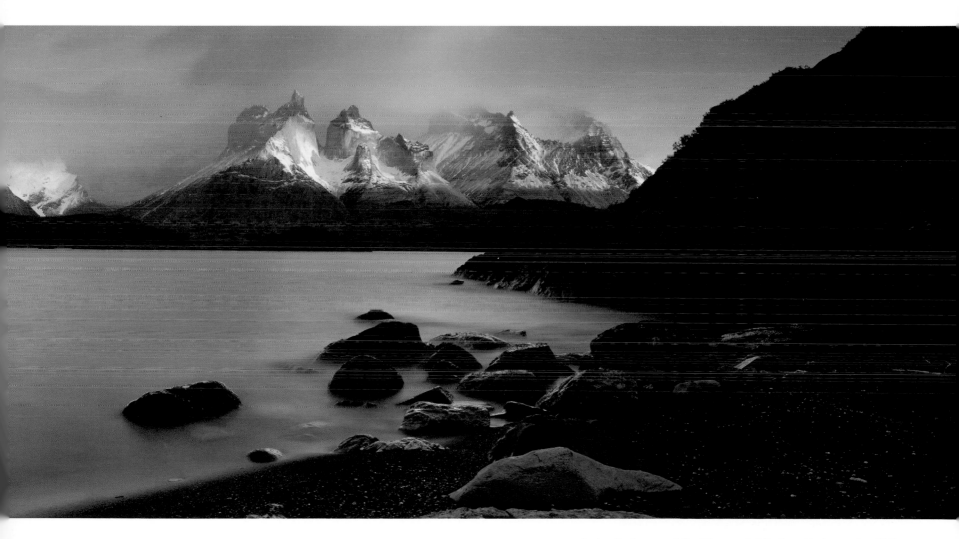

Lake Pehoe and the Torres del Paine, Patagonia, Chile
• Fuji GX617, 105mm lens

Being There

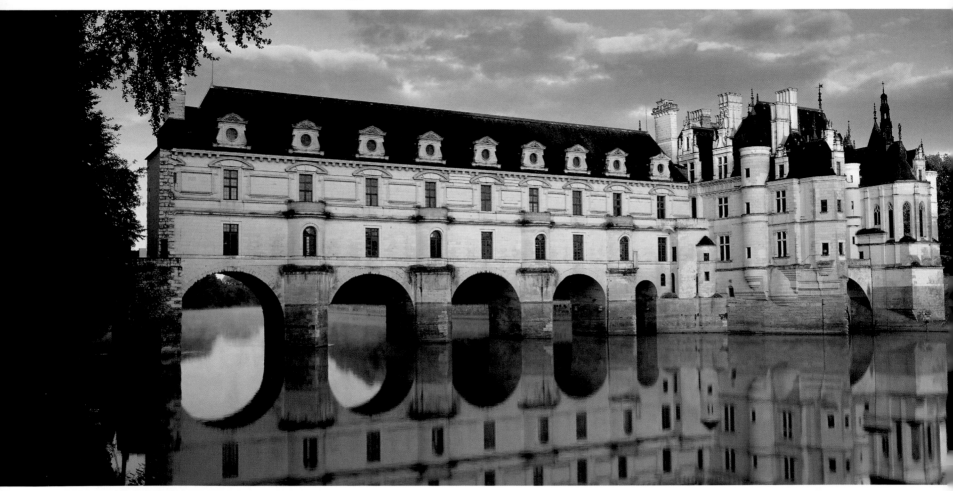

Château le Chenonceau, Loire Valley, France

*Under a grey sky with the wind whipping the water this scene looked fairly
sombre. The key was to envisage how it could look with the first soft light of day
and perfect reflections.*

• **Fuji GX617, 105mm lens**

Being in the right place at the right time is, of course, the prime essential of all photography. 'Being There' is all about the finding, visualizing and planning of an image before shooting the picture. A seasoned pro will have an uncanny knack for it. Whatever the discipline – sports, news, wildlife, fashion or landscape – it's the same for all of us. Finding that special place is the hard grind of this game, it's what takes up the most time and effort, and is without doubt one of the big differences between making a great shot and taking a snap. Knowing what to do once you are there is the second half of the equation that produces strong images.

So, where to begin? It's important to have a starting point, an idea of what you're after, whether you're in the Rocky Mountains or the Loire Valley. Aimlessly wandering is rarely productive. Guide books, existing photographs, other travellers or local knowledge can all be useful, but ultimately there's no substitute for getting the boots on and eyeballing the lie of the land. It's time consuming and often frustrating, but it has to be done. There's nothing worse than being somewhere tantalizing with gorgeous light splashing across the landscape and not knowing where to head to get the shot as the sun starts to drop. Just to go to where everyone else has been, to the well-known viewpoint, to replicate what has been done countless times before, is not an option. That's just taking a snap. To make something special means getting out and looking; using your most important piece of kit – your eyes.

Once that magical spot is found the key is to visualize how it could look in different lighting conditions at the beginning or end of the day, taking into account where the sun is rising and setting in relation to the lie of the land and seasonal factors. This is a skill that comes hand-in-hand with a feel for natural light and is crucial for all location work. It can't really be taught, it's a case of looking and learning. Really use your eyes to analyse every element in the scene.

After all that it becomes a logistical exercise, planning how and when you're going to be in the chosen place at the right time. That can be as easy as a drive and a stroll, or can mean several hours hiking in the dark before dawn. Compared to all that, shooting the picture is the easy bit.

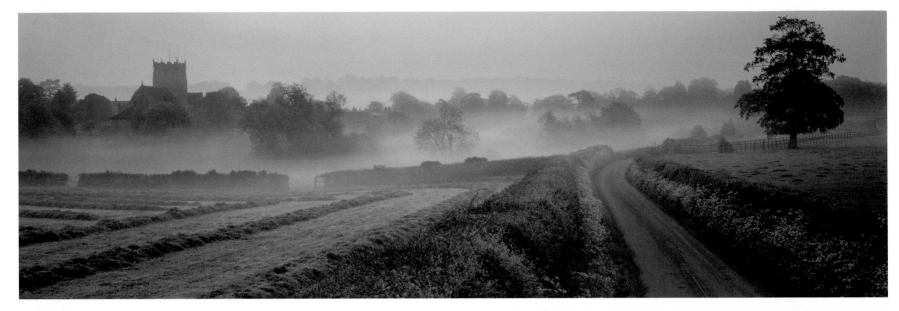

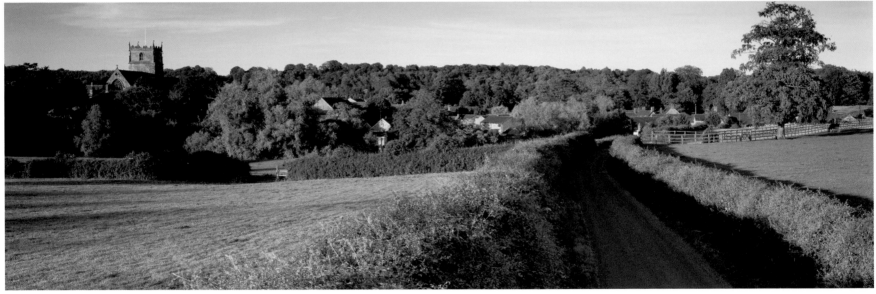

"Really use your eyes to analyse every element in the scene"

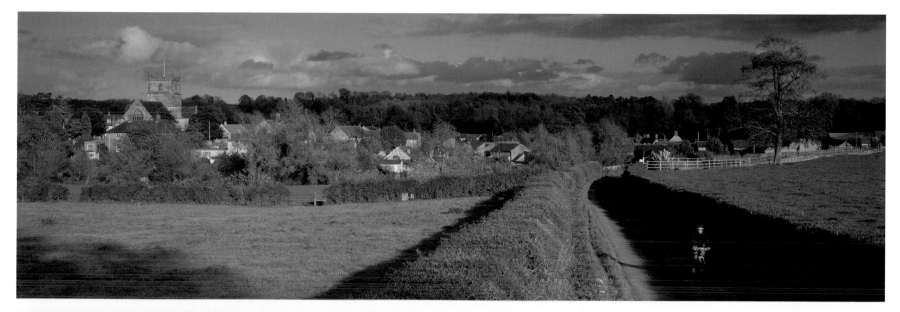

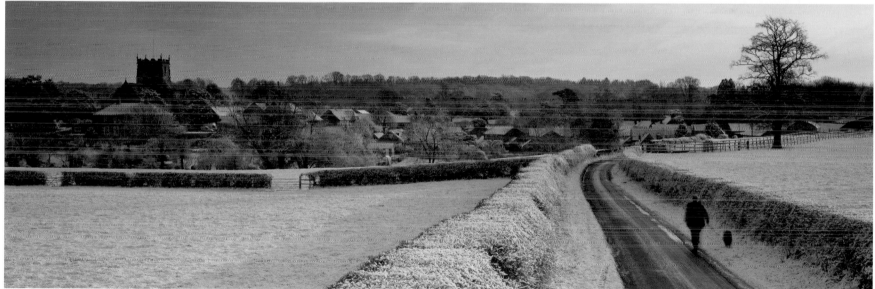

The Four Seasons, Milborne Port, Somerset–Dorset border, England

I wanted to do a set of images with identical compositions to illustrate the passage of the four seasons. Finding a location with a strong composition that would work in the different lighting conditions of the seasons was the key. I shot from the roof of my Land Rover to get above the level of the hedgerows. Winter was the shot I was most worried about; snowy conditions with crisp morning light are a rarity in deepest Dorset. I shot this at dawn with the first light creeping over the village from the southeast and the Vicar looking bemused as he walked his dog. Spring was shot at dawn straight into the light before the sun popped over the horizon, with mist lying in the fields. I love the soft watercolour feel of this one. Summer was shot late on a June evening with the last sun sidelighting the village from the northwest, and autumn featured Wendy on her bike on an October afternoon. I tied a marker in the hedge to mark my spot after shooting winter, but I guess a cow must have munched it, because it wasn't there in spring.

• Fuji GX617, 180mm lens

The Old Man of Storr, Isle of Skye, Scotland

It's windy, it's wet, my cameras are untouched, the Land Rover is full of soggy camping gear and the midges are swarming - all typical conditions here on the Isle of Skye. With the fiery Cuilin Ridge, the matured Trotternish and salty coastlines all garnished with dashes of northern light, Skye serves a heady photographic menu. There is, however, one major drawback: the weather. Oh, and let's not forget the midges. We've spent four days location searching; now, we wait. Dramatic sky, gorgeous dawn light highlighting the pinnacles of the Old Man of Storr, the Cuilin beyond with an endlessly receding vista of loch, mountain and sea - this is what I require - I want it all. However, what I require and what nature deigns to provide are often poles apart. I've had this image in the back of my head now for ten years; it may have to wait another ten.

Now, sipping Talisker in the evening, I'm pondering the chances of getting dawn light. The fronts are piling in off the Atlantic with relentless regularity, and anything could happen. We have to go for it, so it's a 5am start with a one-hour climb to be in place by sunrise. I'm concerned about these winds though; they'll give me problems. It doesn't matter how sturdy my tripod is, gale force winds make life difficult.

At 5am, I can see stars through broken cloud cover. Up the hill we plod, wondering if I'm too old for this, lungs pounding, I don't want to be late. Maybe I should go back to window cleaning. Wendy is behind with another tripod in case I want to double up on 35mm. What a trooper. Big black clouds are sweeping over the ridge promising rain, but in-between there are clear gaps. It could be good; it all depends on those clouds massed over the Torridons to the east. Finally, we're up there in the half-light of dawn. The wind is whistling over my chosen mound, we can't even stand still, but I manage to find a ledge that is reasonably sheltered tucked away just below

"What I require and what nature deigns to provide are often poles apart"

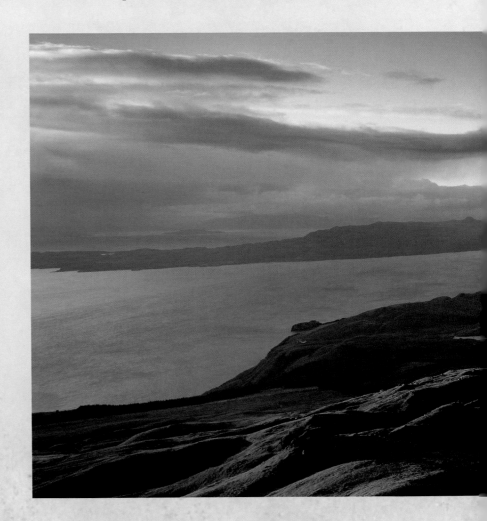

the summit. I want to set up the camera and wait but every few minutes there's a shower, so I have to keep it in the bag until the last moment. I'm using my Fuji GX617 with a 90mm lens, 220 Velvia, no fancy filtration here, just a 0.9 ND grad on the sky. I'll let the quality of light and composition take care of the rest. We'd been up here a few days ago to check it out. When the light is good I need to be ready, not still debating my options.

Wendy is watching the sky to the north, letting me know when likely breaks in the clouds will occur. The sun is just up but obscured by cloud, but I'm getting increasingly optimistic and excited. The sky is fantastic, as is often the case between showers. I go through my usual pre-shooting checks, then do it all again. This is a routine I've been all through so many times, but you can never take it for granted.

Out of nowhere, golden light explodes on to the scene, bathing the landscape in gorgeous crystal clear light … sheer absolute perfection. The pressure is on now,

this may only last a few seconds. Spot meter reading on the pinnacles, set aperture, shoot … 1/3-stop brackets either side, the exposure is changing as I'm exposing. Eight frames gone, reload; with high winds and cold hands it's no time to be messing about, this needs all the efficiency of a Ferrari pit stop. I get off a few more frames before the light goes. Did I get it? Will we get another chance? Did I get the exposure right? Is the filter OK? Any rain on the lens? All the usual doubts.

The sun comes out again about 20 minutes later, but it doesn't quite have the quality of earlier. I float back down the hill on air, buzzing, knowing we've witnessed one of those special moments. When it's good, Scotland is very, very good. Maybe I'll put off a return to window cleaning for now.

After that morning the rain clouds close in again. We cross to Harris but don't shoot a single picture. So, two weeks' work boils down to a two-minute burst of light. But it was worth it.

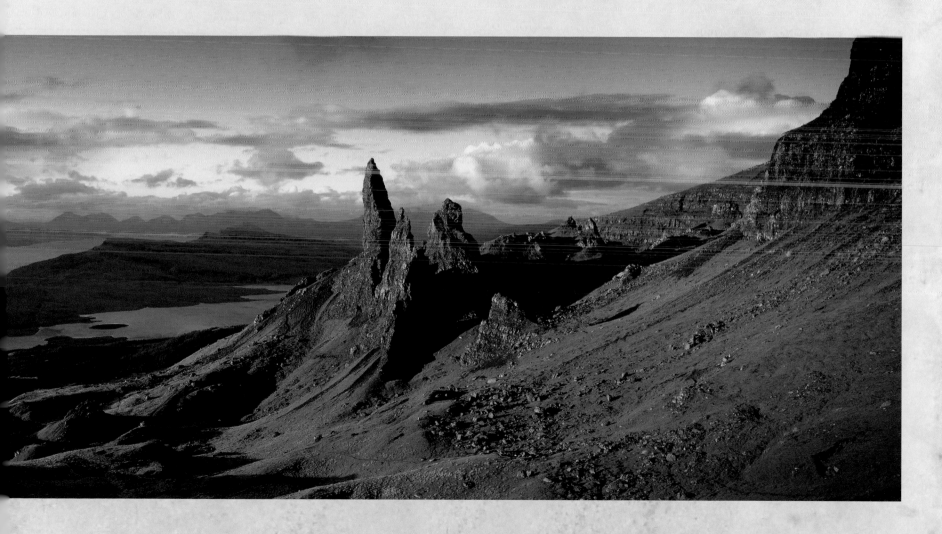

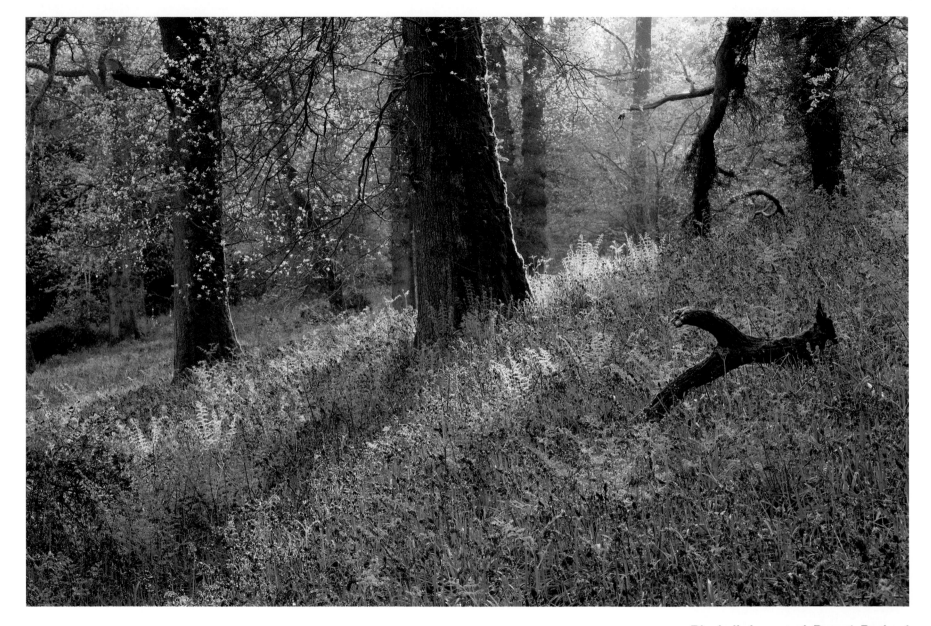

Bluebells in a wood, Dorset, England

I'm kneeling in amongst the bluebells on a spring evening with soft light filtering through the trees, gently backlighting the scene. How did I find this spot? I went for a walk. Location finding isn't rocket science, it's just getting mud on your boots.
• Canon EOS-1Ds MKII, 70–200mm lens

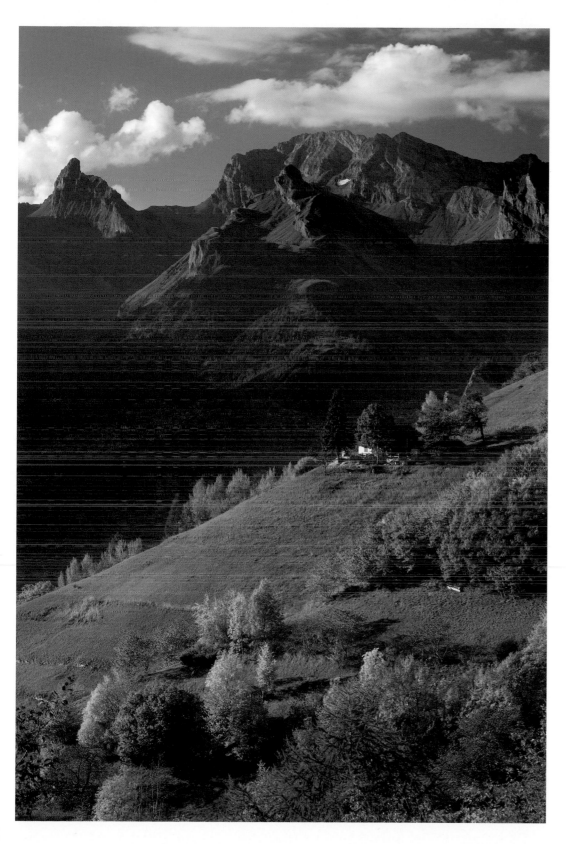

**Autumn colours at Isérables above
the Rhone Valley near Sion, Le Valais,
Switzerland**

*The late afternoon light catches the alpine autumn
colours above the Rhone Valley. This is an image that
could only work in autumn. Being There is usually
dependent on the seasons. I'll often 'bank' a location
with the idea of returning when the right seasonal
conditions prevail – it could be months or years later.
A good idea for a unique image is a valuable asset.*
• **Canon EOS-1Ds MKII, 70–200mm lens**

Light

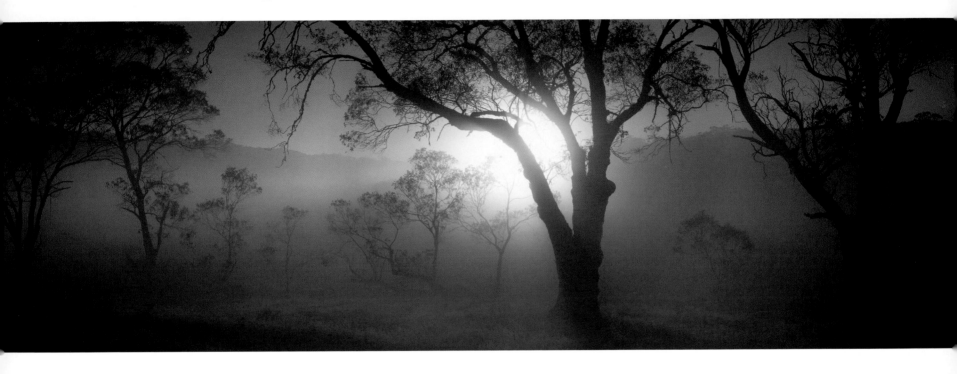

**Dawn at Polblue Marshes, Barrington Tops,
New South Wales, Australia**

*Two kangaroos bounce out of the mist, passing between
the tent and me. Did I just see that? Australia is so
different: the wildlife, vegetation, landscape, pubs …
I love it. Camping out in the boonies in Oz is one of
life's greatest pleasures. This morning I have the luxury
of shooting within yards of our camp. The rising sun
backlights the mist lying on the marshes, silhouetting
the eucalyptus trees in liquid gold.*

• **Fuji GX617, 90mm lens**

Light is the most fundamental element of photography. A photograph
made in the wrong light is worthless, no matter how dramatic the subject.
Conversely, given the right light a photographer can make a lump of coal
look good. Unlike studio photographers in their warm dry studios who
create the lighting to suit, we troops out in the field have to use what
nature provides. Waiting for the light to filter through the atmosphere is
frustrating and time-consuming, but the subtleties are endlessly variable.
All photographers can, given half a chance, drone on ad infinitum about
the quality of light. There are so many variables that affect it. In truth
after a quarter of a century I feel I'm still just scratching the surface of
appreciating the finer points of using natural light. As a musician's ear
becomes, with experience, attuned to the subtleties of pitch and tone that
the rest of us can't hear, so a photographer's eye picks up the variables of

"Being a photographer means living your whole life subconsciously considering the light"

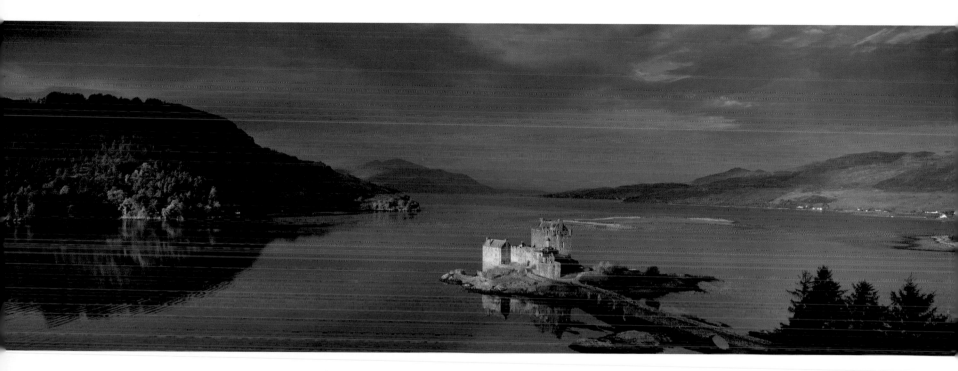

light that most don't notice. But to start to appreciate these aspects of light it's important to understand two fundamentals that determine its characteristics – the directional nature and colour temperature of light.

Natural light can be strong directional sunlight, or soft, hazy, diffuse, overcast or a combination of all of these. Basically, what determines the directional nature of the light we receive from the sun is the atmosphere it's shining through and at what angle, i.e. the time of day. Clouds, haze, pollution and the weather all have an effect. The crisp light in New Zealand after a weather front has passed through is very different from a humid day in Bangkok. On top of all those variables we have reflected, artificial and ambient light to consider, and how they all balance. In truth, being a photographer means living your whole life subconsciously considering the light, but there are worse things to be obsessed with.

Eilean Donan Castle, Loch Alsh, Wester Ross, Scotland

On a dull October morning on the west coast of Scotland a momentary burst of light spotlights the incomparably situated Eilean Donan Castle. A lucky shot? You just don't know how long I waited for this. And of course Being There has nothing to do with luck. The light in Scotland at this time of year is to die for, but it often takes some waiting for.

• Fuji GX617, 180mm lens

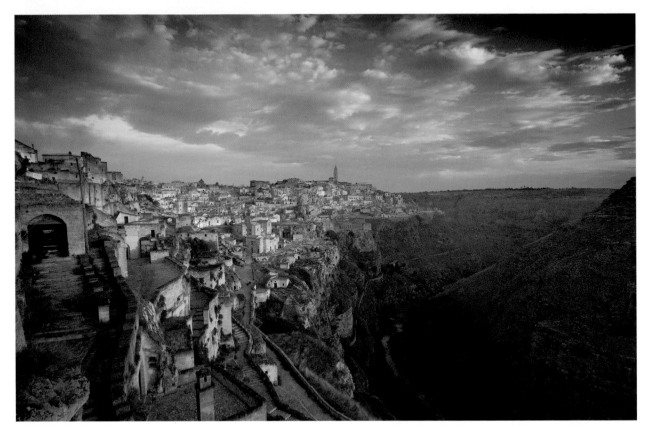

Dawn light on the *sassi* at Matera, Basilicata, Italy

I saw Matera featured on a TV programme and just had to come. It's like a scene out of biblical times. Right up until the 1960s people used to live in the caves, called sassi, *under the town. Yesterday I did my location searches and now I'm here at dawn, setting up, wrestling with the tripod legs, waiting for the light. I see the first rays of the day kissing the top of the church tower, slowly creeping down to bathe the town in warmth. There's a dramatic sky beautifully sidelit by the rising sun. If only it were always like this.*

• **Canon EOS-1Ds MKII, 17–40mm lens**

Old Sherborne Castle in the dawn mist, Dorset, England

I'm standing in a field surrounded by cows, gathered around like a bunch of paparazzi. I'm concerned that they're getting so excited about the interruption of another routine day munching grass they'll poo in my Lowepro. One seems determined to lick my Canon. I'm not sure it's designed to stand such treatment. Across the valley Old Sherborne Castle lies shrouded in mist early on a summer's morning. The art of Being There has been enhanced on this occasion by local knowledge – this is my patch, and I know when and where mist is likely to lie from many dawn patrols.

• **Canon EOS-1Ds MKII, 100–400mm lens**

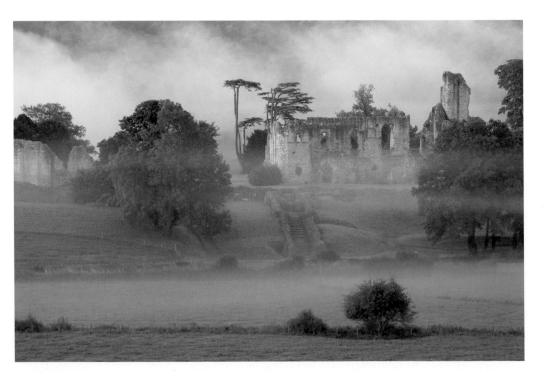

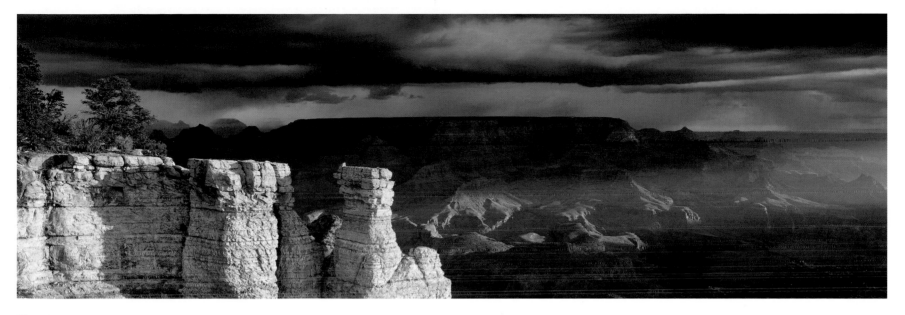

The Grand Canyon, Arizona, USA

Waiting – it's the name of the game. I'm standing on the rim of the Grand Canyon at dawn perusing the skyline to the east, wondering if the clouds will part. Heavy storm clouds lie brooding over the massive gorge. Then a heavenly shaft of light lasting less than 30 seconds paints the landscape momentarily and makes the whole trip worthwhile.

• Fuji GX617, 105mm lens

All light sources have a colour temperature (CT), measured in degrees Kelvin. The most dominant one, the sun, is reckoned to have a CT of 5,500K at midday – this is what is defined as white light. A typical domestic light bulb radiates Tungsten light, which is 3,200K. It's actually a cooler CT, but confusingly looks more orange than white light, so we call it warmer. The sunlight at sunset at has a lower CT, typically anything down to about 2,000K, and looks warm and golden. This is because the rays have to slice through a larger layer of atmosphere to get to us; the dust in the air scatters the longer wavelengths – the blue end of the spectrum – leaving the orange, shorter wavelengths to transmit through. Correspondingly, the ambient light left bouncing around the atmosphere after the sun has set has a very high CT in excess of 10,000K, and so looks blue. To really appreciate this, stand outside your house at dusk, looking in. As it gets darker the interior lights look very orange compared to the blue light outside. Normally our eyes and brain adjust to compensate for the CT of the dominant light source to make it appear white, but seen this way with the two light sources in juxtaposition the effect is obvious.

Along with Being There, a feel for light is The Most Important Element of Photography. If you're in the right place, with the right light then the most important elements in the making of a photograph are in place before a camera is even touched. It's why I spend far, far more time waiting for the light than I do behind the camera. It has affected my sanity, but like location searching, it has to be done.

Shapes

Point and shoot – that's how most pictures are taken. Look, raise your camera, point and shoot. What could be simpler? But we all know the difference between a grab shot and a striking image is down to the composition. Given that you're in the right place at the right time, the arty bit is often how the picture is composed. An eye for the arrangement of shapes within a frame is one of the differences between the taking and making of a photograph.

Composition, or more simply where to point the camera, is all about arranging shapes in the frame. Our first natural instinct is to put the main object of interest in the centre, point and shoot, but a bit of thought about how to frame a picture can transform a snap into a work of art. The simple expediency of moving the main subject away from the centre of the frame can have a dramatic effect on the impact of an image.

The Golden Rule of Thirds is a compositional tool that has guided artists for centuries, possibly millennia, maybe ever since man daubed pictures on cave walls. If the area of a picture is divided up into thirds, then strong lines within the composition – such as the horizon or a prominent tree – will

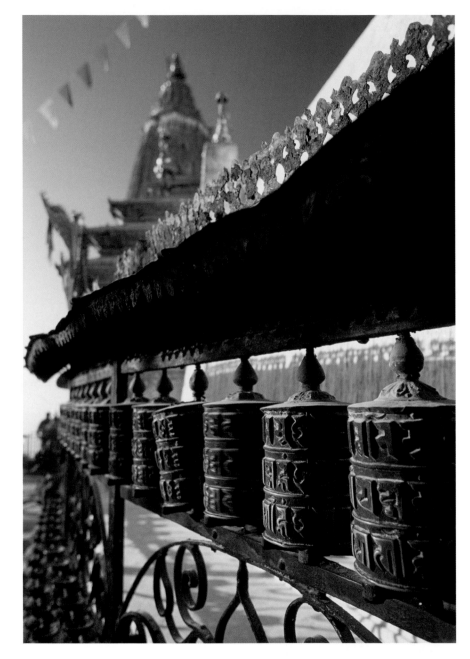

Prayer wheels at Swayambhunath Temple, Kathmandu, Nepal

The first direct rays of the day eventually penetrate the haze sitting over Kathmandu, lighting up the temple of Swayambhunath on the hill above. It's my last day in Nepal and I'm trying to squeeze out a few more shots from what has been a magical trip to the Himalayan Kingdom. The country is rapidly descending into chaos, strife and guerrilla warfare but for now all is peace and Buddhist harmony as monks circulate, chanting and spinning the prayer wheels in the crisp dawn light. The intricately carved wheels and the woodwork lead into the shot, and I drop the background slightly out of focus to give a sense of place without detracting from the foreground. The vertical line of the temple is about one-third in and the line of wheels one-third up, but it's not a conscious decision to use the Golden Rule, more often than not it comes naturally because it just looks right.

"The best compositions are always the simplest; there should be nothing in the frame that doesn't deserve to be there"

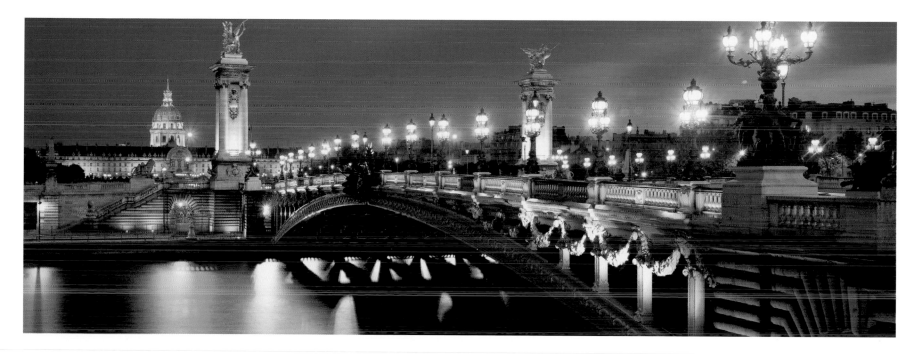

Pont Alexandre III, Hôtel des Invalides and the River Seine at night, Paris, France

I'm standing waiting for the lights to come on, shuffling from foot to foot in the cold winter wind blowing along the River Seine. There's always this dead time of about an hour to wait after dusk before it's dark enough to make a night image but at least I've had plenty of time to compose this shot. With the Pont Alexandre III leading into the frame towards the Hôtel des Invalides it's a classic adherence to the Golden Rule of Thirds. The two lines of the embankment and the tops of the row of lights on the bridge and Les Invalides bisect the image area by a third horizontally, while the two towers at the end of the bridge roughly do the same vertically. It's not an exact science and there are discrepancies, but as a rule of thumb for how to piece together a composition it takes some beating. Eventually the lights come on and the sky darkens enough for me make this exposure and head for warmth. Paris is surely the most beautifully lit city at night.

• Fuji GX617, 180mm lens

give the most pleasing arrangement if they are positioned along one of those lines of thirds. It's a technique that is unfailingly useful, to such an extent that most painters and photographers, indeed all artists, have developed it as a subconscious compositional default setting. Instinctively I will position elements within a frame along the lines of thirds without ever thinking about it; in fact to do otherwise takes a conscious decision to override the Golden Rule.

It is unarguably true that photography is the art of knowing what to leave out. My mother-in-law (bless her) when taking a snap usually moves back into the adjacent county in order to 'get it all in'. The result is acres of dead area as foreground and a mass of confusion (the family) in the middle distance. The best compositions are always the simplest; there should be nothing in the frame that doesn't deserve to be there. Confusing detail in the background kills a shot. Get it out; drop it out of focus, move, change composition, bend your knees or climb a tree, do whatever it takes. Sweep your eye from corner to corner of the frame and consider every element in the shot, how can the composition be improved, is there anything in the shot that shouldn't be? Be bold, be experimental, be arty, get high, or get low, whatever will make for a bolder composition.

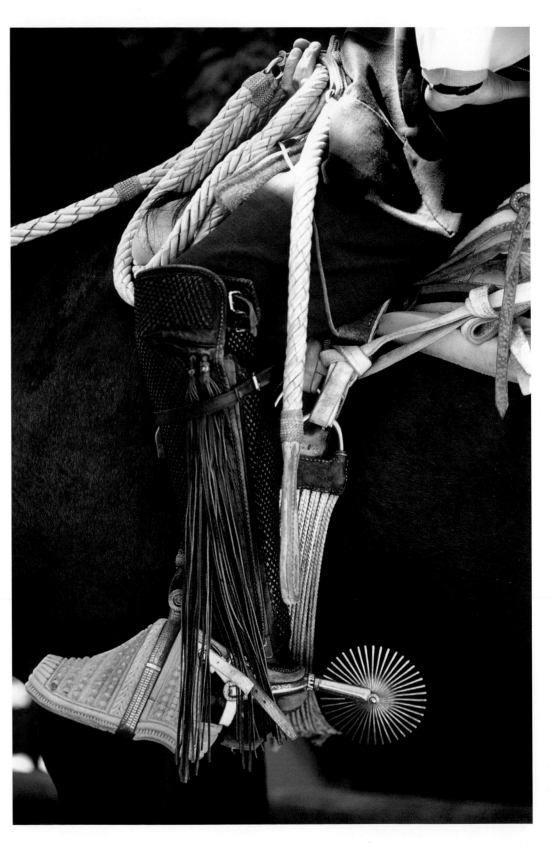

Detail of saddlery of a *huaso* (Chilean cowboy) at rodeo, San Fernando, Central Valley, Chile

Sometimes composing an image has to be a lightning fast decision based on intuition. At a rodeo in Chile's Central Valley I'm circulating amongst the huasos *waiting their turn to tame a calf in the dusty ring. I know the sort of shot I want – highlighting the intricacies and elaborate craftsmanship of their equipment – but inevitably when the moment comes it's fleeting. I arrange the strong shapes in the frame, sweep my eye from corner to corner of the eyepiece and shoot a frame, adjust the framing slightly, check focus, and expose two more frames before the* huaso *spurs his mount into action.*
• Nikon F5, 70–200 lens

A feel for composition is all about the positioning of strong shapes in relation to one another. As such I don't believe it can be taught; to me it's pretty much instinctive. Ask why I've placed that rock in the foreground in that corner of the frame and I can't explain, it's just a matter of harmony. It's another skill to be developed and kept in your toolbox to be used in tandem with all the others as part of the photographer's vision that starts to create a photograph before a camera is even touched.

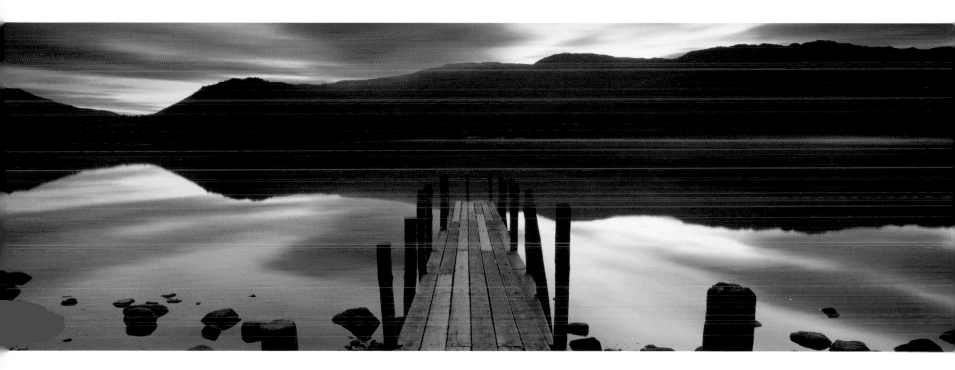

Derwentwater at dawn, Lake District, Cumbria, England

Dawn seeps through the sky, reflecting in the still waters. All is calm, tranquil and ethereal. I live for moments like this. I've been standing by the tripod on the end of the pier, watching as the darkness breaks, waiting for the light. As the flame red spreads through the sky from the east I take an exposure reading and start to expose. All rules are made to be broken, and here I'm deliberately flouting the Golden Rule of Thirds by placing the pier slap bang in the middle of the frame. Usually that's a definite no-no but the lines leading into the frame here are so strong it just has to be done. Images such as these, evoking powerful concepts for the viewer to connect with, are always winners. I do believe pictures can be over analysed but it wouldn't take a huge leap of imagination to connect this one with thoughts of departure, discovery and new beginnings. I am paying lip service to the Golden Rule with the water line being one-third down the frame. Crucially there's nothing anywhere in the frame that distracts from the simple lines of the composition.
• Fuji GX617, 90mm lens

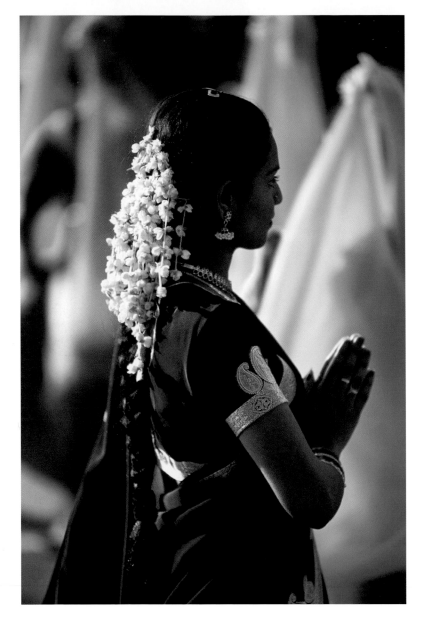

New Year Parade, Singapore

At a New Year's ceremony in Singapore the Indian women are in their finest saris.
This fleeting moment comes and goes almost before I can register it in my eyepiece.
The mechanics of taking a picture – the exposure, focus etc. – should, with practice,
become second nature, leaving the eye to concentrate on what's happening in front
of the lens. To me this exquisitely presented lady represents all that's exotic about the
Indian culture. The vibrant saris and sharp, tropical light giving high contrast dictate
that this can only be a very colourful picture.

• Nikon F5, 70–200mm lens

Colour

In terms of colour there are five options. Full throttle colour: bright, bold, saturated and full on. Subdued colour: muted, subtle and washed out. Minimal colour: so restrained you don't even notice it. Monochromatic colour: as many shades as you like but all of one colour. And monochromatic colour with no colour: black and white.

How photographers use colour is usually dependent on the nature of the light. By definition, a misty dawn landscape will have soft, watercolour, muted hues. The colours in a scene lit by strong, clear, directional light will be bright and saturated. The contrast and the colour vibrancy of an image are inextricably linked; increase the contrast in post-production and the colour saturation seems to increase, and vice versa. In the field and in post-production the photographer has to make a decision whether to emphasize or minimize the colour content of an image. Go too far on maximizing colour and the result looks false, treacly and tasteless … although colours that are too restrained can rob the image of its impact. As usual, subtlety is the key.

But colour is also a key consideration when pre-visualizing and composing images. Using just one splash of colour in an otherwise monochromatic scene is a very powerful tool, as is offsetting primary colours in simple, bold, graphic compositions. And pre-visualizing how a scene could look lit by the widely varying colour temperatures of natural light at different times of the day is yet another key part of a photographer's vision.

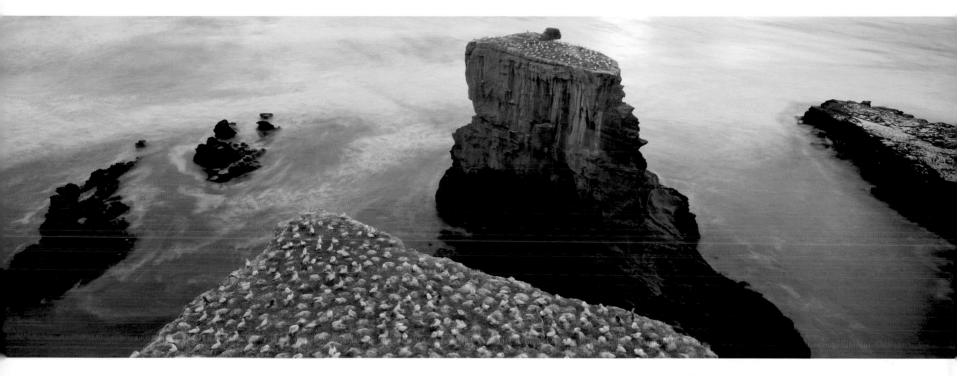

Gannet colony at Murawi, North Island, New Zealand

The sun has sunk into a layer of cloud over the Tasman Sea and the colour temperature of the remaining ambient light takes on a cool, blue tone. I've been shooting the sun setting over the sea stacks and carry on as our star disappears for the night. I use a neutral density filter to prolong the exposure, giving a milky effect to the movement of the water. People will think the blue, monochromatic tones are the result of a filter, but in fact it's all down to the nature of the light at dusk. Our eyes and brains in tandem do a sort of 'auto white balance', meaning we don't usually register these shifts in the colour temperature of the light; but film, or a digital sensor, does.
• Fuji GX617, 90mm lens

"How photographers use colour is usually dependent on the nature of the light."

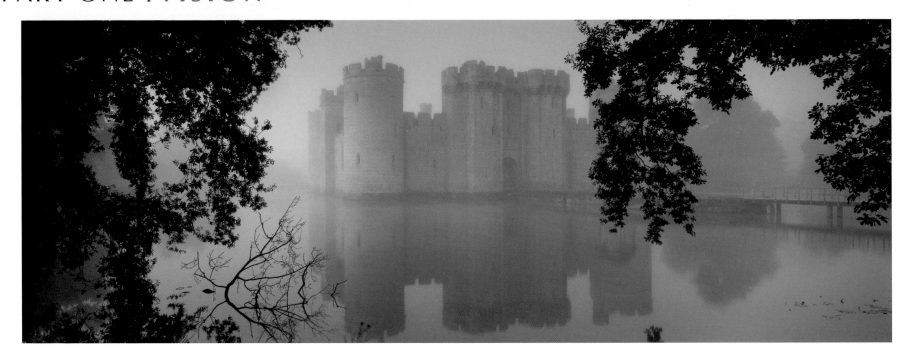

Bodiam Castle at dawn, East Sussex, England

Another misty dawn at Bodiam. The sun is up but is so far having trouble slicing through so much mist, so I've got the merest hint of directional light striking the left wall of the castle. Colour and contrast usually go hand in hand, and this is such a low-contrast scene that the colour is restrained to the point that there's hardly any. It is however, to my eyes, a beautifully subtle scene, and would be a very different picture if shot in black and white.

• **Fuji GX617, 90mm lens**

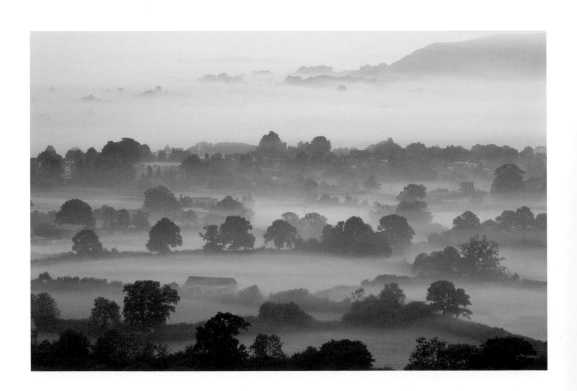

Montmartre at night, Paris, France

I am of the last generation of photographers who were trained initially in black and white. In the first term at college standing in the darkroom, watching my first print appear in the dish of developer in the gloom of the safelights, I thought it was magic. I still do. It's not just nostalgia; no one can deny that black and white has a unique quality. In this digital, full-colour age it seems timeless. Sadly, I don't work in mono as much as I'd like any more. Maybe I should. They say you can always convert from digital colour images, which I know is true, but I think a photographer's vision needs to be tuned into different wavelengths to work best in mono.

• **Nikon F5, 70–200mm lens**

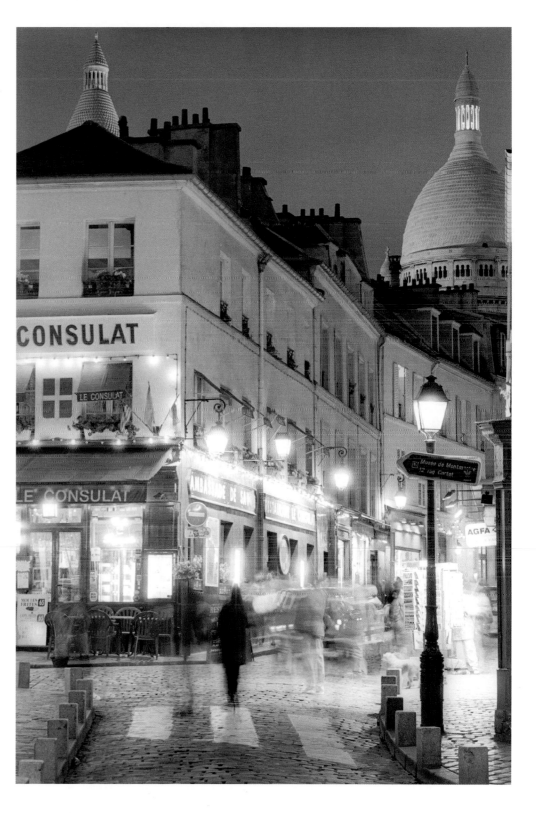

A misty dawn in the Blackmore Vale from Bulbarrow Hill, Dorset, England

Wendy and I spend much of the year on the road, living out of a rucksack or the back of a car. It can be a bit of a rootless life, so summer is usually devoted to reconnecting with home. Working my home turf gives me the advantage of local knowledge. With a high-pressure system sat over England, after a still night I know mist is bound to be draped over the patchwork of fields in the Blackmore Vale. I'm standing on the slopes of Bulbarrow Hill; it's hardly a Himalayan peak but it does give great views over the green and pleasant land of Dorset. With the light of dawn tingeing the mist, it's a soft, low-contrast scene like a watercolour, with muted, subdued colours.

• **Canon EOS-1Ds MK II, 70–200mm lens**

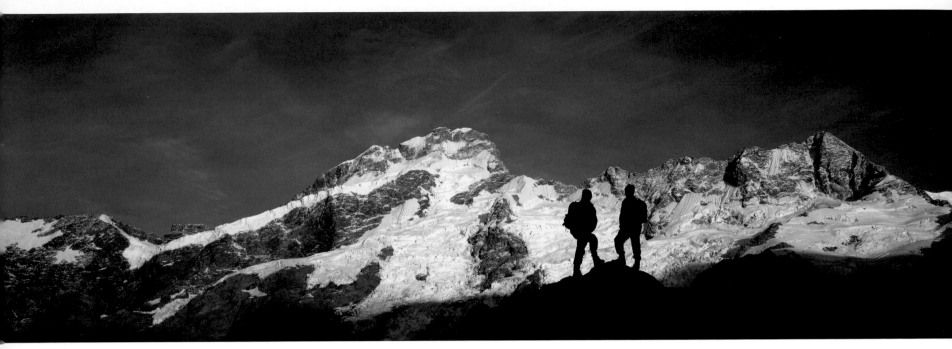

Distance

I could call this section 'How to make things look big', as we're talking all about scale here. How do you emphasize the size of the Himalayas, for example? Easy, show them in relation to something relatively small that we all know, like a tree. Fine. But if you're standing at the foot of the tree with it looming over you it looks massive even compared to the towering mountains in the distance. Take a few steps back and the effect is lessened. Come back 100 feet and the tree is still large but not as dominating. Come back a mile and the tree looks dwarfed by the mountains looming over it. It's only from this distant perspective that we see things at their true size in relation to other features around them. The trouble is, by definition, we have to be a long way back. It's a view on the world photographers call a long-lens perspective, as that's the tool we use to emphasize it. Anything longer than about 100mm (in 35mm-format terms) does the job, but the longer the lens the more pronounced the effect.

**Hikers near Mount Cook, Aoraki National Park,
South Island, New Zealand**

There's no better way to give a sense of scale than to incorporate human figures into the shot. I'm shouting instructions across to my wife and brother-in-law to get them to pose in a suitably intrepid manner. The first sunlight of the day is playing across the snow-capped peaks of the Southern Alps, silhouetting my reluctant models. If I were to move back the perspective of the mountains would appear bigger in relation to the figures, but I feel Wendy and Simon would be somewhat lost in the image, and they're doing a sterling job. Crawling out of your sleeping bag pre-dawn and hiking several miles to stand on a hillock looking in awe while being shouted at by a demanding photographer before breakfast isn't everyone's perfect way to start the day. Funny that.
• Fuji GX617, 180mm lens

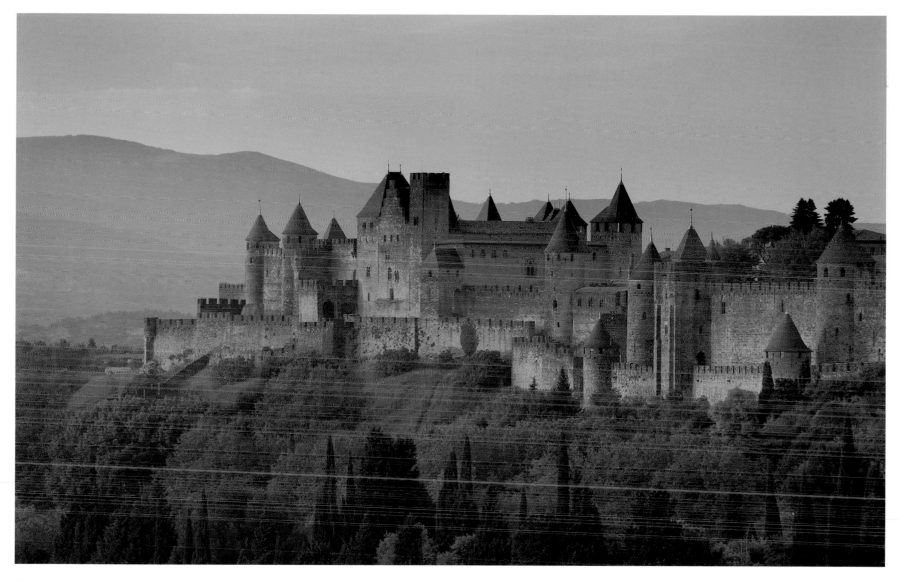

Carcassonne, Languedoc, France

The Cité of Carcassonne is everyone's fairytale castle realized. Situated in one of my favourite corners of France, it takes some beating. Every year we seem to end up drifting through this part of the world in a haze of croissants, cassoulet and carafes du vin. I've shot the Cité from all angles, up close and personal and from afar. This evening we've driven down a farmer's track and have the luxury of working from the tailgate of the Land Rover with a baguette and fromage on the go to ease the passage of time as we wait for the evening light. I spent all of the previous day cycling through the countryside surrounding the town looking for this viewpoint, it has taken some finding but it's worth it. I'm about two miles away working with a 400mm lens to flatten the perspective of the Cité and Montagne Noire beyond. The narrow angle of view also has the advantage of enabling me to exclude all the clutter of the modern town, which sprawls around the base. I'm worried about the risk of wind causing lens movement, which is always an issue when working with long lenses, but it's a relatively tranquil summer evening in Languedoc so I should be OK. As the sun sinks into the haze the light loses some of its punch, softening it a touch, but also giving the warm tone I've been waiting for.
• Canon EOS-1Ds MKII, 100–400mm lens

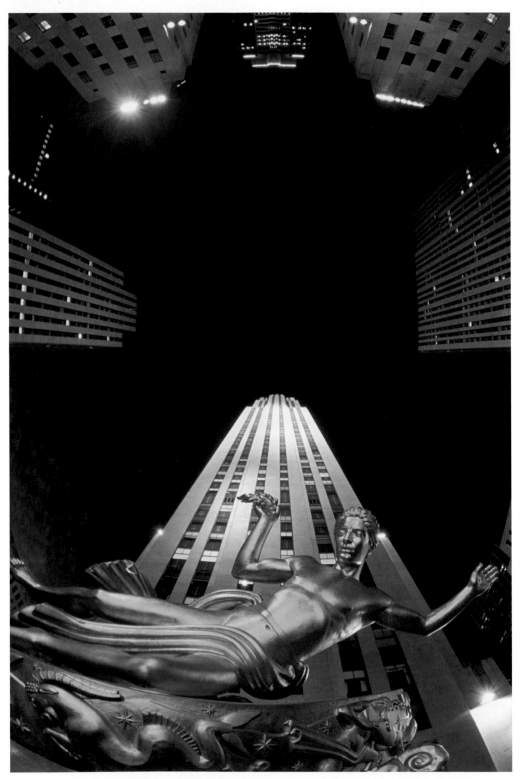

I often use a 400mm lens to really flatten the perspective. Similarly the up-close view with the eye dominated by the foreground and the distant objects tiny in relation we call a wide-angle perspective. A focal length shorter than 35mm gives this view, but to really emphasize this effect to the ultimate degree I use a 15mm fisheye lens with a 180-degree field of view. With this perspective everything from a few inches in front of the lens to the distant mountains needs to be sharp, so a correspondingly small aperture for maximum depth of field is usually prescribed.

So, in the field, tramping around in the heat of the day, chasing locations, choosing viewpoints, it pays to be thinking about perspective. It's all about the foreground, do you want it to dominate or not? Those wild flowers blooming in an alpine pasture, how do you want to feature them? Get down amongst them with a fisheye lens and the plants virtually touching the front element, in which case the distant mountains will be but pin pricks on the horizon, or stand back and have the flowers as a carpet of colour in the bottom of the frame with the peaks rearing above? Or something in between? The choice is yours.

The Rockefeller Center, New York City, USA

From one extreme to another, from a French long lens perspective to a fisheye in New York. I'm crouching by the tripod underneath a statue at the Rockefeller Center, craning my neck to look up through the eyepiece. The extreme wide-angle perspective allows the foreground to dominate, with the camera looking almost vertically up and the towers leaning into the shot. Using the unusual perspective of either long or short lenses is often a very useful way of getting a new slant on well-known vistas, particularly in cities.
• **Nikon F5, 16mm fisheye lens**

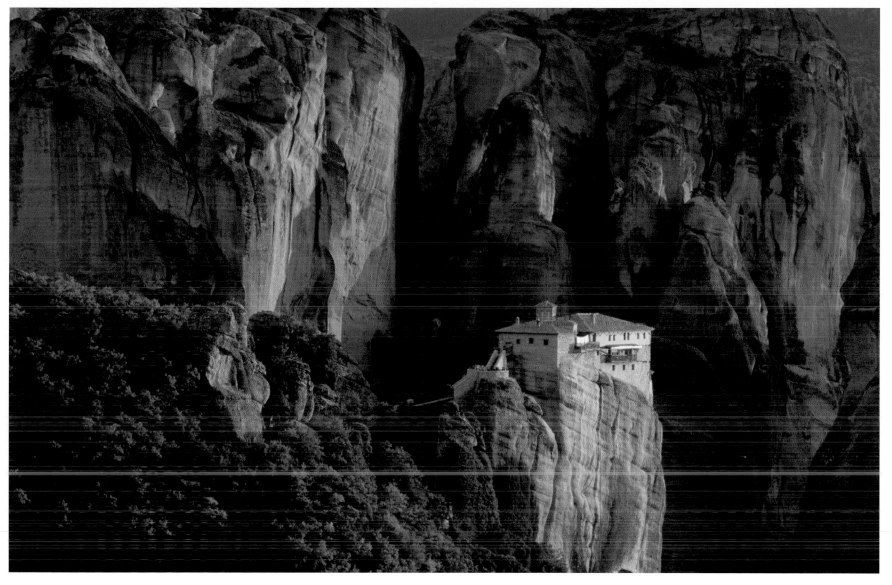

Roussanou Monastery, Meteora, Greece

*Strange people, monks. They tend to site their monasteries in the most inaccessible places.
I guess there's a reason for that, and not just for the benefit of future photographers. I
saw the monasteries at Meteora in northern Greece featured in a Bond film years ago
and they struck a chord, so here I am, scrabbling across rocky slopes in search of the
definitive angle. With the soft evening light sidelighting the scene, I shoot with a long lens
to isolate the monastery and cliffs. This perspective emphasizes the dramatic sighting of the
monastery dwarfed by the surrounding rocky pinnacles.*

• **Nikon F5, 70–200mm lens**

"It's only from a distant perspective that we see things at their true size in relation to other features around them"

Time

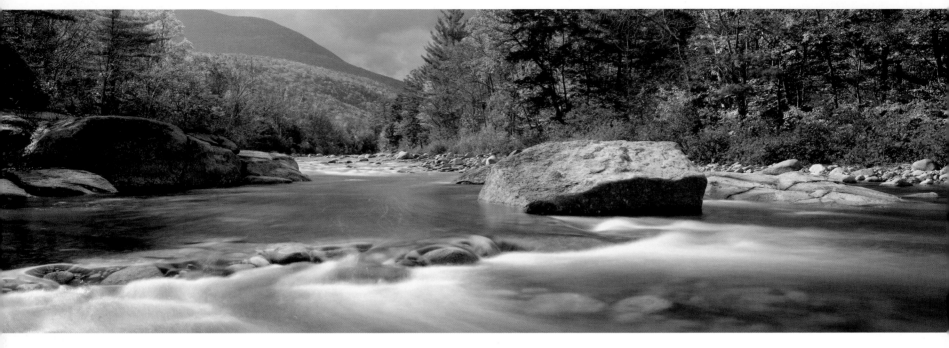

A photographer's life is dominated by the need to be in the right place for dawn and dusk. The period immediately before and after sunset and sunrise is happy hour, when the natural light goes through some wonderful transformations. Ninety per cent of my photography happens around these times. There are exceptions of course; the seasons and latitude have a huge bearing on my timetable. For example north of the Arctic Circle in summer the sun just bumps around the horizon all day, never setting, and never getting that high. The light can be fantastic all 24 hours, which presents something of a problem in knowing when to time an eyelid inspection. Up on Canada's Ellesmere Island I was happily shooting away in slanting golden light at 2am. In complete contrast as I sit writing this book it's

12 noon here on the Seychelles island of La Digue, a little parcel of tropical paradise slap bang in the middle of the Indian Ocean just south of the equator. The sun is vertically overhead, beating down with a tropical ferocity that sends even the most fanatical sun worshippers heading for the shade. Photographically it's a hard, high-contrast, unflattering light. Here, between the hours of 9am and 5pm I wouldn't dream of touching a camera. Conversely consider a winter's day in the Scottish Highlands. The days are short and the sun never gets very high in the sky, so if the sun appears it's quite feasible to be shooting all day. The key is the angle of the light, low, slanting rays sidelighting the world are what we like. But there are endless variations that a photographer's eye needs to be tuned into.

Autumn in the Saco Valley, White Mountains, New Hampshire, USA

I spent all afternoon in this spot, using the crisp, low-angled light of October to investigate all the photographic options. Often I'm waiting for the sun to drop near to the horizon, but here in mid-afternoon in the New England Fall the light was perfect. By the time the sun was setting, the trees on the bank were throwing long shadows over the water. There's a perfect time for every shot, knowing when that is likely to be is what it's all about.

• Fuji GX617, 105mm lens

ROUND THE WORLD IN SEARCH OF LIGHT

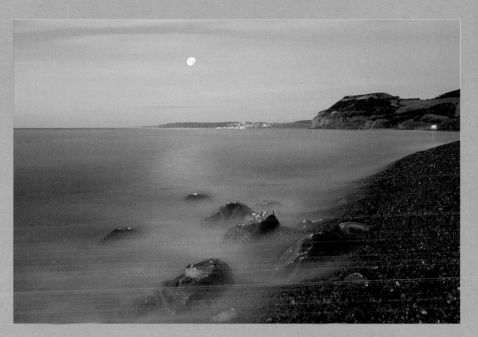

4am Eype Point, Lyme Regis, Dorset, England

*A full moon hangs over the Jurassic Coast casting a moon shadow
of me by the tripod over the rocks. The faintest light is starting to
seep through the sky from over Portland, making a photograph
just possible with an ultra-long exposure of 15 minutes. The colour
temperature of the ambient light gives the whole scene a blue tinge,
my eye automatically adjusts for it but the film does not. It's so dark I
can barely see what I'm framing through the eyepiece, but the lights
twinkling in the distance at least give me something to focus on.*
• Nikon F5, 17–35mm lens

5.30am Cape Breton, Nova Scotia, Canada

*Another coastline on the other side of the Atlantic at dawn. The sun isn't yet up but from its lair just below the horizon
to the east it's bottom lighting the clouds, sending streaks of pink and mauve through the sky. There's no direct sunlight
yet but the diffuse glow is starting to give the faintest touch of soft, low contrast directional light on the landscape.
It's another long exposure, and I'm checking and adjusting the timing constantly as the light levels increase.*
• Fuji GX617, 90mm lens

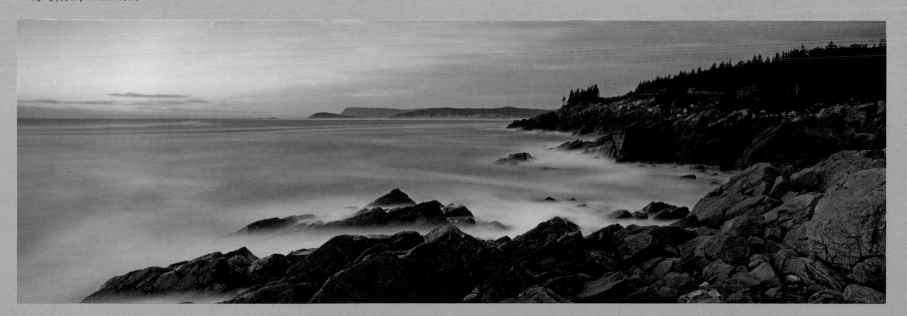

TRAVEL | DIARY

6.30am: Torres del Paine National Park, Patagonia, Chile

The sun pops over the horizon and the first direct rays of gold paint the highest peaks of the Torres del Paine. The clouds clinging to the massif are lit up in the fiery light and it's one of those moments I know will stay with me for the rest of my days. I work methodically, double-checking the exposure, filtration, focus and framing. We've come a long, long way and camped out in howling winds for a week for this … what a reward.
• Fuji GX617, 180mm lens

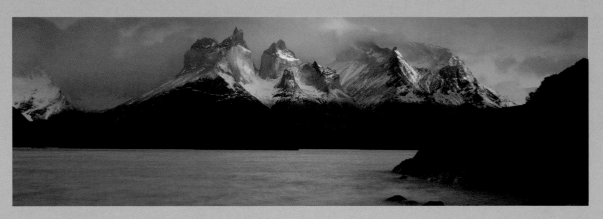

9am: Tarn Hows, Cumbria, England

On an autumn day in Cumbria the clouds part and the sun splashes patches of light across the Lake District, making the russet tones glow beneath the heavy brooding sky. As usual with this corner of the British Isles, it has been an exercise in patience, waiting for the light. The clouds close in again and the scene is but a memory. I could have a long wait until the next opportunity.
• Canon EOS-1Ds MKII, 24–70mm lens

10am: Location searching

The sun is high in the sky and the light has lost all its subtle appeal, so it's time to get out location searching – finding and planning the next few days' shoots, by foot, cycle, car or boat, whatever it takes. Sometimes it's as easy as going for a pleasant stroll, other times it's a toil involving many miles. Well, no one ever said it was easy.

2pm: Siesta

Those dawn rises catch up with you sooner or later.

5pm: Dunguaire Castle, Co Galway, Ireland

The sun is dropping fast over the west coast. I'm crouching by the tripod trying to get the definitive angle on the castle when a slice of light pierces the stormy clouds rolling off the ocean. I'd been eyeing the swan with her cygnets for some time, hoping against hope that she'd stay in situ long enough to provide foreground interest.
• Nikon F5, 20–35mm lens

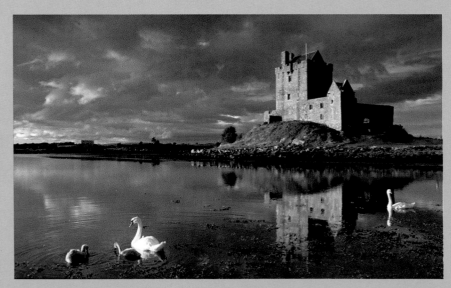

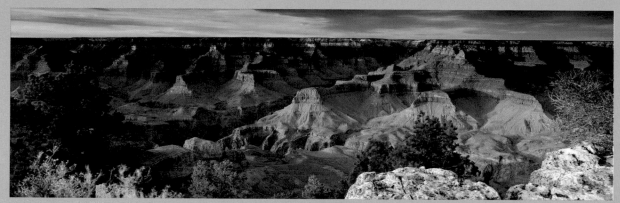

6.30pm: Grand Canyon, Arizona, USA

The last weak sun of the day is sidelighting the canyon, picking out the relief and textures of the gaping chasm. The light is fading fast but it has a certain soft quality. Just as I'm checking my exposure a tourist appears at my elbow, wanting to tell me all about every camera he's ever owned. This is one of the hazards of the job, particularly in well-known spots like this. I nudge him to his fate over the rim of the precipice. Of course I'm joking, but I did strongly consider it.
- **Fuji GX617, 105mm lens**

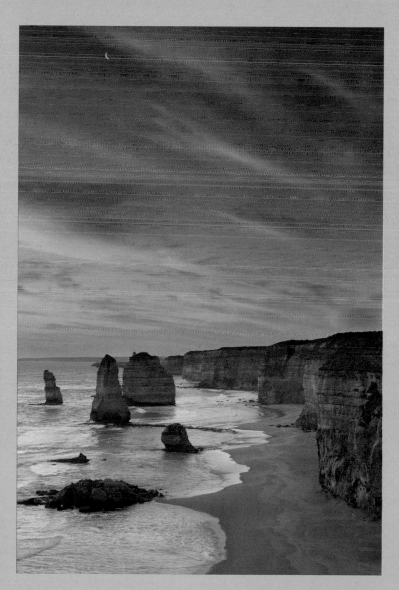

8pm: The Twelve Apostles, Great Ocean Road, Victoria, Australia

The sun has sunk below the western horizon and the sky is streaked with pinky-orange in a carbon copy in reverse of the Nova Scotia dawn, only this time I've got the silvery crescent of the moon on tonight's menu. Far down on the beach a posse of penguins waddle ashore. What a beautiful evening on the tip of this beguiling continent. Just one point I'd like to mention to my Aussie friends; those stacks, the Apostles? Someone can't count.
- **Canon EOS-1Ds MKII, 24–70mm lens**

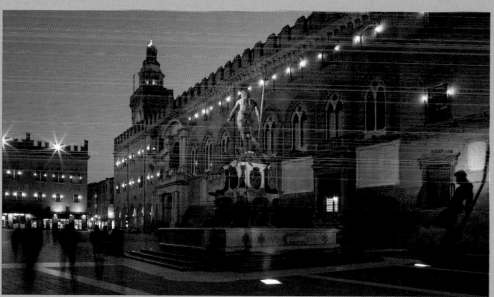

9pm: Piazza del Nettuno, Bologna, Emilia-Romagna, Italy

It's getting dark now and the lights around the piazza are coming on. There's still just enough light in the sky to balance perfectly with the artificial lighting. There's a period of about 10–15 minutes when the balance is perfect for night shots: leave it too late and the sky will go black. To my mind the shadow of the statue on the right makes the shot. I get some friends to be creative blurs in the left corner of the frame and we're away.
- **Canon EOS-1Ds MKII, 24mm shift lens**

Motion

Life often seems a bit of a blur. Much as we'd all like to slow things down now and then we're all whizzing about, and so is the world around us. Waves lap, trees lean, clouds drift, birds flutter, leaves scatter, grass sways, water ripples, wind gusts, sheep graze, people stride and the sun rises – the world is a busy place. A photograph must somehow convey that motion, to not do so usually results in a somewhat sterile take on the world.

Photographers have a choice; to blur or not to blur, that is the question. Using fast shutter speeds we can freeze all movement, or go slow and everything becomes a bit fuzzy; lock the camera off on the tripod while the world swirls around it, or have the camera moving as well. If it's the latter then the slower the shutter speed the more surreal, even impressionistic, the image becomes. I use motion in pictures to suggest speed, or to emphasize the bustle of a busy market or street scene.

How much motion is evoked is dependent on the shutter speed, the velocity at which the subject is moving and the amount of panning; it's a complex relationship that is best perfected with trial and error. Typically, for a cyclist whizzing past along a Dutch canal I'd use a shutter speed of about 1/8sec. Of course, the beauty of shooting digitally is you can fine-tune the amount of motion blur with just a few test shots. But whether

"To blur or not to blur, that is the question"

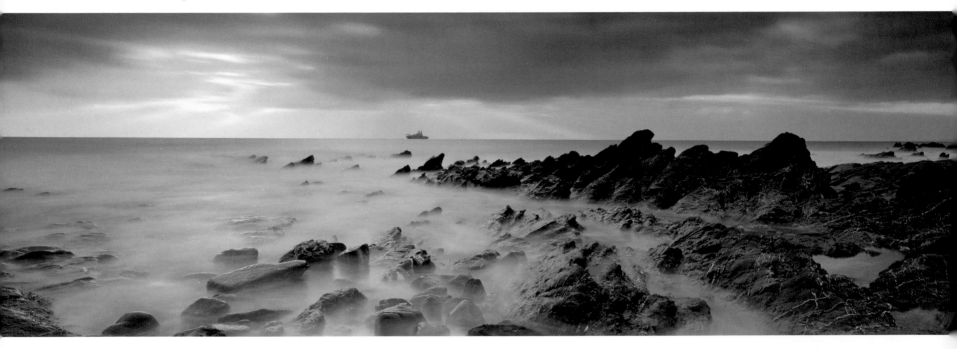

Dusk on the Lizard Peninsula, Cornwall, England

It's late on a winter's afternoon and I'm standing counting off the time in the middle of an eight-minute exposure with the waves lapping around my feet. The tide is coming in and after this exposure I'll have to up sticks and move up the beach to avoid a soggy camera situation. It's a risky set up; one large wave and several thousand pounds' worth of equipment is history. I'm using a neutral density filter to slow down the exposure. There's movement in the water and in the sky as the clouds pile in off the Atlantic. The light has got a steely, cold, grey quality, with the setting sun weakly piercing the clouds to the west to give a few heavenly shafts. The movement in the sea and sky is emphasized by the sharp detail in the sculpted rocks and ship on the horizon. Standing looking at this scene with the naked eye it all looks very different from how the finished picture will look; but that is all part of developing a photographer's vision. And heavenly shafts always help.
• Fuji GX617, 90mm lens

Street scene, Hanoi, Vietnam

The alleys of Hanoi are a whirlwind of unfeasibly loaded bicycles, market stalls and women in conical hats – it's intoxicating. I spend several days engrossed in the mayhem, panning and working quickly handheld, revelling in the culture shock. The women with the hats and baskets of produce are the icons this time, and the bustle of Hanoi can only be conveyed with motion. In this case everything is moving, the ladies with the flowers and vegetables, the camera and me. They come past me and I slot in behind and up close long enough to squeeze off a few frames before they become aware of me and stop in bemusement. There's nothing sharp, but the blur makes for an almost impressionistic feel. Here the background distractions are lost in a wonderful fudgy blur, and that's before a beer or two.

• Nikon F5 17–35mm lens

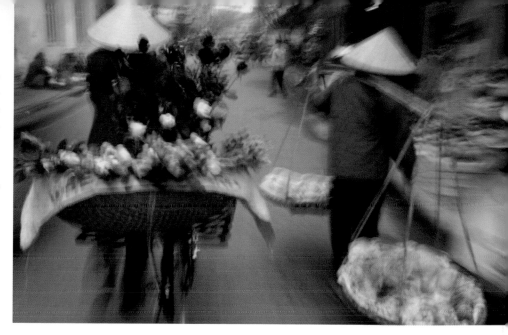

using film or digital a few trial runs practising this useful technique and noting the results in controlled circumstances are well worth the time and effort. Nine times out of ten there's something moving somewhere in my frame, and I often go to great lengths to accentuate that movement. I stop down to the minimum aperture and use neutral density filters to slow the exposure as much as possible. I've spent significant tracts of my life waiting for a waft of breeze to sway the grass in the foreground, or the one

in a hundred wave to crash on the rocks – more waiting, as if there wasn't enough already. In a landscape, movement can add mood and interest. In a street scene it can do the same with the added bonus of masking unsightly details; litter strewn on streets becomes bright streaks of colour, as do garish advertising hoardings and all the other detritus of life. Emphasizing motion is yet another tool in a photographer's arsenal, a vital element in the making of a picture.

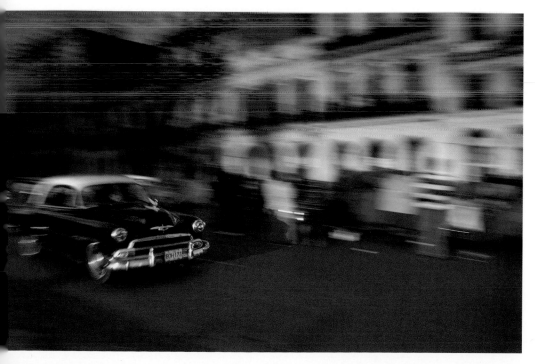

Passing car, Havana, Cuba

Among the most visible icons of Cuba are the 1950s cars. Another aspect of Havana's old town is the fading elegance of the colonial architecture, slightly decrepit but atmospheric nonetheless, and I want to combine these two elements in an image that just says 'Cuba'. The trouble is, up close a lot of the details of Habana Vieja are fairly grotty – ugly cabling, litter, mangy dogs and lots of tourists. So it's going to have to be a panning shot: the movement will convey the bustle of the place while losing some of the distracting details. Finding the right background was critical. I trudged around the city fending off the hustlers and hookers looking for the right buildings, ones that would look good with a bit of blur and evening light. So, here I am all set with the old Buicks trundling past and soft golden rays bathing the buildings behind. Getting a smooth panning action is the key – it takes some practice.

• Nikon F5, 24–70mm lens

Part Two: Environments

Each different environment introduces its own challenges for the photographer, both in the way we use light and construct images and in how we manage to be in the right place at the right time. The light in a rainforest is very different from that of a desert dawn; each particular environment will present the photographer with unique opportunities and problems. But often the photography can seem the easy bit; just getting around and sustaining yourself can be the toughest task. But when it all comes together, like watching the pink rays of dawn kiss the peak of Annapurna as the shutter clicks open, there's nothing better.

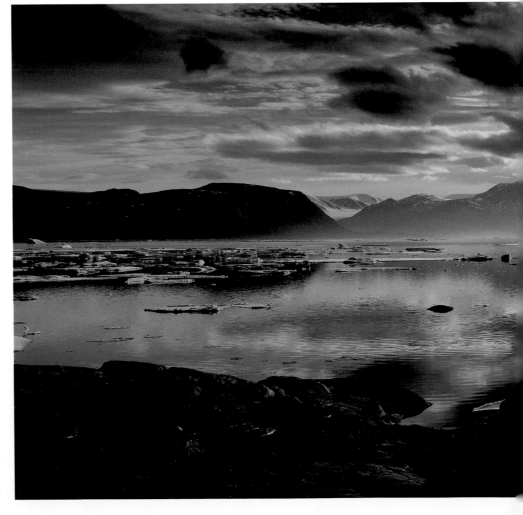

Alexandra Fjord, Ellesmere Island, Nunavut, Canadian Arctic
• Fuji GX617, 105mm lens

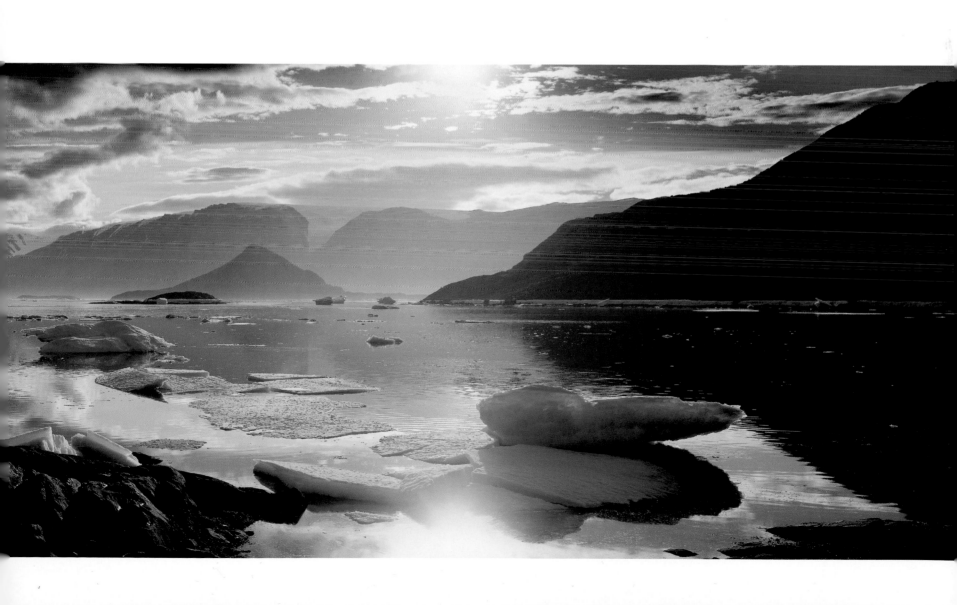

In the Footsteps of the Inca

By the cold light of dawn I encountered Marina, a young shepherdess, tending her flock alone on the pampas, high above the Sacred Valley. We chatted away, unhindered by our complete lack of a mutual language. My Spanish is weak, but it would have made no difference, for she is Quechua, a direct descendant of the Inca. It was one of those encounters that refresh the soul. Machu Picchu, Cusco, the soaring Andes; all of these make this a breathtaking experience, but for me, Marina is the face of Peru.

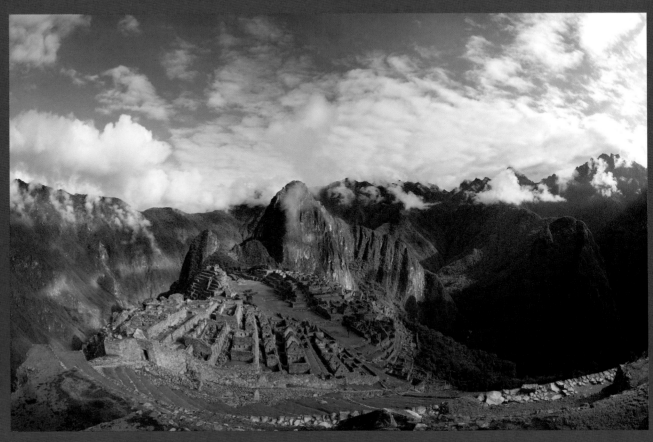

Machu Picchu

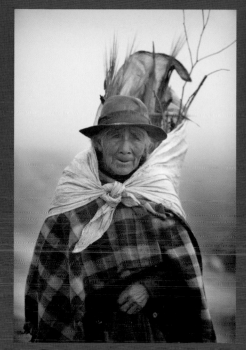

Quechua woman in the mist near Marras

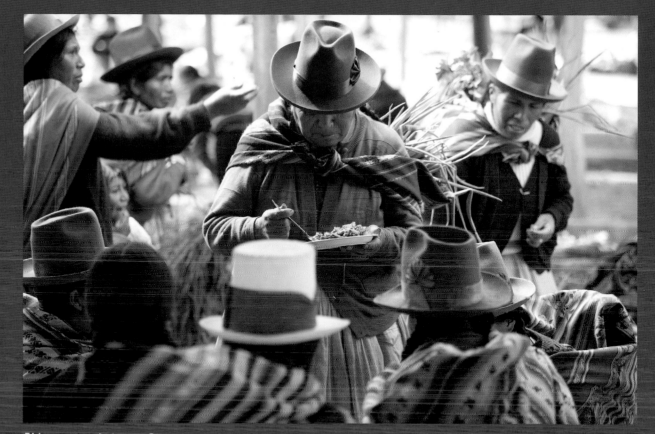

Chincerro market, near Cusco

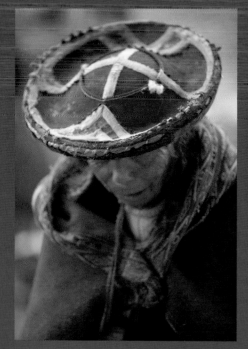

Quechua woman at Chincerro
market, near Cusco

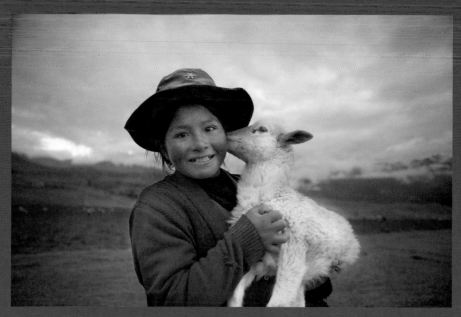

Marina, a Quechua shepherd girl

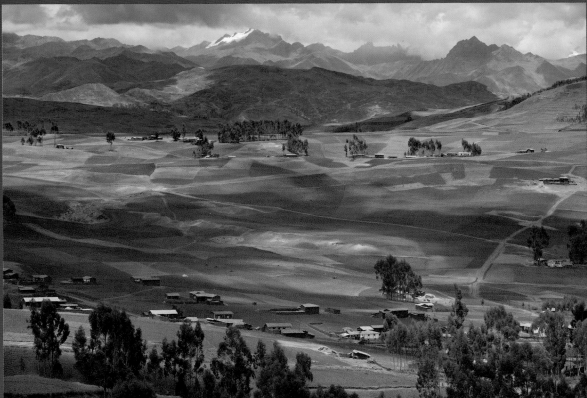

Farmland above the Sacred Valley nears Chincerro, nears Cusco

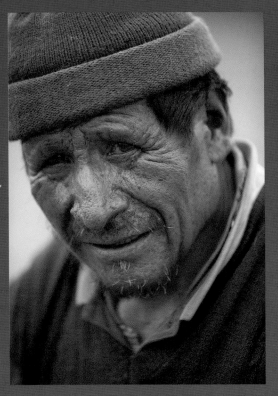

Chincerro farmer

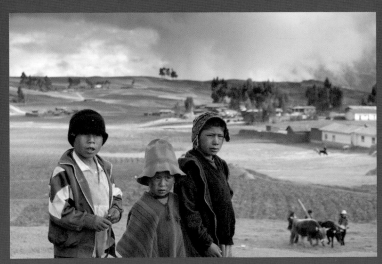

Children, Chincerro, nears Cusco

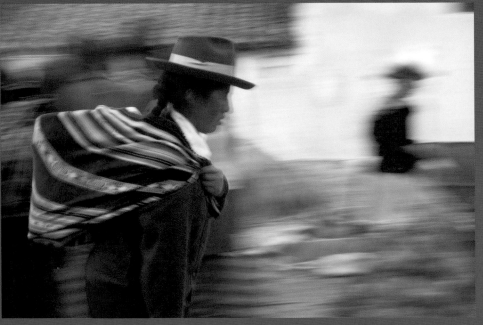

Quechua woman at Chincerro market, nears Cusco

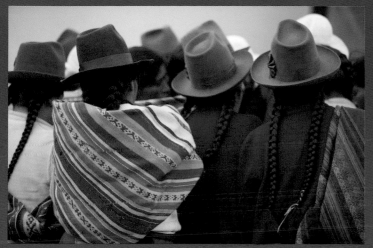

Women with hats and double pigtails, Chincerro market, nears Cusco

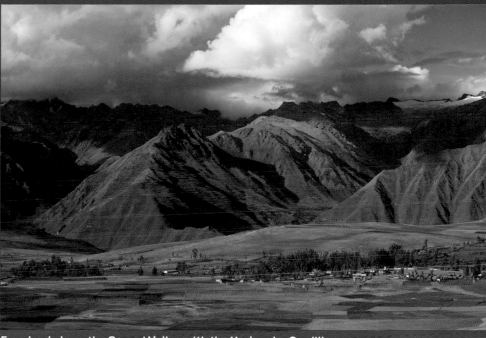

Farmland above the Sacred Valley with the Urubamba Cordillera of the Andes behind

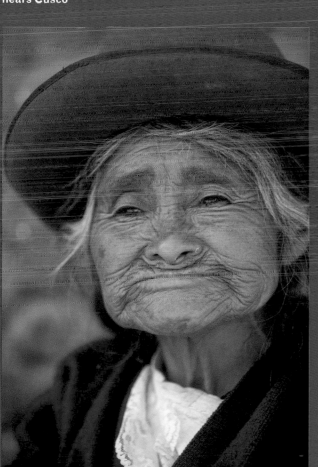

Old woman in the square, Pisac, Sacred Valley

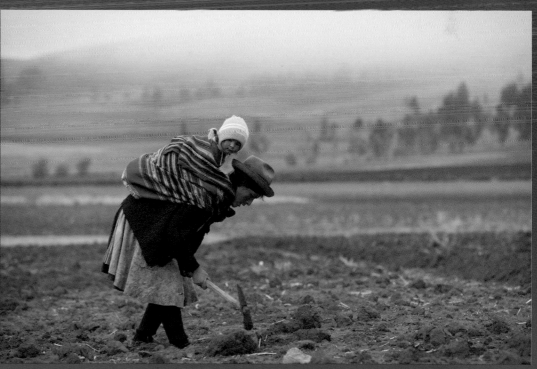

Woman tilling a field with baby in the morning mist, Pampasmojo, Marras

The Road to Zhongdian

How can you possibly sum up China, geographically huge and populously vast? Working there is challenging, at one moment exhilarating, the next depressing. But the menu for the photographer's take-away is enticing: haunting, massive, varied landscapes, bustling streets, frantic markets, new-age cities and rustic villages; and peoples of a rich and varied culture, despite the years under a monolithic government. A few travel tips: don't forget your thermals, take a bath plug and prepare to have all your preconceptions shattered.

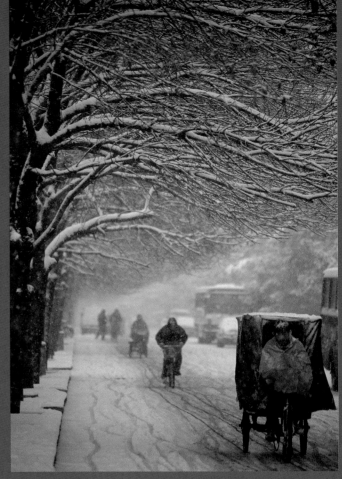

Rickshaws in the snow, Beijing

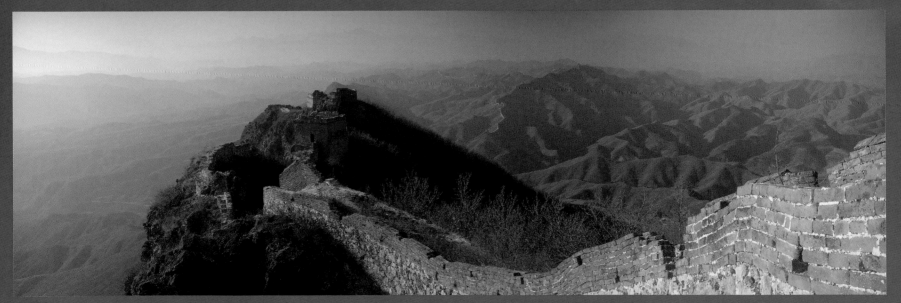

The Great Wall

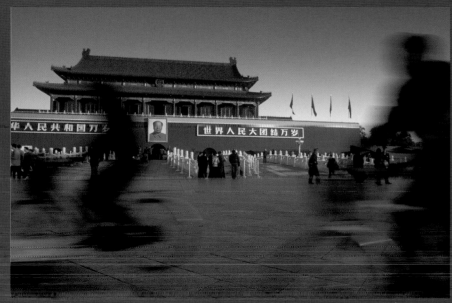

Cyclists in Tian'anmen Square, Beijing

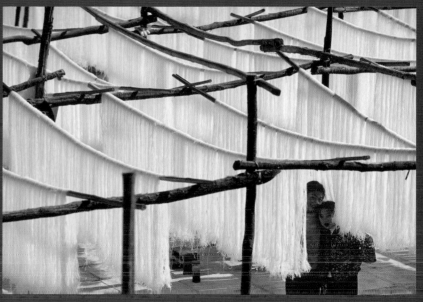

Children playing among drying noodles, Yunnan Province

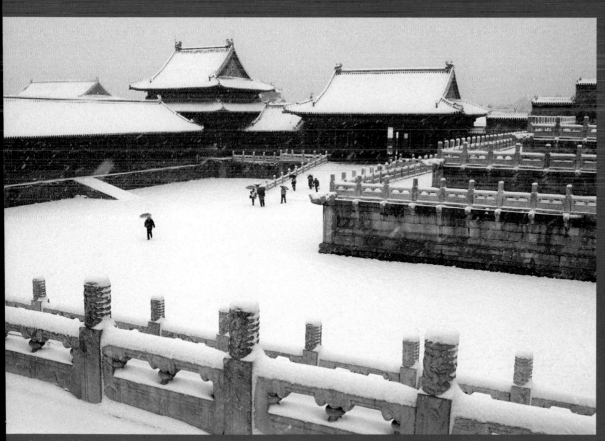

Imperial Palace (Forbidden City) in the snow, Beijing

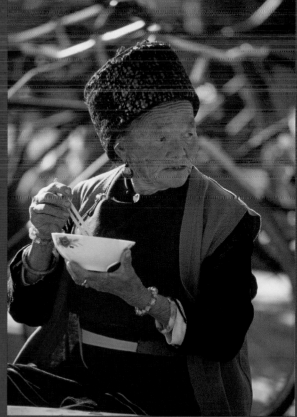

Wase market, Er Hai Lake, near Dali, Yunnan Province

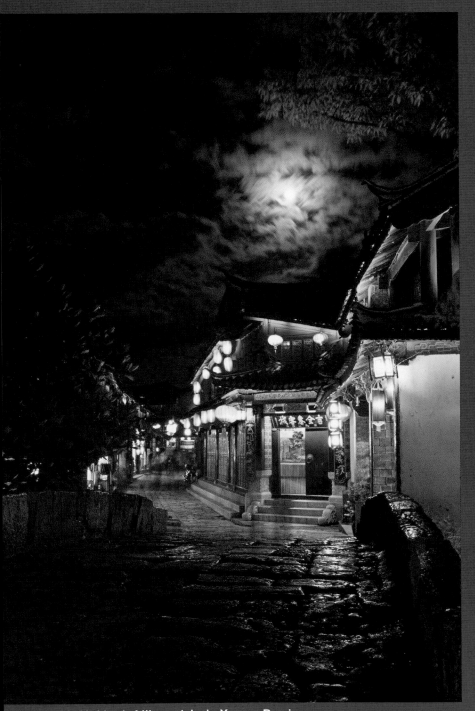

Cobbled bridge in Lijiang at dusk, Yunnan Province

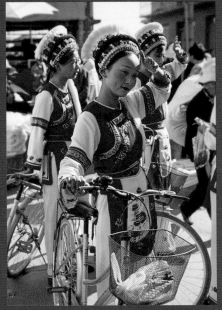

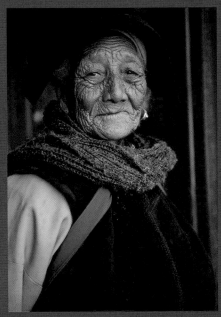

Bai women in traditional costume, Wase market, Er Hai Lake, near Dali, Yunnan Province

Naxi woman, Yunnan Province

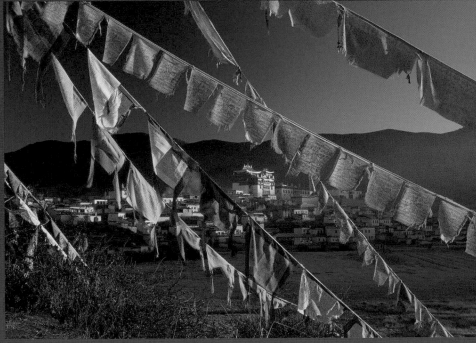

Jietang Songlin Monastery outside Zhongdian with prayer flags, Yunnan Province

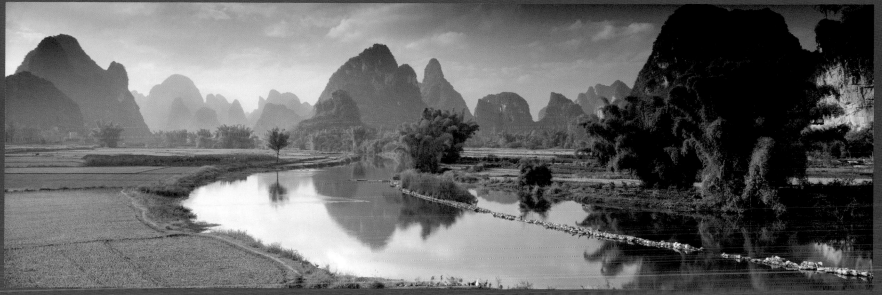

Li River, near Yangshuo, Guangxi Province

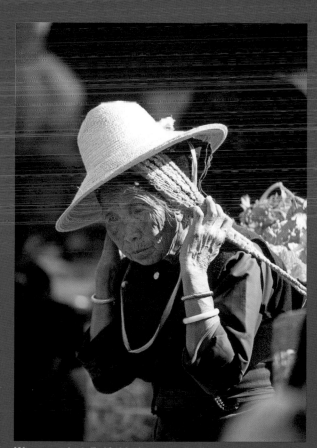

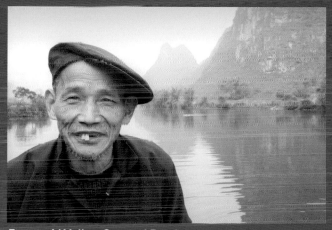

Farmer, Li Valley, Guangxi Province

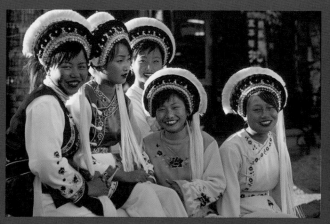

Wase market, Er Hai Lake, near Dali,
Yunnan Province

Detail of Bai woman's costume,
Wase market, Er Hai Lake, near Dali,
Yunnan Province

Bai girls, Dali, Yunnan Province

Rock

There's no denying it, all photographers seem drawn to the mountains, unsurprisingly as they provide some of the most dramatic landscapes on the planet. Photography aside, to stand on a peak at dawn looking at the world stretched out beneath you is one of those experiences to connect you with the very roots of your soul. It's a tough environment to work in though.

Getting to where you need to be for that epic vista can be somewhat tricky, to say the least. You can use mountain roads and cable cars, but depending on how far you want to take it, sooner or later you're going to have to get your boots on and walk. There's no getting away from it. Lugging gear up hills is just part of the job. I was two inches taller before I was a photographer. A mountain photographer will first and foremost have to be a mountaineer, willing and able to deal with all extremes of weather and terrain. Mountaineers though are obsessed with only one thing – The Route – while we photographers are fixated solely on The Shot. To be in the right place at the right time high in the mountains for that ultimate image can be a complex logistical challenge involving many nights spent camping in the thin air. Tough choices about what can be carried on the back have to be made – another lens or more food?

In an ideal world I would have the panoramic camera there on a lofty ridge with both 90mm and 180mm lenses, and also my complete DSLR system with lenses ranging from 15mm

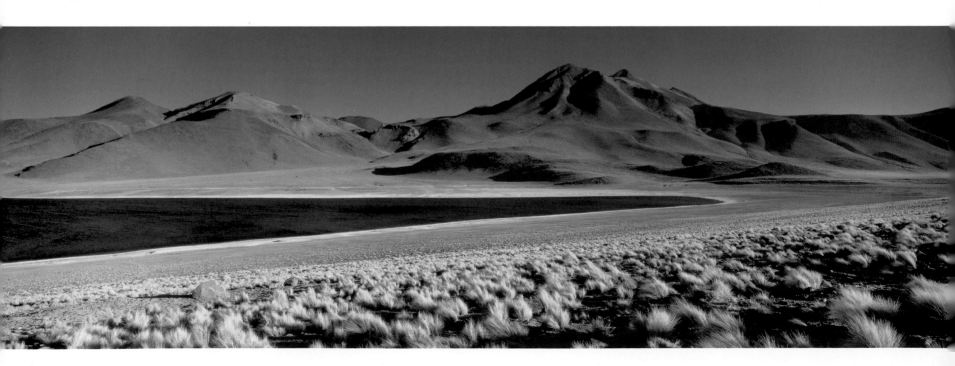

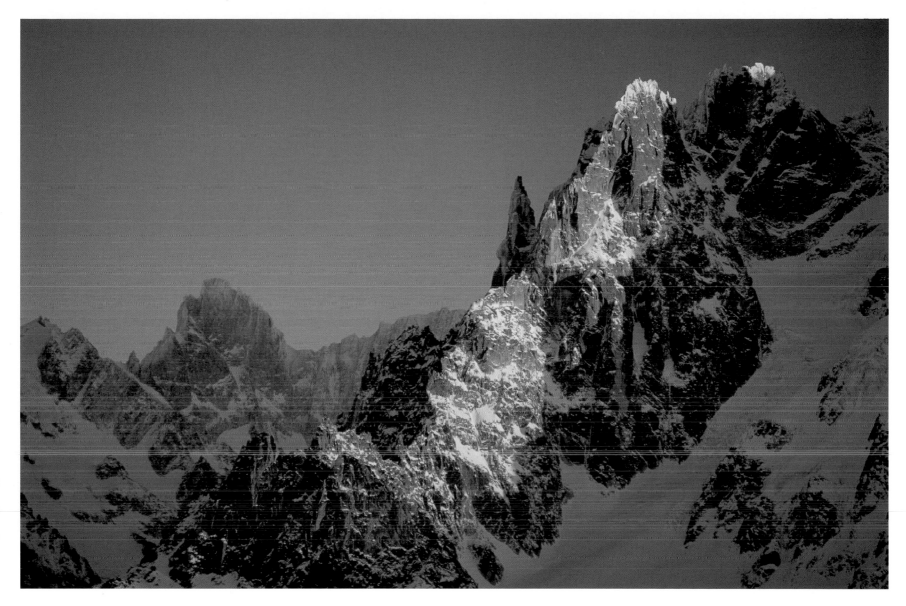

Laguna Miscanti and Cerro Miñiques, The Andes, Chile
*We're camping up at Laguna Miscanti, which lies high in the Chilean Andes above
the Atacama Desert. These mountains are dry as a bone, the thin air equally so,
making the Milky Way display at night the best I've ever seen. Normally for a shot
like this I'd use a polarizer to accentuate the blue sky, but the air is so clear up here
there's no need. Normally I hate uniform blue skies, devoid of any interest, but
clouds up here just don't happen. It's a pretty elemental shot, entirely in keeping
with the environment.*
• **Fuji GX617, 90mm lens**

**Mont Blanc in winter, Le Brévent, above
Chamonix, Haute-Savoie, France**
*The last glimmer of light from the setting sun
catches the serrated ridge on the flanks of Mont
Blanc on this winter evening. I've cheated for this
one: rather than hiking here, I caught the cable
car up to Le Brévent to make the most of the view
across the French Alps.*
• **Nikon F5, 70–200mm lens**

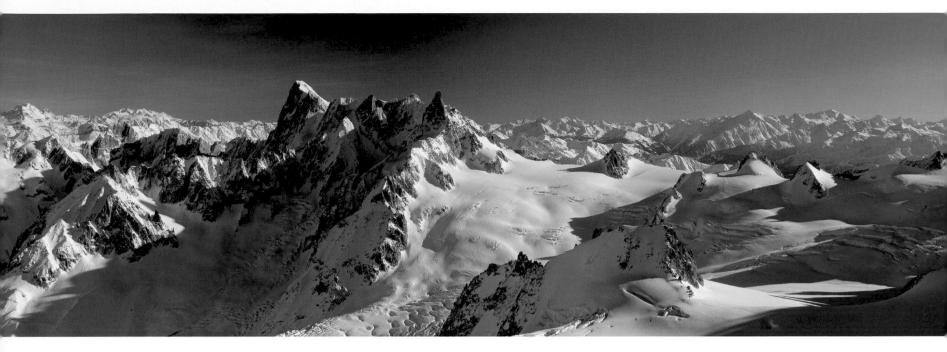

to 400mm, but unless I have a small army of Sherpas in support that's just not practical. All that kit is two, maybe three, full loads on very sweaty backs. In the Himalayas I do use porters, which gives me the luxury of taking everything, but usually working high means working light. In fact taking too much gear is a mistake – eventually it will weigh you down physically and mentally. It has to be fun, a joy to be there rather than the drudgery of an endurance course. If the light and the location are dramatic enough the classic combination of an SLR with a mid-range zoom will suffice. Typically, I take a carbon-fibre tripod, my DSLR body and just two lenses; a 24–70mm and 70–200mm, along with the usual bits and pieces: cable release, polarizer and ND grad filters and, crucially, spare batteries. Up high, in the cold, with the world laid out beneath you is not a situation to be in with flat batteries and no spares. All of that can be carried with only minor damage to the spine and knees, along with the usual mountain necessities: clothing, food, water, head torch etc. But of course all this stuff is secondary to the really important gear, your eyes, which

The Alps from Aiguille du Midi, Mont Blanc, near Chamonix, Haute-Savoie, France

Down in Chamonix the valley lies under a layer of fog, but up here at the Aiguille du Midi it's a pristine winter morning with views as far as the Matterhorn. I've been waiting a week for conditions like this. I'm wheezing in the cold thin air with a stinking cold that will turn to bronchitis after this mountain foray. But what a view …
• **Fuji GX617, 105mm lens**

Val di Fassa, Dolomites, Trentino-Alto Adige, Italy

On my first trip to the Dolomites I never saw the mountains, they remained obstinately shrouded in thick low cloud and I retreated into Austria without a single picture made. It happens. Dealing with the vagaries of the weather is one of the most frustrating aspects of the job, and mountain climates are notoriously fickle. On this second visit to Italy's most dramatic mountain range I'm luckier, and a day spent trekking around the Val di Fassa has yielded this superb location. Persistence has been rewarded.
• **Nikon F5, 24–70mm lens**

"A mountain photographer will first and foremost have to be a mountaineer, willing and able to deal with all extremes of weather and terrain"

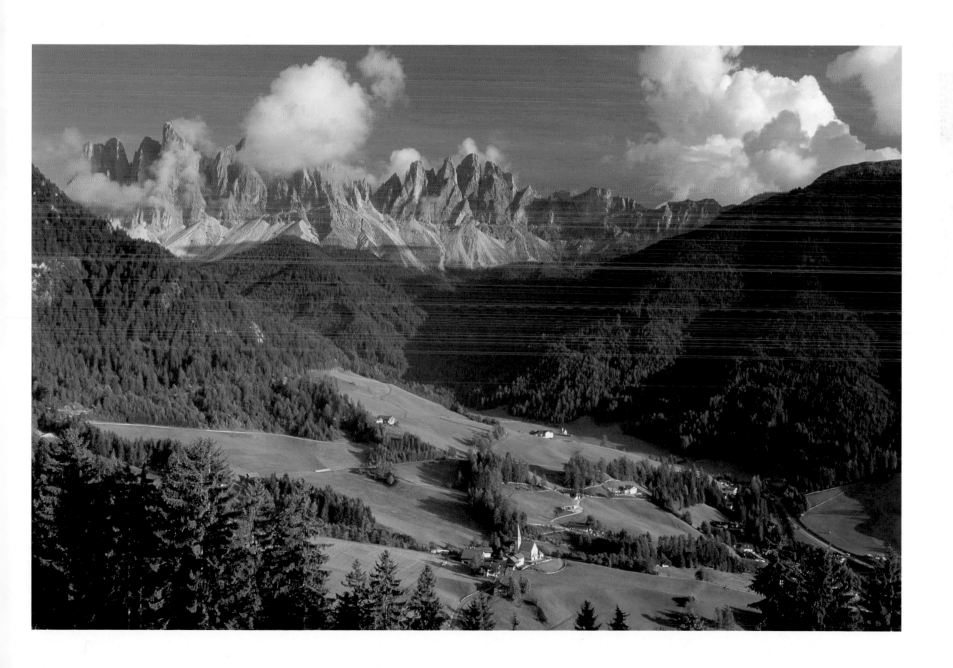

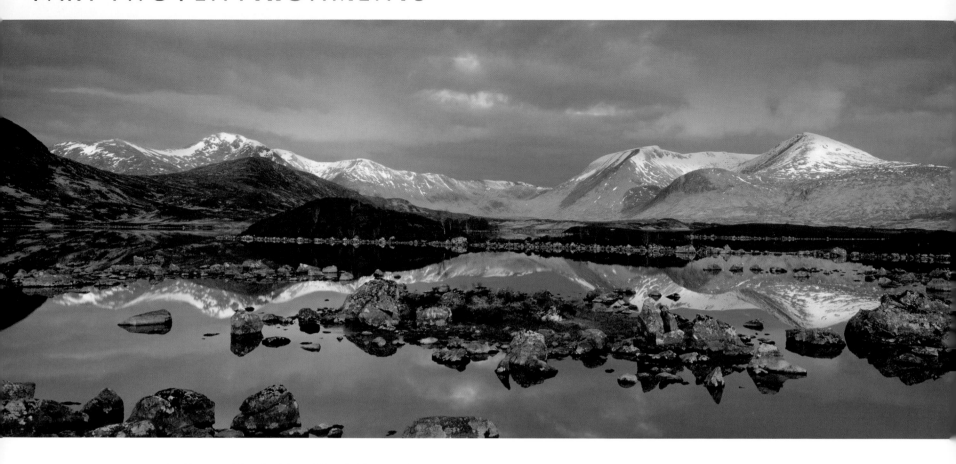

are constantly searching, looking at the light, considering perspectives, pre-visualizing how those soaring peaks could look in different lighting conditions.

But mountain photography doesn't always have to be so extreme. Actually I think the tops of mountains are often overrated places; bleak, windswept and shrouded in cloud. Some of the best alpine views are of the towering snow-capped peaks rearing above verdant valleys, the juxtaposition of the two emphasizing the scale of the mountains. And no photographer can resist rocky summits reflected in a glacial lake. Mountain cultures are some of the most vibrant and colourful I've come across. Trekking in Nepal isn't just about the huge vistas; the people and their villages living in the shadow of the Himalayas make for a heady photogenic mix. And the colours and faces of the Quechua, direct descendants of the Incas living high in the Andes, have to be seen to be believed.

Dawn at Lake Matheson, near Fox Glacier, Westland National Park, South Island, New Zealand
Sometimes mountains just look their best from afar. At dawn on the shores of the lake, the Southern Alps are mirrored in the still waters. I'm revelling in nature's harmony, until a posse of boisterous backpackers arrive, destroying the mood as they shout to each other across the lake. Heathens.
• Fuji GX617, 180mm lens

Lochan na h-Achlaise and the Black Mount, Rannoch Moor, Highlands, Scotland

In terms of height, the Scottish Highlands don't really cut the mustard compared to the Himalayas, Rockies, Alps or Andes. But size isn't everything. Atmospherically speaking, the Caledonians are second to none. The combination of low northern light, dramatic weather and an abundance of mountain and sea lochs make it a Mecca for landscape photographers, despite the unpredictable climate. It's where the photographic bug first bit me, changing my life forever. Patience is a must when working here; I've had many, many fruitless trips, camping in Glencoe, listening to the sound of rain lashing the tent. It's enough to drive you to whisky.

• **Fuji GX617, 90mm lens**

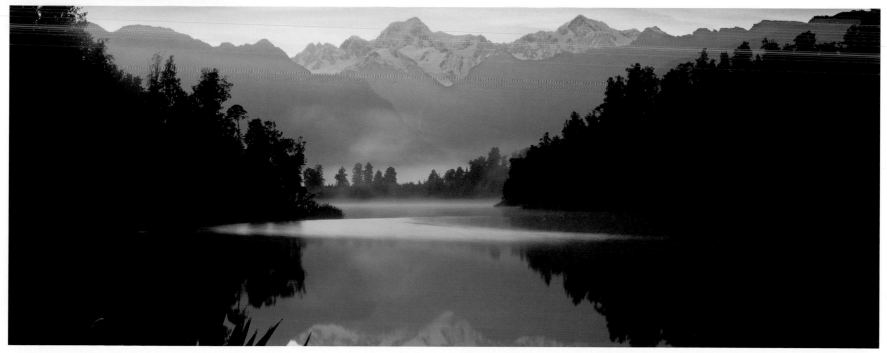

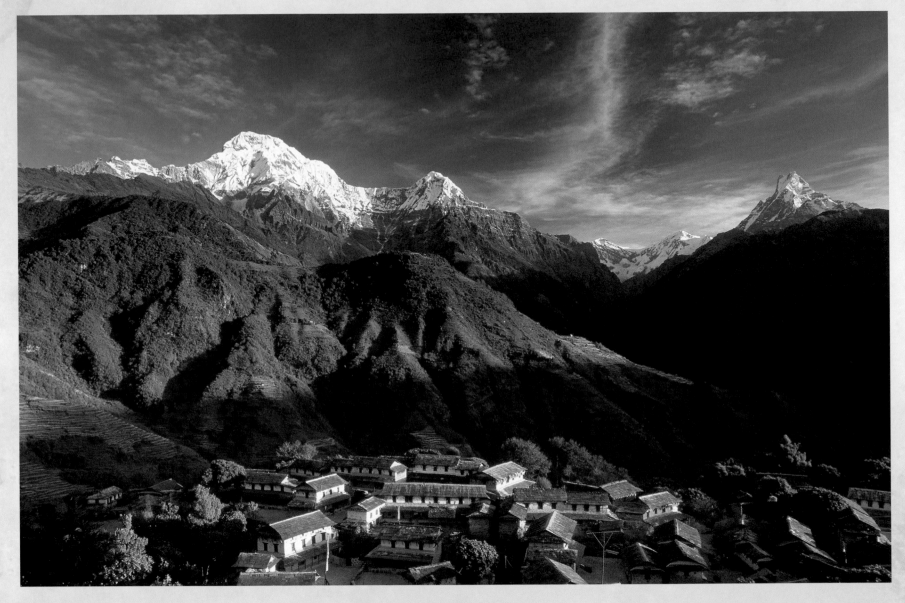

Pokhara, Nepal

The peaks of the Himalayas rise above the mist on the lake shore, impossibly high. Today we're off, after the joys of Kathmandu and a few days getting organized it's time to do what we've spent hours talking about in pubs in Dorset, the Annapurna trek. Yesterday we met Lil, who is to be our guide and porter for the next few weeks. I felt a twinge of western guilt as I showed him the rucksack we hope he'll carry for us. Lil is just over 5ft and only marginally taller than our monstrous sack full of decadent possessions, which we're expecting him to lug for $5 a day. His own possessions consist of a bundle no bigger than my bum bag, all that he'll need for several weeks in the high mountains.

Several days later we're toiling up yet another never-ending ascent. The Himalayas are big. It's a deeply humbling experience when a lithe and sprightly barefoot octogenarian skips past as I

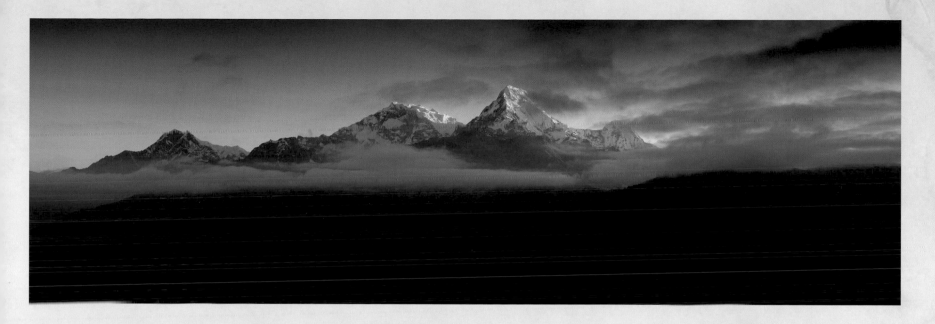

puff and sweat up the third 1,500ft climb of the day. No wonder the Gurkhas are so fit. I have all my photographic gear on my back, Wendy has a day sack and Lil has the kitchen sink. Lil and I are playing a constant game of guessing how high we are. I have an altimeter watch and he's convinced I'm cheating, but I'm not, much. The views down the valley to the steep terraced hillsides and villages perched in ludicrously inaccessible spots are absolutely breathtaking. Right now there is nowhere else I'd rather be.

We're toiling our way up to a village called Ghorepani, where I think we'll base ourselves for a couple of days as the vistas up there sound most promising. We've left roads far behind but it's quite a busy place, with a constant stream of porters, donkey trains and other trekkers using the ancient pathways.

My gear for this trip consists of two SLR camera bodies and four lenses up to 200mm plus the panoramic beast with a 105mm lens. It's all crammed into a photographic rucksack with a backpacking harness, which makes all the difference with such a heavy load. A carbon-fibre tripod is strapped to the back. It's a

good little 'pod and delightfully light, but I miss the height and stability of my regular piece. But all tripods are compromises, and when the only transport system is your own feet you can't have it all. Here in early winter at this height the temperatures at night plummet and battery consumption is an issue. I've got lithiums in the F5s and the spot meter with a couple of spare sets. None of these villages have mains power.

At 5am the next morning we're going up hill again, this time by the light of our head torches. My breathing in the thin freezing air is a little easier, as I'm getting used to it. To the east the first glimmer of pink light is tingeing the sky. Behind us in the gloom I'm aware of the vast bulk of Annapurna, one of the world's few 26,000ft peaks. My pace increases as I feel the excitement and tension of what may be the shot of the trip unfolding. Up on top of the hill I turn round with gasping lungs and there is Annapurna rising out of the cloud, I'll never forget this sight. I have a few seconds gazing in awe before battling with the tripod. With my cold fingers, getting the filter rings on the lens thread is a fuss and I'm aware of the brightening sky. I haven't come

this far and climbed this high to miss the sunrise. The sun peeks over the foothills and paints the snowy upper slopes of Annapurna. Shoot. Wind on. Check everything. Hell … the filter has misted up. Wipe it. Take another spot meter off the cloud around the mountain's base. Reset exposure, Wendy is on filter-wiping duty as the lens is constantly misting up between frames. Shoot more, do brackets, reload. Check everything again. The cloud is now obscuring the peak. That was it, all over in maybe three minutes.

One week later and we're ambling down the trail back from the Annapurna Base Camp towards Ghandruk with a couple of French trekkers talking about food. It has become an obsession, and our little Photographic Army of three certainly does march on its stomach. The Nepalese live on Dhal Bhat, a vegetable curry with Himalayan-size mountains of rice. It's good healthy swag but I have to say, after three weeks of it I'd sell my soul for a bacon sandwich. Nepal has been a classic trip. Photographically it has been far more than just mountain scenes; the people and village life are unique. Lil is still with us - he's a real star, he never complains.

Sand

There are few more elemental environments on this planet than deserts, and photographers find them irresistible. The classic sweeping sand dune landscape is the definitive desert view that takes some beating. The clean lines and shadowed curves of a sea of dunes in the first or last light of day are quite simply photographic nirvana. But there's far more to deserts than sand dunes; the textures and patterns of the desert environment in microcosm are fascinating. Tiny sand signatures of all sorts of creatures let you know you are not alone. If you look hard enough, the plants and wildlife are exquisite, and leave you in awe of their powers of survival. Each time you go back, you see more; it is a bewitchingly pure environment, daily refreshed by the blowing sands erasing all traces of passing. And deserts are not all sand, but often twisted rocky landscapes shaped by wind and, yes, water.

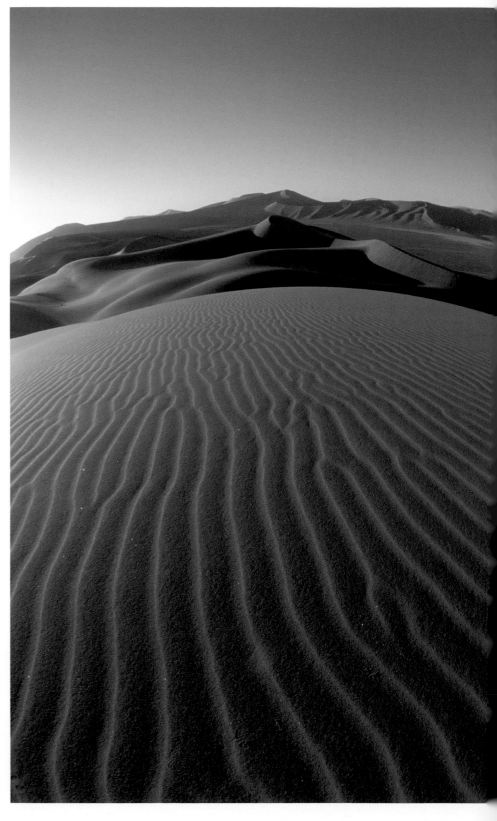

A fisheye view of the Namib Desert, Namibia
I have to be so careful not to get my tripod legs in the shot here. The 180-degree field of view emphasizes the ripples in the dunes in the foreground. Combined with the extreme barrel distortion of the fisheye lens it creates a graphic image. It's not an effect that often works, and can be easily overdone, but it's a delightfully tiny lens I'd not be without.
• Nikon F5, 16mm fisheye lens

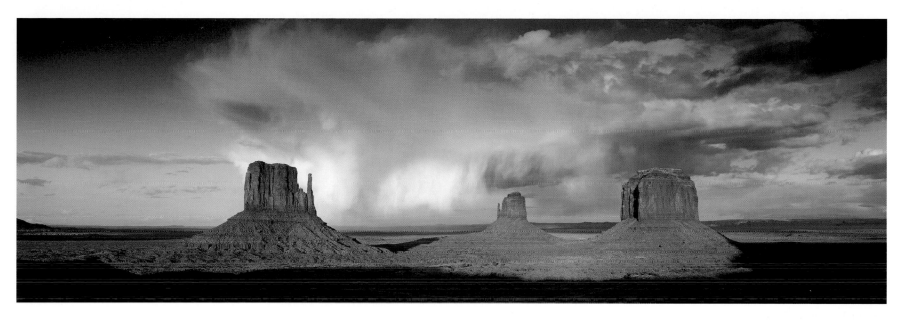

Monument Valley, Utah, USA

I've only just arrived but this view looks so familiar from so many westerns. I'm half expecting John Wayne or Clint Eastwood to ride through. The landscapes of the American southwest are impressively dramatic, but have been photographed extensively by legions of Ansel Adams disciples. It makes it a challenge to come up with something unique, but I should never underestimate the variety of Mother Nature's fare. So often I have to wait days or weeks for the right light, but on this occasion I'm in luck. A local rainstorm sweeps across the desert, dropping a brief shower on the buttes of Monument Valley and presenting me with the most dramatic sky I could have wished for. So often an interesting sky can make a landscape.
• Fuji GX617, 105mm lens

I was no youngster when I saw my first desert, and now I have to say I'm hooked. Of course they are not easy places to hang out in for long. Proximity to water dominates everything and everyone, and nobody in their right mind chooses to be out long in the midday sun. At all times, whether on foot, in a car or on a camel, carry plenty of water. People die as a result of something as trivial as a puncture. Hiking up dunes laden with gear is seriously hard work in the heat, and keeping sand out of the equipment is a major bugbear. Hard as you try, particles start accumulating in the depths of the camera bag.

After weeks of desert life, the car and all inside it are coated in layers of dust. Eventually the lenses start making gruesome grinding noises when focused, a sound as welcome to photographers as fingernails on a chalkboard. But I never lose sight of the fact that this is what they are for. Attached as you may be to your gleaming optics they are ultimately just tools. Use them, don't get too precious about them, and just resign yourself to having to send them for servicing on your return.

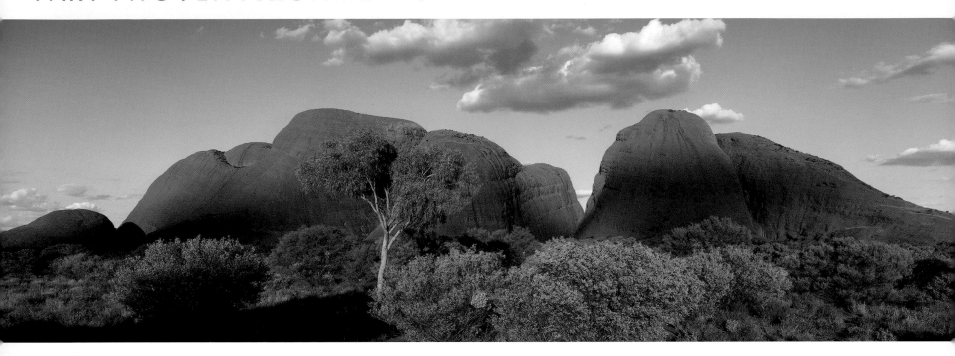

**The Olgas, Kata Tjuta,
Northern Territory, Australia**

*Australia's Red Centre: endless dry bush,
eucalyptus trees, bouncing Joeys, huge
lumps of red rock, Thorny Devils and
flies. Oh, the flies. It is inconceivable to
me how the natives of the Outback live
with them. They try to get in your eyes,
nose, ears and mouth; I hate them with
every fibre of my being. And I think this
is maybe the hottest place I've ever been.
We're camping nearby, not by choice
this time. Much as we love the outdoor
life, a bolthole away from the flies and
heat would be welcome, but all the local
hotels are full, so it's tough. But you
have to suffer for your art, and despite all
of that I wouldn't trade this experience
for the world.*

• Fuji GX617, 90mm lens

The desert is one of nature's most elemental environments.
Photographically deserts are irresistible, largely because of the
fantastic, beautiful shapes that wind and water have shaped the
landscape into, be they the sweeping dunes of the Namib or the rock
formations of Utah. Sometimes the sheer emptiness and absence
of anything can be compelling. In these flat, seemingly featureless
expanses no obstructions mask the sun's rays in the last minutes
before it drops beneath the horizon.

In such landscapes one lone feature, such as a rock, a tree or even
a road, can become a dramatic icon, emphasizing the emptiness
beneath limitless skies. In such situations lenses of extreme focal
length can be powerful tools, both wide angle and super-telephotos,
but for me the desert just cries out for the panoramic format.

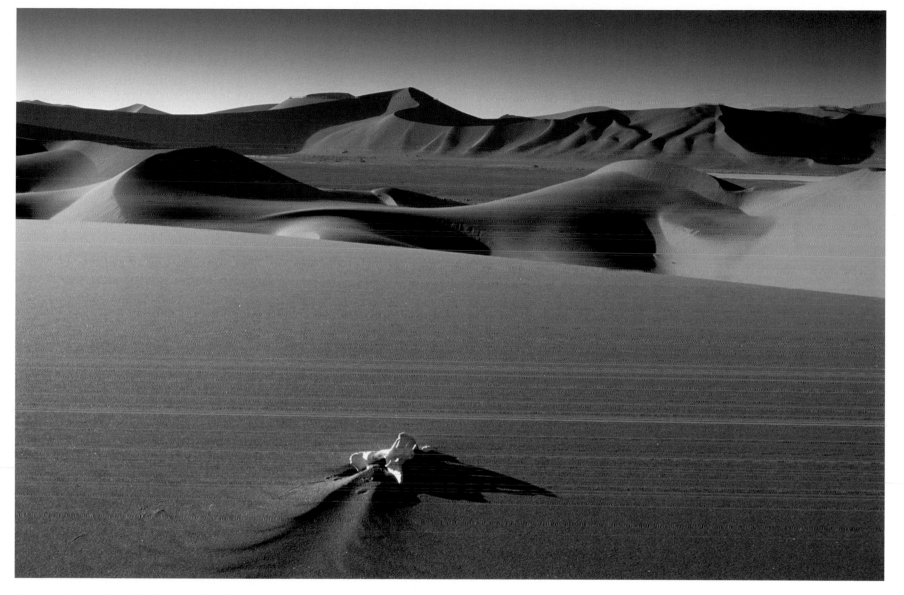

Oryx vertebra, Namib Desert, Namibia

The absence of trees and other features to give scale to the desert means the use of human figures, or in this case animal bones, is a handy way of giving depth to an image. I just have to be vigilant not to walk into my own shot, besmirching the pristine scene with my footprints.

• **Nikon F5, 20–35mm lens**

"One lone feature can become a dramatic icon, emphasizing the emptiness beneath limitless skies"

NAMIB DESERT, NAMIBIA

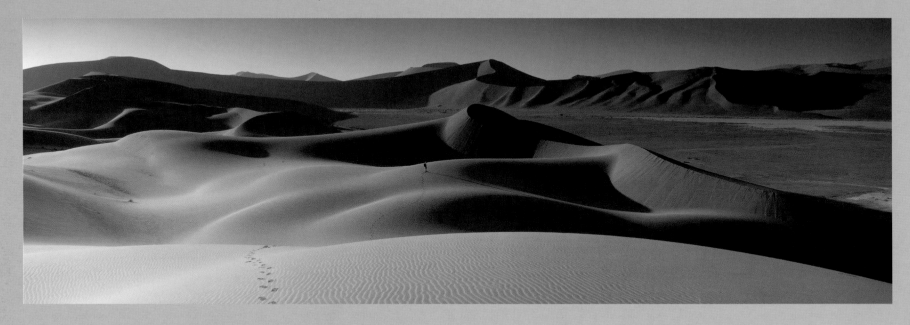

3.30am:

We crawl out of the tent in the pitch black, blearily registering the carpet of stars hanging overhead. The fact that there's a completely clear sky is taken for granted, there are seemingly never any clouds here.

4am:

We're trundling along the rutted dirt road in our 4x4 heading into the Namib Desert National Park, eyes out on stalks for any wildlife straying into our path. The odd wrecked vehicle abandoned along the way testifies to the risks. It's a 90-minute drive to the Big Dunes, and we'll do this route four times today.

5.20am:

The last section is strictly 4WD only, and in the half light before dawn the Toyota is squirming in the soft sand, the engine working hard as we plough on. This is real Boy's Own stuff, I love it.

5.40am:

We're on foot now, toiling up a massive dune, tripod on my shoulder. Two steps up, one step back. I seem to be making little headway as the sky to the east is getting rapidly lighter.

6am:

Lungs pumping, I crest the dune. In front of me lies a sea of dunes as far as I can see. We were here yesterday, location finding, but in the fresh light of dawn it's an altogether more dramatic sight. In my haste I grapple with the tripod legs like a drunken bagpiper, eventually subduing them. Camera on tripod, frame shot, place filter, attach cable release, set aperture, check focus, wind on film, check the camera is level, check all is tight on the tripod, take a preliminary spot meter reading off the sand, set shutter speed, glance at the eastern sky. The sun is not up yet but will be imminently. Check everything again.

6.20am:

From our elevated position we can see the sunlight creeping across the desert, painting the landscape. This is it; this is the moment we work for. Take another light reading and adjust the shutter speed, shoot. Wind on, expose -1/3 stop. Wind on, expose +1/3. Do it all again. Take another light reading; the levels are increasing all the time. Do it all again, reload. Pause. Consider. How can I improve this? A sense of scale is missing.

6.30am

Wendy slowly walks into the frame, taking one step at a time, careful not to tarnish her solitary footprints. With her sack on her back she's looking suitably intrepid. I beckon for her to stop in the prime spot, giving a human perspective to the sweeping scene. Take another exposure reading, expose. Bracket exposures. Do it all again. Reload. Double-check everything. Expose again.

6.40am:

The power of the sun is now burning through. I do some alternatives on 35mm, going in tight on my supermodel with a long lens. It looks great.

9am:

The long drive back to the campsite seems a chore in the morning heat. We've got no option, staying out in the open desert would be madness.

11am:

I'm sitting in the pool at the campsite, not swimming, just wallowing like a hippo, trying to keep cool.

2pm:

I'd really like to sleep, but there's nowhere to shelter. The tent is a furnace, so I'm still in the pool, reading.

4pm:

At last, we're checking our stuff, saddling up for the evening shoot.

4.30pm:

Driving again, the novelty of this route is starting to wear off.

6pm:

I'm shooting a solitary stunted tree, dwarfed by the sand dune behind. Working with a 300mm lens the true perspective is emphasized. It's a graphic composition. An oryx wanders past in the distance. What do they find to live off?

7.30pm:

Back on the road again. In the dusk light an ostrich races alongside our vehicle, leaving us standing. Show off.

9pm:

Wendy is cooking pasta by the tent, I'm clutching a cool beer, gazing up at the stars, feeling totally and utterly content. It has been a long day, and tomorrow will be too.

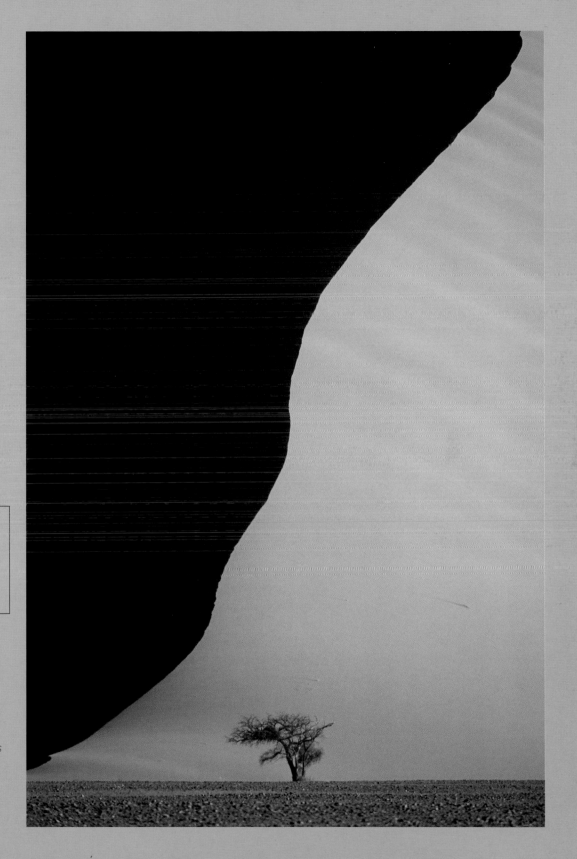

Ice

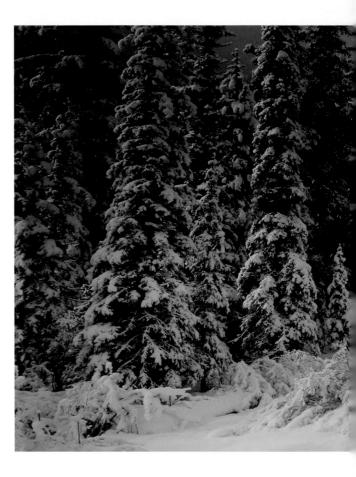

Where I live in southwest England, it has to be said, winters are a sad disappointment. Grey, windy and wet – they'll never catch on. I grew up in Canada, and childhood memories are of a winter wonderland between November and April. I miss those crisp snowy days with the fresh snow hanging from the trees in sparkling winter light – I just don't get enough of them photographically. I took them for granted back in Ontario; I'd give my eye-teeth for a few of them every winter now. So, the only answer is to head north, or back to Canada.

Of course like all environments there are some particular challenges to working in icy climes. I'm not your grandmother so I won't implore you to wrap up warmly, but it goes without saying that if you're not prepared the photography will suffer. This game can involve long periods of inactivity waiting for the perfect conditions for exposure. Battery consumption in the cold is also something to be aware of. It's shocking how quickly standard alkaline batteries will run down in sub-zero temperatures. To be precise, a set of alkaline AAs will last for approximately 3,000 pictures at 20°C, at -10°C you get just 300. I use lithium batteries in winter, which will last much longer. Also consider keeping your camera body inside your jacket for warmth while waiting. That's not really an option with the panoramic as it's a serious beast of a camera. As it's totally manual, batteries aren't the issue but leaf shutters don't like the cold and can stick.

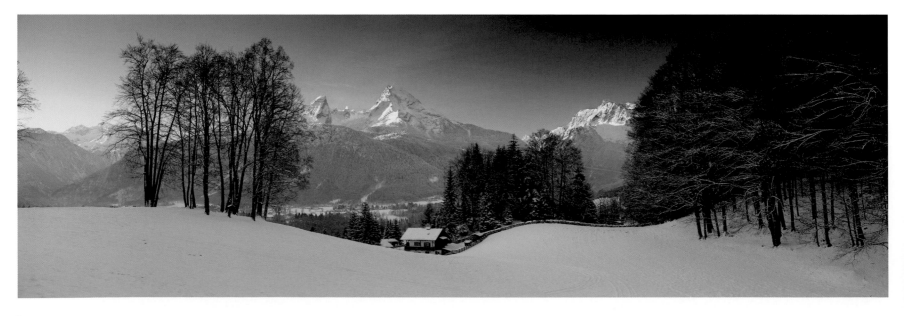

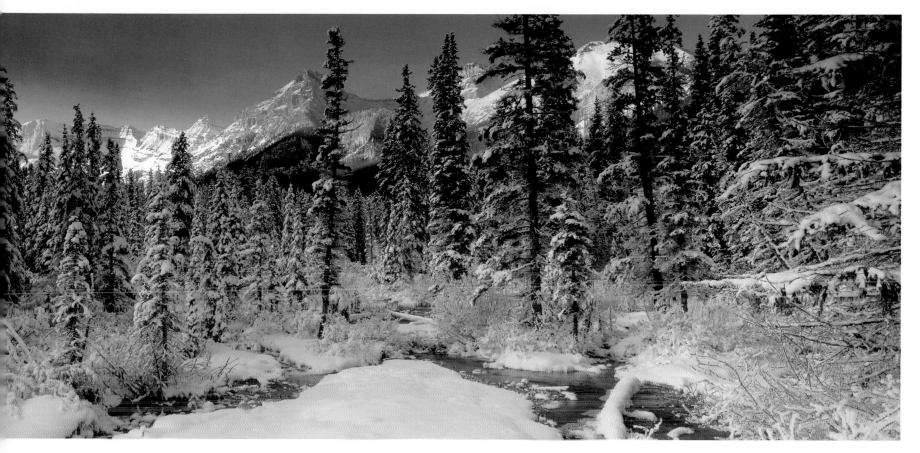

"Exposing for snow is all about considering how much texture you want in the surface"

Berctesgarten, Bavarian Alps, Germany

I've got all hot and sweaty trudging up the hill, my boots crunching in the snow; now I'm standing, waiting for the light and cooling rapidly. The picture I have in mind is a straightforward image (the best always are) with the first light of day striking the peaks. Calculating your exposures with a lot of snow around can be tricky, but taking a reading from a mid-tone will always work. The trick is to know what your mid-tone is; in this case I took a spot meter reading off the trees by the Alpine chalet in mid-distance.

• **Fuji GX617, 105mm lens**

Banff National Park, Alberta, Canada

We're spending Christmas in Banff, except the unthinkable has happened, there's no snow! Large areas of ugly brown streak the hillsides, what is the world coming to? Finally, up the Bow Valley near Lake Louise I've found a patch where fresh snow is hanging from the trees. Except this morning the whole region sits under a bank of dense, low cloud. I'm standing waiting for the light with frozen toes, wishing I'd bought the thermal boots. Finally there are traces of blue above and the Rockies just start to appear through the clearing mists. I'm balancing the exposure between the sunlit mountains and the foreground with a 0.9 ND graduated filter and for my exposure readings I'm alternating between spot meter readings of the snow in the foreground and the trees in the middle distance. For the snow readings I open up 1½–2 stops on the indicated exposure. The two different methods seem to corroborate each other so I can't be far out. Eventually the sun burns off all the cloud, but I suspect the shots with the first hints of the peaks looming through will be subtler.

• **Fuji GX617, 90mm lens**

**Eilean Donan Castle,
Loch Alsh, Scotland**

*On our last night the snow fell,
giving perfect conditions over the
Scottish Highlands just as we have
to head south. It's a deeply painful
experience, having to drive away from
here now. I'm ruing the deadlines
and commitments that clutter up
life, making this departure necessary.
As we cross the bridge from Skye
the first sunlight beams along Loch
Alsh, taking our breath away. A few
minutes later we're passing Eilean
Donan Castle. This is too much. Not
only is there fresh snow but perfect
reflections for this classic Scottish
scene. I just can't resist – I pull in and
dive for my gear. Stuff the timetable.*
• **Nikon F5, 17–35mm lens**

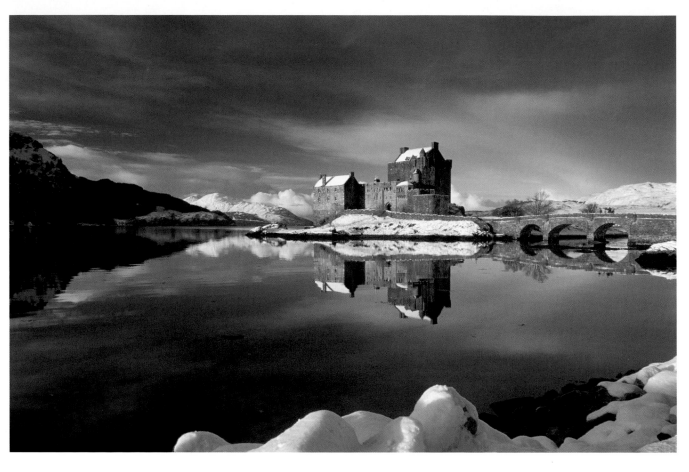

Winter light can be so dramatic. Days are short and the sun never gets very high in the sky, meaning photography is possible all of the daylight hours. Making exposures with so much light bouncing around – off the snow, ice or water – can be tricky. What do you expose for? Where are the mid-tones? Exposing for snow is all about considering how much texture you want in the surface. Overexpose and the whites blow out, underexpose and the snow looks like a dirty grey mass. Ideally, every crystal and ripple in the snow will be visible. How you tackle this will depend a lot on what kit you're using. In the old days, and still now with my panoramic camera, I take multiple spot readings off the surface of the snow with a hand-held exposure meter and open up about 1½–2 stops on the indicated reading. Shooting digitally the brightness histogram display becomes an especially useful aid after a test exposure in these situations, to ensure that highlights aren't being lost. But here again, as with most aspects of photography, experimentation is rewarded. Do tests, note what you're doing in terms of how you're exposing, analyse the results carefully, learn from your mistakes and enjoy a warm glow of satisfaction from the winners. With all the technology in the world, trial and error still remains the only way to consistently improve your photography.

As with deserts, the craftsmanship of Mother Nature's sculptures in snow and ice provides us with endless inspiration. The biggest challenge really of this type of work is finding those perfect icy landscapes – the combination of fresh snow and sparkling light is a rare one.

ALEXANDRA FJORD, ELLESMERE ISLAND, CANADIAN ARCTIC

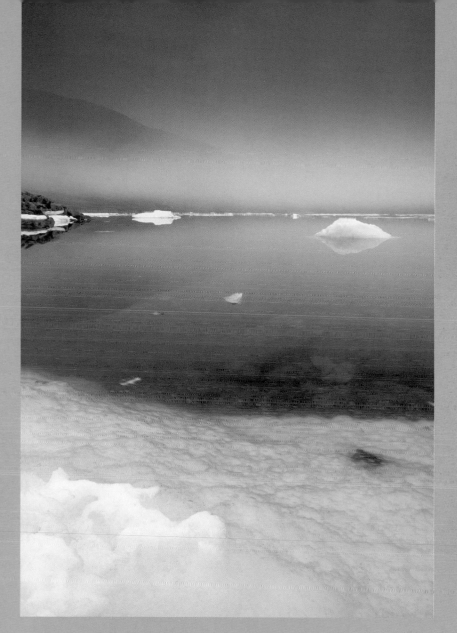

27 July:

We're on the first plane in to fog-bound Resolute for ten days, embarking on a sea kayaking expedition in the Canadian Arctic. There's just one problem; no kayaks. Apparently they're following on another plane. So, we wait.

28 July:

We're still awaiting the kayaks, so we're sampling the joys of Resolute. If Canada had political prisoners this is where they'd be sent. Forget any notions of pristine Arctic landscapes. In the dense fog and biting cold this is a grey, bleak dump; a collection of pre-fab huts that is the jumping off point for many polar explorations. But we're buzzing at the start of our Arctic Adventure. After all the books we've read on the quest for the Northwest Passage we're here, on Cornwallis Island, and hopefully tomorrow we're heading further north; to the very edge of the permanent ice-pack, to Alexandra Fjord on Ellesmere Island, off the north shore of Greenland, so far north it's off the top of most maps. Maybe. Nothing is for sure in the high Arctic.

29 July:

The kayaks have arrived, and so we're taking off in a Twin Otter with all our gear for two weeks at the top of the world. We fly for two-and-a-half hours in a complete whiteout before bursting out into the sun glinting off the unspeakably spectacular glaciers, peaks, bays and ice flows of Ellesmere Island. It is such a contrast to Resolute. Landing on a vaguely level and straight strip of tundra we set up camp on the edge of a bay crammed with the most beautifully shaped ice. I walk along the shore in the evening; in fact it's more like midnight, but with 24-hour daylight here time becomes elastic.

30 July:

As we assemble our kayaks, I'm looking at the amount of kit we've got to get in. It doesn't seem possible, even before I consider the photographic stuff; a full Nikon 35mm system, tripod, and the panoramic camera. No way!

31 July:

Finally we're ready. Our two-man kayaks are crammed full of all we'll need for a fortnight – camping kit, food and water, all sealed in waterproof sacks. I have no idea how we've managed to cram it all in. We're wearing trendy bright yellow survival suits in case of immersion in the freezing water, and on the foredeck of our vessel I've got my camera kit. And so finally we're off, paddling down Alexandra Fjord on glassy waters amongst the ice floes. Bearded seal occasionally pop up to track our progress. There's a walrus hauled out on the ice ahead so we spend 15 minutes hiding; they have been known to get inquisitive with kayaks, even amorous. Being tipped into these black icy waters by a humping walrus doesn't really appeal.

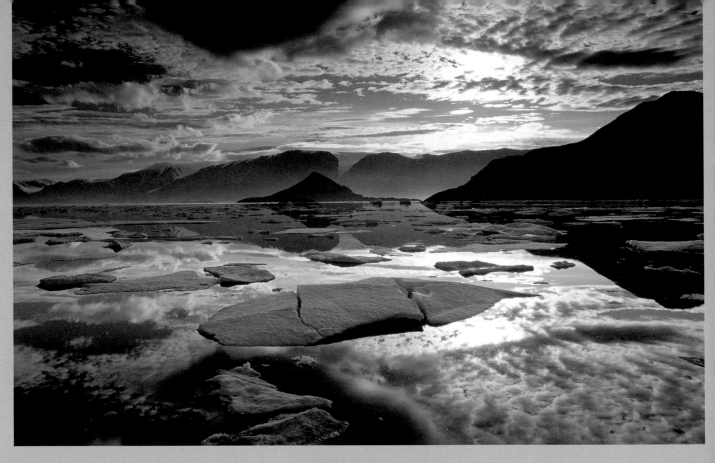

1 August:

With the sun behind thick cloud and a wind blowing off the ice the temperature plummets, and we're wearing every layer we have. This is the Arctic summer, which lasts for a few weeks at most. You've got to wonder what the dark winters are like. Our camp is on an island in the fjord; our tent is definitely a Room with a View. Some time in the afternoon/evening/night (who knows) the wind drops and the clouds part, revealing the most perfect scene of Arctic splendour – flat calm waters mirroring the rippled clouds, floating ice and the sweep of the fjord beyond. This trip has been in the back of my mind for so long, a personal ambition that has finally come to fruition. If I don't manage to shoot one more picture here it will have been worthwhile, for this.

3 August:

Another day spent dodging the walrus. The pack ice has closed ahead and we have to find a spot to camp before we're stuck. We're well into it now, paddling boldly in this pristine wilderness. Mind you, a shower and a malt whisky would be very welcome. But this is the business, it is the wildest, most remote place I have ever been.

4 August:

I'm on a hill looking down on a vista of ice and rock stretching to infinity. In the still air the sound of a barking walrus reverberates over the pack ice. The light from the northern horizon is low and golden. My watch tells me it's 2am and I really should be getting some sleep, we've got another long paddle tomorrow, but I just can't pull myself away from this scene. In the bay below the rest of the crew are huddled in their sleeping bags. Apart from them I doubt there's a single other person for hundreds of miles. Certainly I know I am the sole human gazing out at this scene of utter tranquillity. It's almost possible to believe all is well with the world.

5 August:

We're floating amongst the ice on mirrored waters. Dipping our paddles into the perfect reflections seems a travesty. I'm grappling with my paddle, trying to get to my cameras without dripping salt water all over them. Kayaks are great ways of getting around these parts but not so good for photographing from. I think I've already lost a lens to the salty drips. But I'm not losing sleep about it.

6 August:

A long day, grey and windy. The tents are anchored down with rocks and the sleeping bag has never been so welcoming. I'm contemplating how the trip is going photographically. As usual, the worm of self-doubt turns in my gut. Have I made the most of this unique environment? We've seen some incredible sights on the water, but shooting from the canoes is a nightmare. Getting to the camera in a hurry is impossible, by the time I have it and have sorted out my composition without our paddles in the shot, attached a filter and exposed a few frames the rest of the group are way ahead, leaving us adrift in the ice flow. Still, if it were easy everyone would be doing it.

7 August:

We're talking to Resolute on the radio, trying to coordinate our pick up from a bay to our north. But there are problems, they don't think a plane can get in there, so we'll have to head back to Alexandra Fjord.

10 August:

In the early hours the winds drop and we pack up for the crossing. By the time we're ready the wind is back at full force, but we decide to go for it. Launching the kayaks over the ice shelf into the churning waters is … challenging. Actually, we're all terrified. But by helping to stabilize each other's kayaks we go for it, immediately pointing the bows into the 3ft high waves. Grey icy water surges over the deck. Once we're all launched we plough across the fjord, paddling like we've never done before, fear balanced by exhilaration. In the middle of the fjord the wind drops and we're paddling through the bizarre ice shapes, buzzing with our adventure. Moods can change here in seconds – from bleak, icy danger to benign, tranquil beauty. As we haul the boats out for the final time on the south shore it starts snowing.

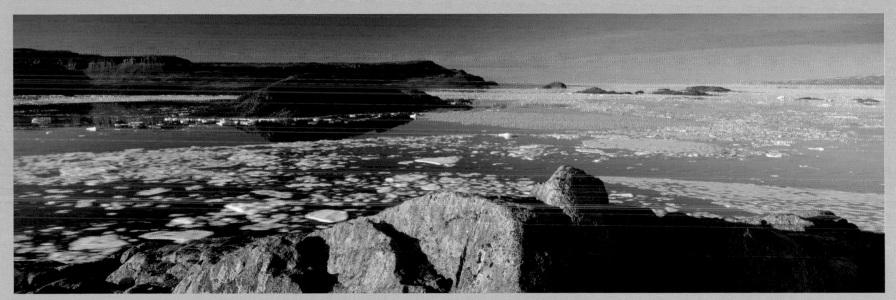

9 August:

We've been camping on a headland north of Alexandra Fjord for two days, waiting for the winds to drop. The previously flat, calm waters are now raging grey seas with white horses and spindrift. There's no way we can cross in these conditions, so we wait, spending long hours huddled in our tents. I'm reading a book about the early Arctic explorers being forced to spend winters trapped in the ice in these very parts. Hmmm. I'm not sure we've enough peanut butter for that. The brief summer is coming to a close, the sun is briefly dipping below the horizon at night and a layer of ice is visible on the waters close to shore. A plane is supposed to be picking us up tomorrow but unless the winds drop it won't happen, and when one will be able to get in after that, no one knows. We're all feeling a touch exposed.

11 August:

Good news, a Twin Otter is on the way to pick us up. All our flight connections back to the real world have been missed, but who cares? The fresh snow on the mountains backdrops the approaching plane, it's so beautiful – do I really want to leave? It seems I may not have an option. The pilot's moaning about our load and says I have to leave my photographic gear for a subsequent plane to pick up. As I suspect that may not be until next summer I dig my heels in: if it can't go, neither can I. A standoff ensues. Eventually my Canadian friend Jim manages to negotiate an agreement and I'm allowed on the plane clutching my salt-encrusted cameras. The plane labours into the air, heading south, as we peer out at the dramatic Arctic wilderness we are leaving behind.

Earth

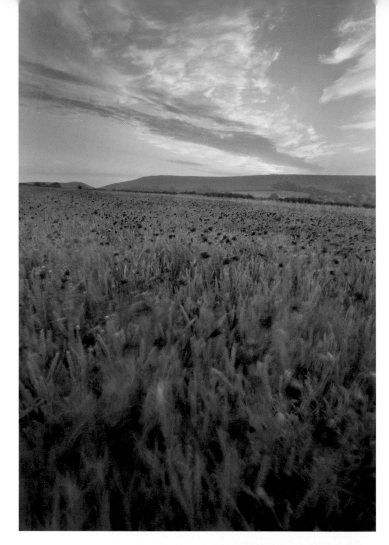

As a 14-year-old boy on our return from Canada, I remember looking down from the circling Jumbo Jet at the patchwork of fields that make up England's green and pleasant land. It seemed a toy landscape in contrast to the huge open spaces of Canada. In Europe the rural landscapes have been shaped and maintained by man for centuries, even millennia, to such an extent that the old stone walls, rustic barns and church steeples are as much part of the environment as the trees and hills. Age generally mellows man's input and the rural architecture of a region becomes deeply embedded in its character and culture.

For all the challenges of deserts and ice caps some of my favourite trips have consisted of loading up the motor and drifting through the rural heartlands of Europe. On a long haul flight difficult compromises have to be made with what can be taken, and I often opt to travel light with just the DSLR system. So on these road trips it's such a relief to load up virtually all the gear I own, including the heavy artillery.

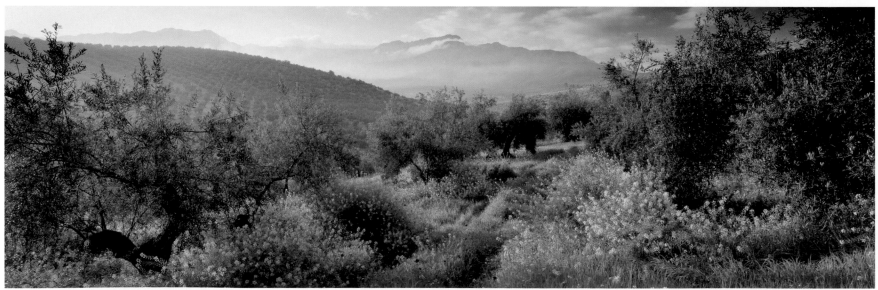

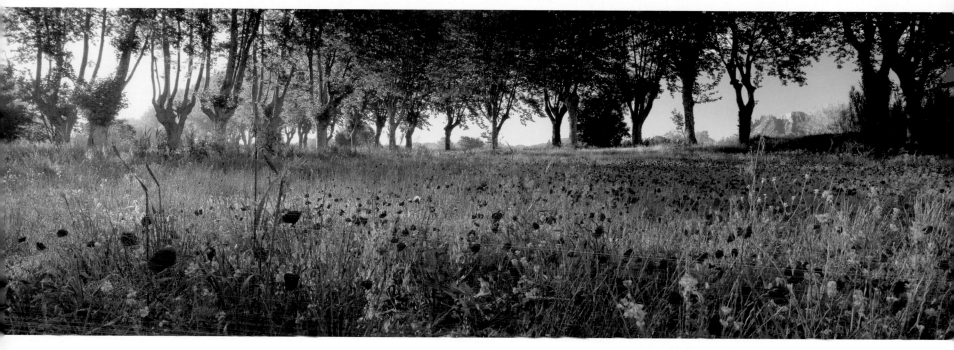

Poppies near St-Rémy-de-Provence, Provence, France

By one of those typical tree-lined roads near St-Rémy-de-Provence I find this concentration of poppies. They're everywhere in southern France in late May. I never can resist getting them in my foreground. Well, Monet did, so why can't I?

• **Fuji GX617, 90mm lens**

Sunrise near Corton Denham, Somerset, England

It's late June, about 4.30am and I'm in the middle of a poppy field waiting for the light. Before the sun pops over the hill and bores into my lens causing flare, I expose with the dawn sky and the poppies swaying in the breeze.

• **Canon EOS-1Ds MKII, 17–40mm lens**

Olive grove near Cazorla, Andalucia, Spain

We've found this spot in Andalucia that's proving very difficult to leave. With the wild spring flowers growing in among the olive groves it's a verdant, lush landscape that we're cycling through every day in search of locations. I reckon I've made some worthwhile images and it's probably time to move on, but somehow, we just can't seem to.

• **Fuji GX617, 90mm lens**

I've been wedded to the panoramic format for some 17 years. I first hired a panoramic camera on trial and was so bowled over by the impact of the big 6x17cm transparencies for landscape work that I immediately bought one. Since then it and its successor have been round the world many times. As yet there's no practical digital alternative to the big 'pano' and I still love the impact and quality of the format. The camera itself is big and bulky, but not particularly heavy. It's also delightfully simple, with no electronics and not much to go wrong. Having said that it does demand a different, more rigid way of working, I have to be meticulous in the way I put together an image and operate the camera. I strongly believe you need to be diligent whatever camera you're using, but with the panoramic it does take a while longer to set up and deploy. This can be a good thing, imposing a more disciplined regime on the business of making an image, and when you see a print from this format enlarged up to several feet wide it makes it all worthwhile.

"Location searching in such regions
can and should be a real joy"

Littondale, Yorkshire Dales National Park, England

The stone walls and barns of the Yorkshire Dales are a national treasure. It's one of my favourite parts of England. It's an early summer evening, about 8.30pm, and friends are waiting for me in the pub in Kettlewell, but I just can't come away. It's tough maintaining a social life when the days are long and the light is good.

• **Fuji GX617, 90mm lens**

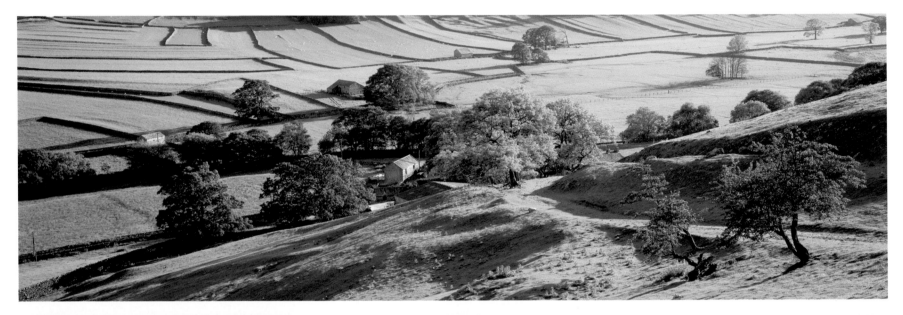

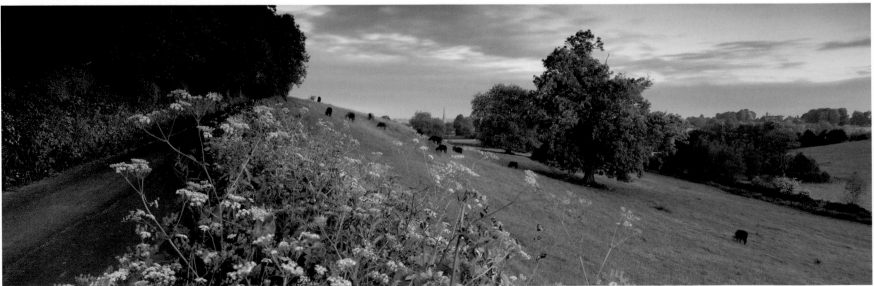

In Europe the classic regions of Provence, Tuscany and Andalucia take some beating, but of course there are many, many other equally bucolic and enticing areas. Indeed part of the attraction of such trips is getting off the beaten track and discovering for yourself rural backwaters not mentioned in the guidebooks. By their very nature these are environments lacking in any particular challenge of survival or access. As always, location finding is crucial. I've often found myself in a region I know is attractive, with much photographic potential, but I can't seem to express it in an image. It's extremely frustrating, and it happens all too frequently. A mental block can develop, the harder you look, the less it all comes together. But persistence usually pays off. The location searching itself in such regions can and should be a real joy; if it becomes a chore then something is not right. Cycling and walking are my preferred ways of finding my spots; driving is OK but it's all too easy to whizz past a scene without even noticing it. I just can't work out though why all the *randonnées* seem to incorporate lunch in a sun-dappled square. All in the name of familiarization, of course.

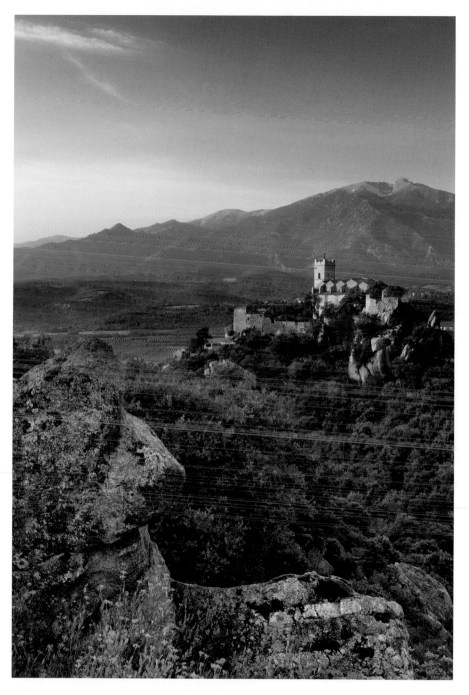

Dawn at Compton Pauncefoot, Somerset, England

I've cycled past this scene countless times without it really registering – it's on one of my regular routes from home. Then last time it suddenly struck me; there's a shot here. Why had I not noticed it before? Either I'm just a useless photographer or there's a lesson here; I'm not sure. So, here I am the next morning, shooting in the soft light of dawn, with traces of pink kissing the clouds and the hedgerow full of early summer colour.

• Fuji GX617, 90mm lens

The village of Eus perched on a hilltop with the Pic de Canigou beyond, the Pyrenees, Languedoc-Roussillon, France

It has taken me four attempts to make this shot of the church with the Pic de Canigou beyond. I've been battling with indifferent, hazy light. I'm still not entirely happy with it; I'd like more drama in the sky. But we've been camping nearby at Vernet-les-Bains in the Pyrenees for five days now and it's time to move on.

• Canon EOS-1Ds MKII, 24–70mm lens

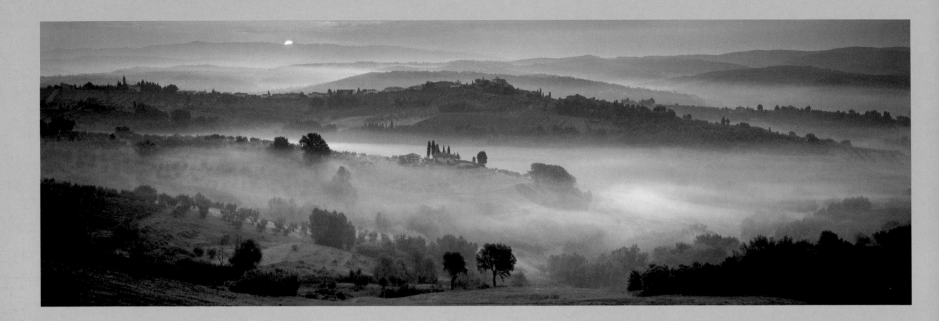

ITALIAN SUMMER

Day 10:

Our Italian Campaign is going well. Like the Vandals and Visigoths we marched into Italy via the Brenner Pass from Austria. We're giving sacking Rome a miss this time but are blazing a trail of exposed images through the country, leaving in our wake vacated campsites and decimated pasta dishes. We've plundered the Dolomites, Lake Garda and Verona and are now pondering our next conquests. A change of plan was decided last night over our vino rosso; we're heading on to Tuscany. We've been many times before, but now we're this close, we can't resist it. It hasn't gelled here in Emilia-Romagna and another wasted day could result in a loss of momentum, that curious fusion of circumstance and frame of mind that determines just how productive a trip is. After a brief visit to Maranello we bomb down the autostrada and set up camp in Chiantishire. The entire population of the Netherlands is on the campsite with us but this is great. From our tent we look over a valley with vineyards, pointy trees and villas, just beyond the German's cycling shorts drying on the line.

Days 11–15:

Our local valley collects the mist at night, so it has provided a few good dawn sessions. I love it when I can just stumble out of the tent to stand bleary eyed by the tripod without having to drive for miles. I've been working on vineyards, both as part of the landscape and close-ups of the ripe grapes in the warm evening sun. They're almost ready for picking and the smell is intoxicating. The ancient village of Badia a Passignano was the setting for an evening shoot, with an olive grove in the foreground. Gutless skies and haze have continued to be a problem, but hey, life is rarely perfect. There have also been details of windows, doorways and markets to shoot in the villages like Castellina in Chianti.

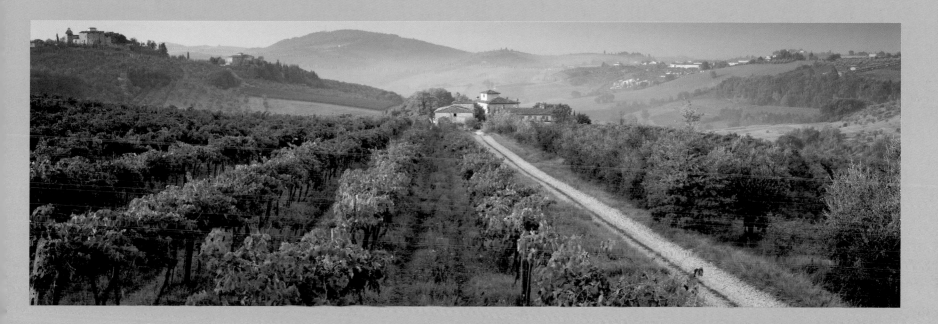

Day 16:

The grape pickers turning up for work are giving me wry and bemused looks. I'm standing on the customized photographic roof platform of our Land Rover parked in amongst the vines at dawn. If this were Britain I'd no doubt have an irate farmer on my hands but not here, no one cares. I've got the panoramic GX617 on the tripod up here with a 180mm lens, a polarizer and a 0.9 ND grad. The sun is coming up to my left giving cross lighting but it's having to slice its way through a heavy layer of atmospheric miasma, and the sky is just hopeless. This could be a strong shot though, and I'm not too concerned about the haze. It will soften the light a touch, which intuitively I think may help this image. Why? I don't know, I just feel it. I'm framing so there's precious little sky in the shot, and the lines of the vines and track lead us to the villa and valley beyond. There's the annoying detail of our campsite on the hillside to the right, I'll just have to annihilate our tent and the Dutch caravans in Photoshop later.

Day 17:

We're moving on to Puglia today. As we drive away from Tuscany I see more great locations and wish we had more time. Well, we'll just have to come back – that'll be no hardship.

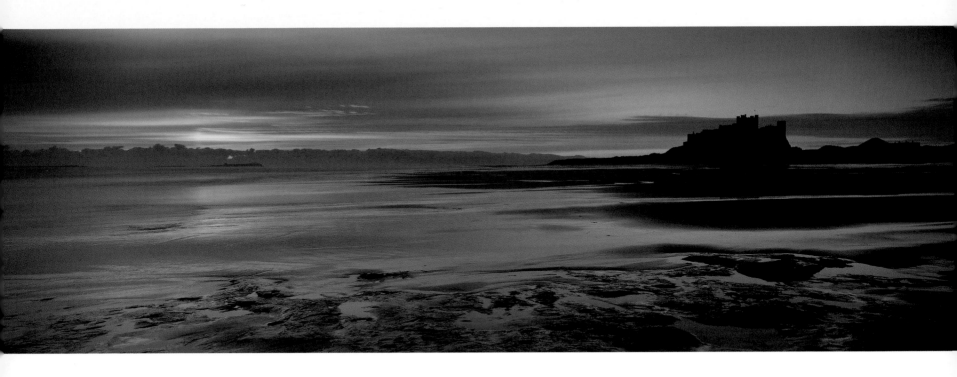

Water

In a village outside Zhongdian, high on the Tibetan plateau in China's Yunnan Province, the kids were playing up for the camera. They may never lay eyes on a distant ocean. For many of us that seems inconceivable. Our connection with the sea is wound into our identity and permeates our lives. We are all inescapably drawn to it, for our leisure, our work, or just to gaze endlessly at its ever-changing moods. For us photographers that is doubly true. The coast has an inescapable draw.

Photographically the possibilities are endless. I could spend my whole career shooting the sea, quite happily. What's more it's accessible, at least if you don't live in Zhongdian. It's easy to stroll along the coastal path and shoot some dramatic images, right? It's safe, anyone can do it. Well, in all my travels the only times I've ever been in peril have been when I've been a fool and underestimated the power of the seemingly benign sea. I came within an inch of drowning in Tahiti, trying to wade between two islands. A French jet-skier picked me up. I've been caught by the wave from the Perfect Storm on the north Cornish coast, picked up and tossed with all my gear on to the

Dawn on the beach at Bamburgh Castle, Northumbria, England

I reckon I've seen more sunrises than I've had hot dinners, but this one takes the biscuit. Standing by the tripod at dawn in the middle of a two-minute exposure I'm marvelling at the colours rippling through the sky and reflecting off the wet sand. A surf is rolling in off the North Sea and Bamburgh Castle stands commandingly overlooking the beach, silhouetted by the first light spreading through the wisps of cloud in unbelievable hues of pink and purple. The novelty of this experience never wanes, even after 25 years of dawn patrols. Last night high winds shattered our tent and we ended up sharing with complete strangers in theirs. To the mystery couple from York, thanks very much; hope we didn't wake you when we crept out at 6am for the dawn light. We'd conquered the wilds of Patagonia but came unstuck in Northumberland – all part of life's rich pageant.

• Fuji GX617, 90mm lens

Anse Severe, La Digue, Seychelles

To find the perfect palm tree stretched across the perfect white sand beach I searched tropical islands right around the globe in a two-year quest. It was tough but someone had to do it. I've never taken the job of location finding to such extremes. I found my Holy Grail here on La Digue in the Seychelles, which is possibly one of the most beautiful tropical islands in the world, located in the middle of the Indian Ocean. I'm here now, writing this book about half a mile from that beach. The tree is no more I'm afraid, but at least that means this picture can never be repeated.

• Fuji GX617, 105mm lens

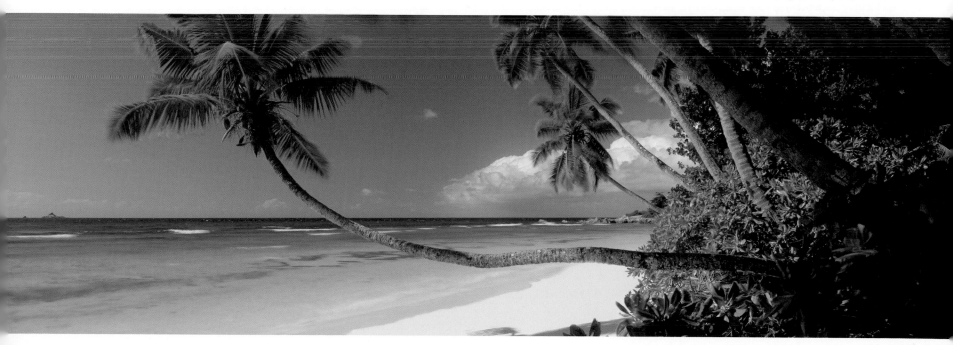

Sunrise at Te Pare Point, near Hahei, Coromandel Peninsula, North Island, New Zealand

There's clarity to the light here in New Zealand that's unique. Perhaps it's due to the absence of an ozone layer over Aotearoa, but it makes for some sparkling photographic conditions. We've had another 3.40am rise this morning, a 40-minute drive, followed by an hour's hike, or tramp as they say in these parts, and now we're in position as the rising sun bathes the bays and cliffs of the Coromandel Peninsula. We scouted this location yesterday and now all the elements have come together beautifully – Mother Nature likes us this morning. I'm pondering how I'm going to make this image, both here and back at base. My working methods have evolved over the last few years as I've partially switched to shooting digitally, and this morning's high-contrast scene will require all the flexibility the new medium gives me. The sensitivity of the sensor, the exposure latitude of the RAW file and the scope for skilled and sensitive processing make a digital camera an incredibly versatile tool.

• Canon EOS-1Ds MKII, 17–40mm lens

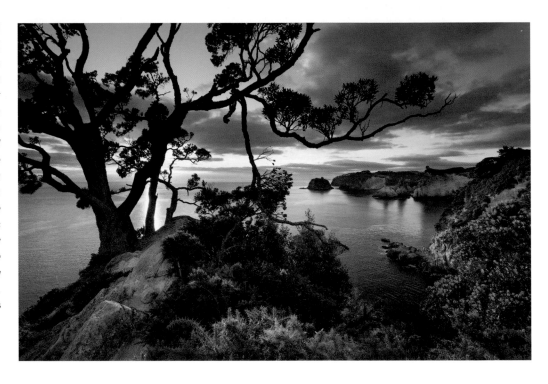

Weary Bay at dawn, Queensland, Australia

Tracing the names up the east coast of Australia, you get a good indication of Captain James Cook's state of mind as the Endeavour *sailed north on his voyage of discovery in 1769. Just out to sea here, off Queensland's Cape Tribulation, they struck the coral reef and almost foundered. After temporarily plugging the breach in the hull with canvas the crew towed the stricken* Endeavour *with oar power across this bay in search of shelter to effect repairs. I love salty stories like that, and have to admit Cook is a hero of mine. I'm on the pier of a rainforest lodge at dawn, breaking all the compositional rules again. It's a long exposure, and I manage just a couple of bracketed exposures while the fire in the sky lasts. It's a beautiful sight in a tranquil location, but a worm is turning inside of me; I'm concerned I haven't made enough strong images yet on this trip. It's the constant photographer's angst, which can only be relieved temporarily with another productive photo-session. Sooner rather than later, it returns.*

• Nikon F5, 17–35mm lens

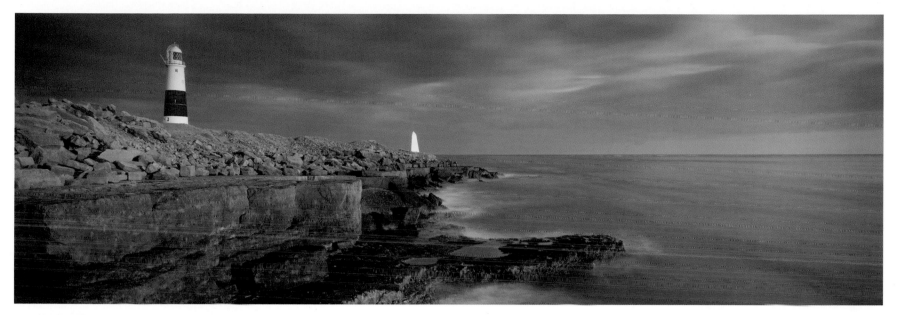

Portland Bill at dusk, Dorset, England

*Off this point is the Race, a meeting of currents
creating some truly evil seas. Normally in winter
this spot is being battered by monster waves: it's the
graveyard of many ships and cameras. This afternoon
the sea is like a millpond and the sky a leaden grey;
I almost abandon my watch, but decide to hang on a
bit longer. So many times I've given up prematurely
and headed for dinner, only to curse myself bitterly as
a final burst of light of the day taunts me. I'm rewarded
as a flicker of gold ignites the rocks. I'm scrabbling to
take a meter reading and expose while the light lasts.
The sea is so calm I'm concerned the scene will lack
the usual drama this location provides, but the quality
of the light more than makes up for it.*

• Fuji GX617, 90mm lens

rocks like a piece of flotsam. It hurt. And I've been cut off by the tide in
Scotland, only to be saved by International Rescue in the form of my
wife paddling out to retrieve me in a rowboat in the dark. I suspect I've
not heard the last of that one. And I've lost many cameras and lenses
to the effects of salt water.

Why does all this keep happening? Well, apart from me being an
idiot there are two mitigating circumstances. Firstly, and I'm sure it's
true for all of us, when I'm working on an image I get totally absorbed,
the rest of the world ceases to exist. Time passes; I often think I've
been crouching by the tripod for ten minutes when it turns out to be
more like an hour. And secondly, the best images are made when you
go for the boldest composition, and that means getting the tripod legs
wet. You're not going to make a knockout picture from the car park.

Keeping your kit dry is one of the biggest challenges here, and there
are waterproof covers made for cameras, which, while not protecting
from a monster wave, will keep the worst of the spray off. Of course
that doesn't actually include the front lens element or filter, as this
by definition must be exposed. So between exposures a soft, dry
lens cloth is needed to remove all the salty moisture steadily adding
diffusion to your image, whether you want it or not.

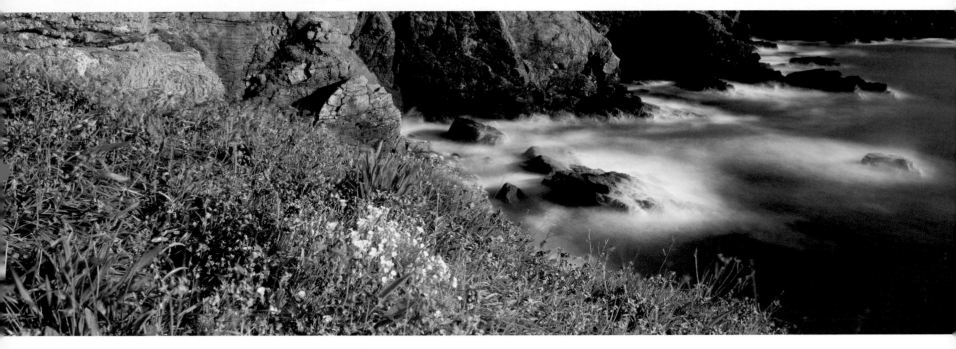

Wild flowers on the cliffs of the Lizard, Cornwall, England

It's late spring in Cornwall and the cliff tops on the Lizard are bursting with colour. I'm feeling alternative this morning and make a shot with no sky, concentrating just on the wild flowers and craggy coast. Maybe I'm biased, but I think we're lucky in the British Isles to have some of the most varied and dramatic coastlines anywhere.
• Fuji GX617, 90mm lens

Using long exposures with moving water is hardly a new idea, but it's one we're all hooked on; it gives a dreamy, ethereal look and I've spent many hours standing with water lapping around my feet waiting to finish another six-minute exposure. To slow exposures down neutral density filters are crucial: I regularly use a 0.6 or 0.9 ND, which equates to +2 or 3 stops of exposure. On larger format cameras with tiny minimum apertures like f/45 and slow ISO 50 film, long exposures are almost obligatory, but with digital cameras it's often difficult to slow exposures enough. With default sensitivities of ISO 100 or faster and minimum apertures of only f/22, exposures longer than a second can be difficult to achieve even with ND filters. Using two in conjunction helps, but they must good filters – both optically and in terms of colour quality – otherwise sharpness will suffer and gruesome colour casts become apparent. I use two Lee 0.9 ND glass filters made especially for digital cameras. The amount of movement desirable is for you to decide. An exposure of 1/2sec on a breaking wave will give a pleasing blurry drama, while an eight-minute exposure at dusk transforms the water into a sea of mercury. Again, do trials, experiment. And above all, know what the tide is doing – is it ebbing or flowing? Check the tide times, wear wellies, and rinse the tripod down with fresh water afterwards to prevent it rusting and clogging up with salt.

"The best images are made when you go for the boldest composition, and that means getting the tripod legs wet"

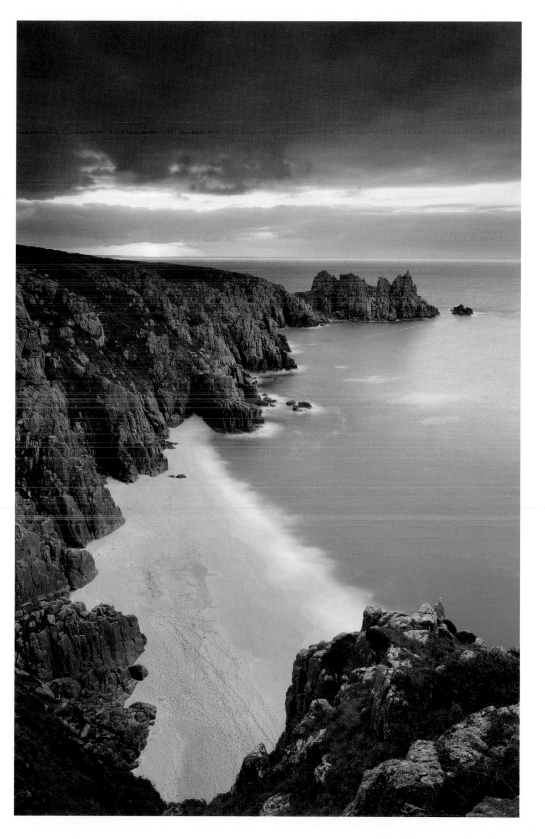

Porthcurno, Cornwall, England

As the sun rises over the Lizard streaks of fire arc through the dawn sky. A 0.9 graduated neutral density filter holds back the exposure on the sky, whilst a 0.9 neutral density filter allows me to slow the exposure to 25 seconds to record some motion blur of the waves breaking on the beach. I expose a test frame, check my highlight alerts and histogram, dial in +0.3 exposure compensation with aperture priority matrix-metering, and start exposing.
• Canon EOS-1Ds mkII, 16-35mm lens)

Wood

The rainforest: a dense green mass of vegetation, difficult to be in, even harder to work in. Where to start? Surely one patch of jungle is much like any other? Everything is up close, in your face, dripping and slimy, there are no sweeping views, and the light is awful. But anyone who has spent time in rainforests knows what fascinating places they are – full of life, the lungs of the planet: I always feel privileged to be there. It's an environment that assaults the senses; the sounds and smells of the jungle permeate my soul. And they are all different. Definitely difficult to photograph, but no one ever said this game was easy.

Monteverde Cloud Forest Reserve, Costa Rica

With the light levels fluctuating widely as the clouds filtered through the trees, exposing for this shot was murder. Halfway through a five-minute exposure the sun penetrated the mist, sending light levels and contrast through the roof. I aborted the exposure and started another. I shot two rolls of 220 just to get one perfect exposure.
• Fuji GX617, 90mm lens

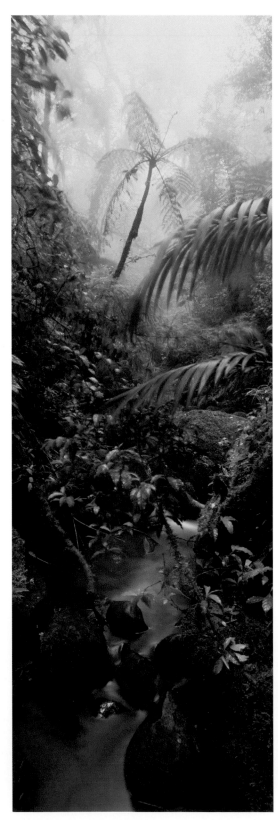

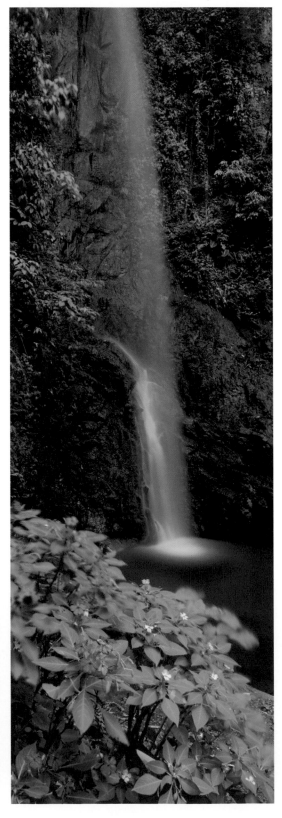

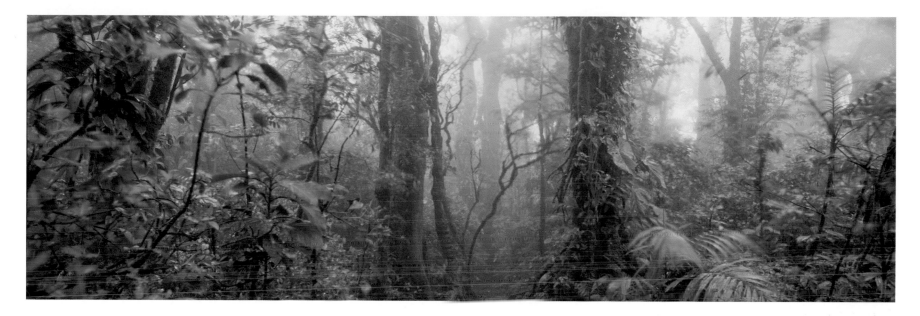

Monteverde Cloud Forest Reserve, Costa Rica

*The mists passing through the forest gave an ethereal mood and a lovely
low-contrast light, perfect for this environment. It also meant everything
was permanently moist, the vegetation, the air, the camera and me.
Keeping the drips off all the gear was a major undertaking.*
• Fuji GX617, 180mm lens

"Light levels are very low, think in terms
of exposures of minutes, so don't even
consider going without a tripod"

**Waterfall with wild Busy Lizzies
(*Impatiens*) near Alajuela,
Central Valley, Costa Rica**
*It's often difficult in the rainforest to see
any colour other than green. Here by the
waterfall these Busy Lizzies give a splash
of pink to offset the cool blues and greens
deep in a jungle valley.*
• Fuji GX617, 90mm lens

As usual, location searching is the key, and that means getting
the boots on. Finding a strong composition is the goal; it's a case of
tuning your photographic vision into the fine details of the rainforest.
I look for visually strong features to base a composition on, such as
roots, vines, streams or some graphic detail. Lighting is the other big
issue, but here under the dense jungle canopy all the previously held
notions of what light I like for landscape work are redundant. Strong
directional sunlight is definitely what I do not need: the contrast goes
through the roof, or rather canopy, resulting in burnt-out highlights
and dense black shadows. Leaden grey skies giving a flat, diffuse
top lighting are perfect. Light levels are very low: think in terms of
exposures of minutes, so don't even consider going without a tripod.

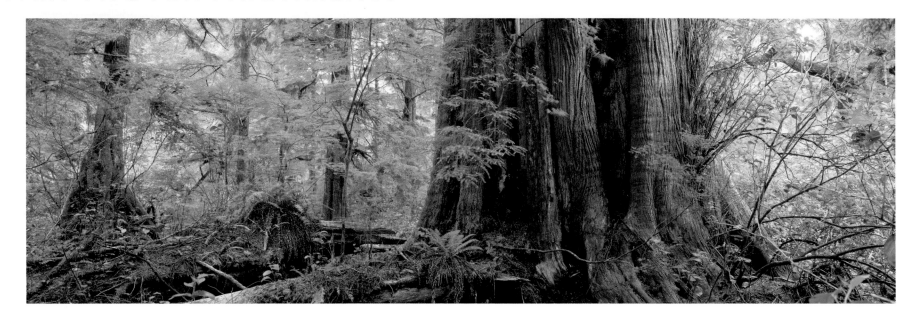

Giant cedar tree, Meares Island, Clayoquot Sound, Vancouver Island, British Columbia, Canada

Not all rainforests are tropical. Here on Meares Island the giant cedar trees that used to be found all over Vancouver Island are truly majestic. How can anyone contemplate cutting down one of these ancient living entities? This one would have been a sapling when the Romans ruled supreme. I can't include the entire towering giant in the frame so I concentrate on showing its girth in relation to the new growth around it.

• **Fuji GX617, 105mm lens**

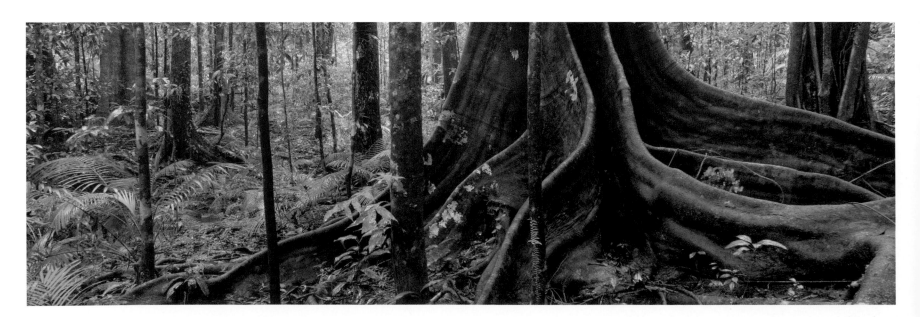

Fill-in flash can be effective for lighting details. And take an empty film canister full of salt. It's for the leeches you see: if you find any of these blood-suckers clinging to your anatomy just pour salt on and they shrivel and drop off. An umbrella is also useful as, funnily enough, it often rains in tropical rainforests, and I mean seriously rains. It's far too hot to wear a jacket and under an umbrella you can continue shooting. Being a bit of a control freak I usually resist being led anywhere by the hand, but there's no substitute for local knowledge, so a guide can provide a fascinating insight into the complex ecosystem. Above all, stop, look and listen. Let the jungle envelop you in its mystery. It's far too easy to trudge past things of interest.

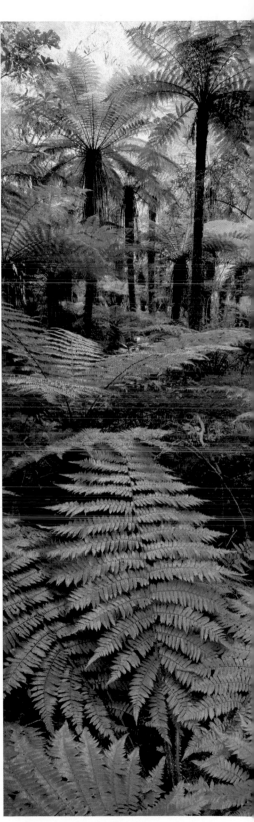

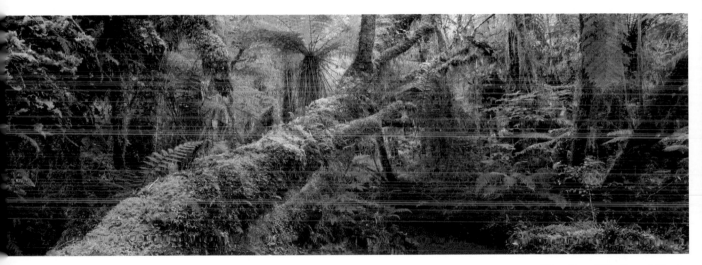

Westland National Park, South Island, New Zealand

At the foot of Fox Glacier in New Zealand's Westland National Park lie tracts of dense temperate rainforest. It seems a bizarre mix: ice and dense greenery. Temperate rainforests have a very different feel to their tropical counterparts – they're much more mossy. In fact the more time you spend in the woods the more you realize all forests are different.
• Fuji GX617, 90mm lens

Buttress roots on tree, tropical rainforest, Daintree, Queensland, Australia

The roots of a tree in the tropical rainforest reminded me of the flying buttresses on Gloucester Cathedral. I suppose they're similarly supportive in the thin soil.
• Fuji GX617, 105mm lens / Nikon F5, 16mm fisheye lens

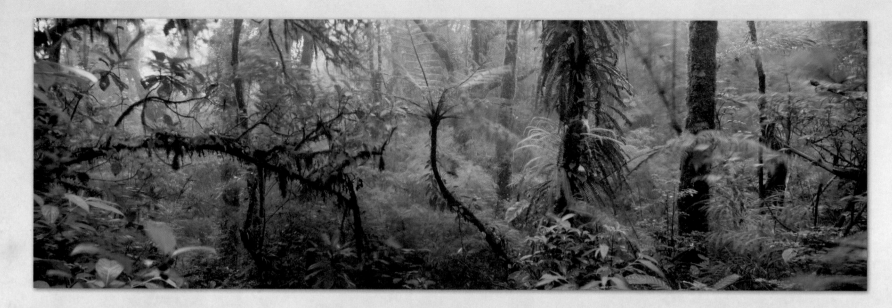

Santa Elena Cloud Forest Reserve, Costa Rica

The mud gets everywhere. I'm wearing a plastic poncho, but it's hopeless; nothing stays dry in here. It's an ethereal place, everything is draped in moss, the cloud hangs amongst the trees, it's dark, damp and muddy, and we love it. After a few days of this everything we own is covered in a thin layer of rainforest slime. The damp mists are swirling all around us, the leaves are constantly dripping, and as we brush through the undergrowth they shed more soggy delights on us just for good measure. The trail is a slippery quagmire that we slosh and slide along like inebriated ice skaters. Welcome to the cloud forests of Costa Rica.

The spine of mountains that to the north constitute the Rockies, and to the south the Andes, crosses the narrow isthmus of Central America as a 6,500ft jungle-clad ridge. The warm air from the Caribbean streams over this ridge en route to the Pacific, cooling as it does and forming dense damp clouds filtering through the woods; this is a cloud forest and it's a first for me. We're spending four days here tramping the forest trails in search of the definitive images of this unique ecosystem, and despite the grime it's great fun.

Photographing the cloud forest presents some serious challenges. The damp and the mud is an inconvenience to us but if it gets into my kit all sorts of bad things will happen. Every day we trudge thorough the forest in search of strong compositions among the seemingly impenetrable mass of vegetation. As it turns out there's a wealth of potential once you get your eye tuned in.

The mud squelches beneath our feet, I stop and look. There's a shot here. Wendy releases the plastic sheet from the back of my Lowepro and lays it in the mud for the bag to rest on. I erect the tripod; Wendy then holds an umbrella over the bag as I rummage inside. Drips run down my neck but the

"Every day we trudge thorough the forest in search of strong compositions amongst the seemingly impenetrable mass of vegetation. As it turns out there's a wealth of potential once you get your eye tuned in"

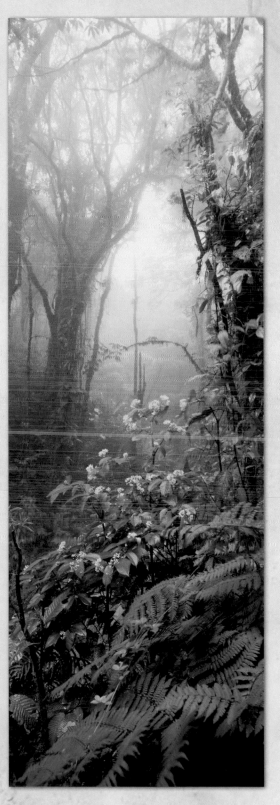

kit is protected. We're working as a well-oiled machine now after days of this. I transfer the camera to the tripod under the brolly; I'm using the panoramic camera vertically. I spot meter off a leaf in the foreground, open the shutter and start the long wait. With a polarizer on to saturate the colours in the vegetation, at f/45 the exposure time is eight minutes. As the feeble light does its work on the silver halide crystals we watch the mists swirling through the lush canopy above - it's incredibly atmospheric. The sounds of the forest envelope us, we are not alone, that's for sure. A jaguar could be within spitting distance and we'd never know it.

After four minutes I take another reading. The light levels are fluctuating as the cloud blows through the trees; it's half a stop brighter now. I end up giving it six minutes and start another exposure, and so on. I get off just eight frames in an hour. I don't feel it's enough, allowing for bracketed exposures and the varying amounts of mist. I reload and start on another exposure. Occasionally the sun briefly penetrates the mists in the upper canopy, sending the contrast sky high and forcing me to abort the exposure. Generally though, the flat low-contrast light predominates.

Trudging back, bag heavy on my back, muddy, soggy, exhausted. Images have been made though, and that always engenders a deep-seated feeling of satisfaction. We descend into the bright tropical sunshine of late afternoon. Below and to the west lies the Bay of Nicoya and the Pacific coast, our next destination: palm trees, beaches and sunshine.

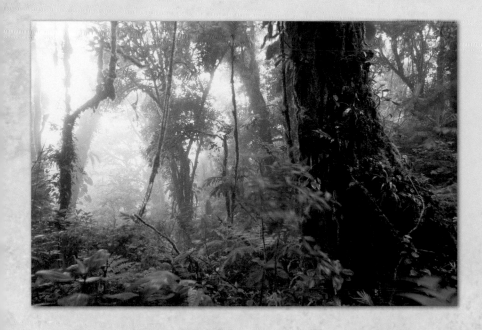

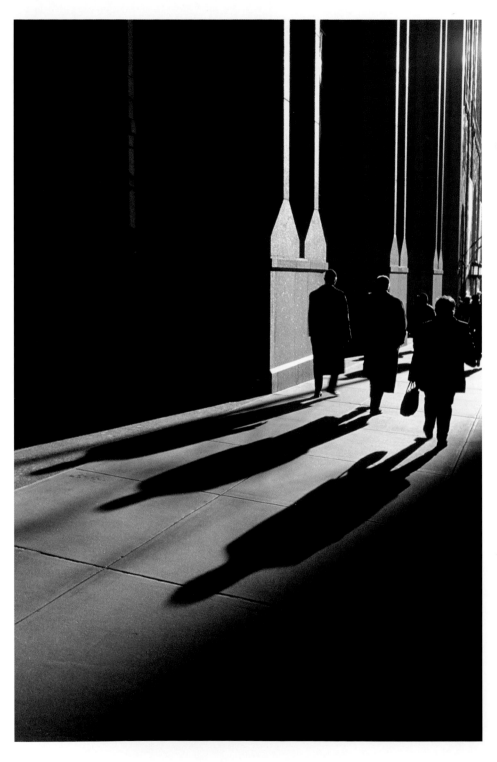

Concrete

In the urban jungle there's always something to point your lens at, whatever the time or weather. In the countryside, days, even weeks can go by waiting for the right conditions, but a few days spent working the melting pots of humanity will always be productive. Pounding the pavements of the world's conurbations can be dispiriting, but who can fail to be stimulated by the vibrancy and variety of cities the world over? Bangkok: it's not a pretty city. On my first visit I hated the choking fumes and oppressive sprawl. Now, after countless pit stops en route to exotic Asian destinations, I love it: the temples, tuk tuks, monks, street food, the bustle and life. Sydney: is there a better-sited capital anywhere in the world? Watching the sun shining down the harbour in the early morning, or catching the Opera House and Harbour Bridge as joggers trot past. Rome: all roads lead to it, which is easy to believe watching the traffic chaos around the Pantheon. A bowl of pasta in the Piazza Navona may set you back a few Euros, but when the lights come on in the Eternal City at dusk it's a setting not to be missed.

Wall Street, New York, USA
Early morning light beams down Wall Street
highlighting the trudge to work in New York.
• **Nikon F5, 17–35mm lens**

Commuter on Millennium Bridge with St Paul's on the skyline beyond, London, England

The steely light of a winter's morning in London lights the elegant lines of the Millennium Bridge over the River Thames, leading the eye to St Paul's Cathedral as a commuter hurries to work. It's a classic example of the use of minimal colour.
• Canon EOS-1Ds MKII, 17–40mm lens

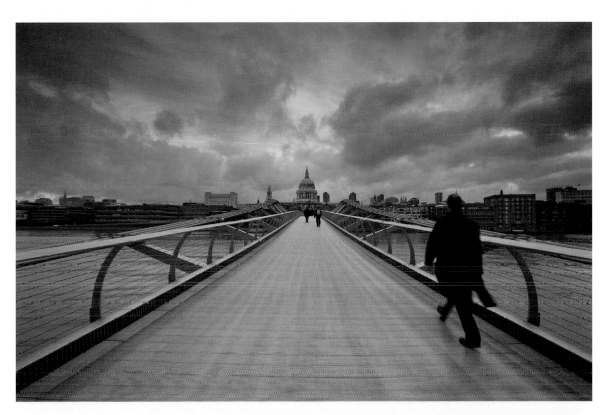

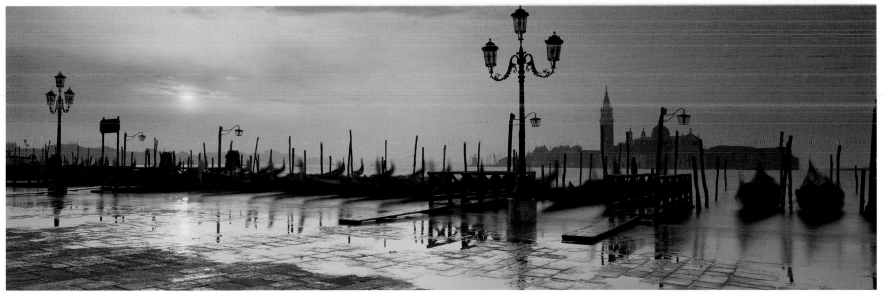

Gondolas at dawn, Piazza San Marco, Venice, Italy

Everyone should see Venice at least once in their lives. It doesn't matter how many times you've seen pictures of it, the first impressions are as if you've stepped on to an opera stage. It has been a Mecca for artists for centuries and is endlessly inspiring. I've now been four times; maybe I should call it a day before the novelty of shooting bobbing gondolas wears off.
• Fuji GX617, 105mm lens

City parks are often exquisite mini-landscapes in the heart of a metropolis, and then there are the people in them, jogging, walking, snoozing; the ceremonies, the monuments, the markets, cafés, bars and restaurants – it's endless. And of course, the street life. Photography aside, people-watching from a pavement café in the spring sunshine is an addictive pastime. Photographically, with so much on offer, the challenge is where to begin. All cities will have their classic views that have been shot ad infinitum, so coming up with something new, a unique take on a well-known subject, is the name of the game. Compositionally, you're doing exactly what you do in other environments; arranging shapes, bearing in mind the Golden Rule of Thirds, looking for foreground interest and considering unsightly distractions. But as cities are all about people I like to include them, if possible. A few blurry figures in the key spot, even if tiny in the frame, can lift an image and give a sense of perspective and place. And bold compositions with graphic shapes from unusual viewpoints are the order of the day. Think laterally. Use your eyes. Bend your knees, or talk your way on to that rooftop terrace.

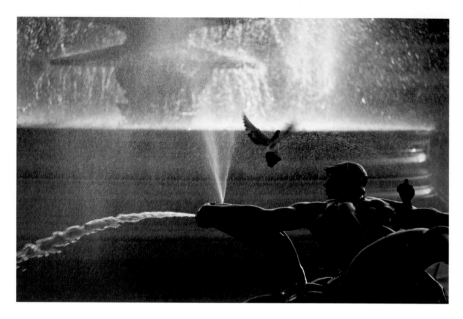

Fountain in Trafalgar Square with pigeons, London, England
The last of the sunlight backlights the fountain in Trafalgar Square. I managed to squeeze this one off before I was arrested and sent to a Gulag by the Tripod Police.
• Nikon F5, 80–200mm lens

**Horse riders in Hyde Park,
London, England**
*It's colour at full throttle for this study
in motion of the Household Cavalry
exercising their mounts in Hyde Park
early in the morning. Spring is my
favourite time for shooting cities; the
parks are ablaze with colour.*
**• Canon EOS-1Ds MKII,
24–70mm lens**

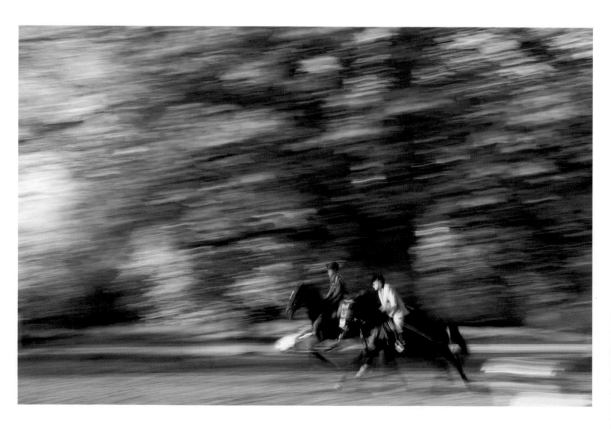

Jogger at Milsons Point, Sydney, New South Wales, Australia

Everywhere you go around Sydney Harbour they're jogging, or rollerblading, or swimming; they're a fit bunch the Aussies. I set this shot up with my cousin's daughter trotting up and down endlessly while I experimented with different shutter speeds. As always, I think a human element lifts the well-known view of the Harbour Bridge and skyline.
• Canon EOS-1Ds MKII, 17–40mm lens

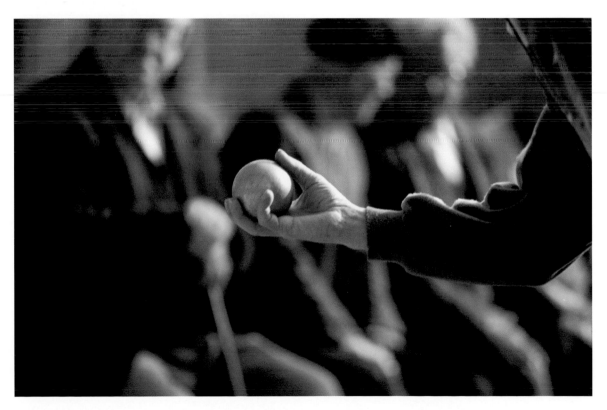

Men playing pétanque, Barcelona, Spain

In the park in Barcelona the old boys gather for boules and a chat in the spring sun. Seems like a good way to pass the day to me.
• Nikon F5, 80–200mm lens

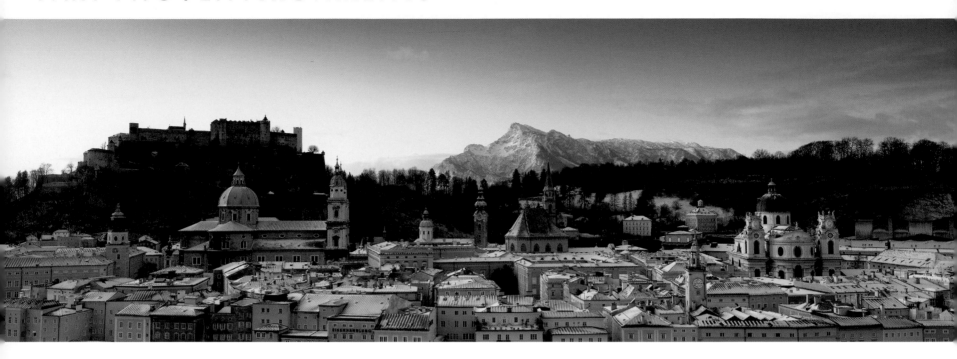

The historical architecture of famous European cities just shouts to be photographed. The buildings speak to us of the passing of time and are often beautifully lit at night. Even the most unappealing area by day can be transformed when illuminated in the evening. Getting to know how a city is lit at night is part of the unique challenge of urban location searching. Making night images is all about planning and timing. Once an image has been pre-visualized and the exact composition planned, it's a case of setting up as dusk falls and waiting for the lights to come on. The best night shots are not made in the dark; the ideal time is when the skies are darkening but still holding enough ambient light to give a rich, dark-blue tone to offset the warm tones of the lights. Shoot too early and the effects of the artificial lights aren't apparent enough, leave it too late and the skies blacken. There's usually a window of about five to ten minutes when the balance between night and day is perfect.

Salzburg in the snow, Austria

The previous evening in Salzburg I'd struggled up the hill above the Old Town with a sprained ankle and a cold to shoot the illuminated city. The floodlights never came on and I retreated to my hotel room feeling sorry for myself. The next morning the whole world looked a much better place as a light sprinkling of snow dusted the city.
• Fuji GX617, 105mm lens

Charles Bridge at dawn, Prague, Czech Republic

The towers, statues and minarets of Prague's Old Town take us straight back to the days of Mozart with no modern distractions to disrupt the skyline. On a grey overcast morning I'm struggling to make something of the Charles Bridge in the flat light. Just as I switch to black and white a couple strolls past hand in hand and I seize the moment.
• Nikon F5, 80–200mm lens

Cities are hard work, you're on the go virtually all day and some of the night. Even in bad weather there are shots to be made, in fact I often wish for rain to turn pavements reflective at dusk. As well as the photography, there are the endless location searches, and struggling on and off the metro at rush hour with a monster camera bag and tripod in search of the next location is exhausting. Sometimes it's necessary to carry the huge bag, but more often I know what sort of images I'm after and take the appropriate set up. If for example I'm working in a busy, crowded market I have just a body and two lenses and no tripod. Fill-flash can also be very useful here. I also love using a fast 85mm f/1.2 lens for portraits in crowded dark bazaars. But the one piece of kit I wouldn't be without though for any city trip is my 24mm shift lens. Make a picture looking up at any building and what do you see? Converging verticals making it look as if the building is falling over backwards. It's actually how we see it, but in print it just looks wrong. So architectural photographers have long used large-format cameras with movements enabling them to correct the verticals and keep everything straight by shifting the lens axis up or down to control the angle of view while keeping the image plane vertical. On 35mm or digital SLR cameras we can achieve the same by using a shift lens. They're expensive, but mine has paid for itself many, many times over.

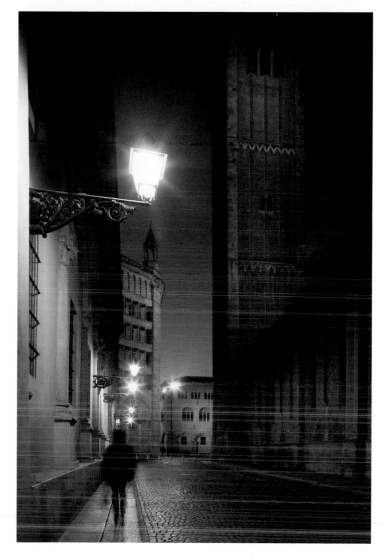

A lone figure on Via Cardinal Forrari at night, Parma, Emilia-Romagna, Italy
I do like a bit of human blur in my night shots, just in the right place. As usual, it's Wendy again as the ghostly figure in Parma.
• Canon EOS-1Ds MKII, 24mm shift lens

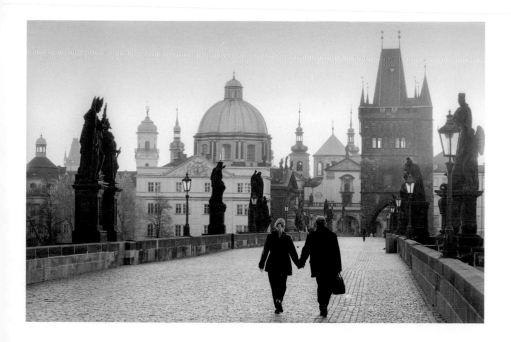

"Cities are hard work, you're on the go virtually all day and some of the night"

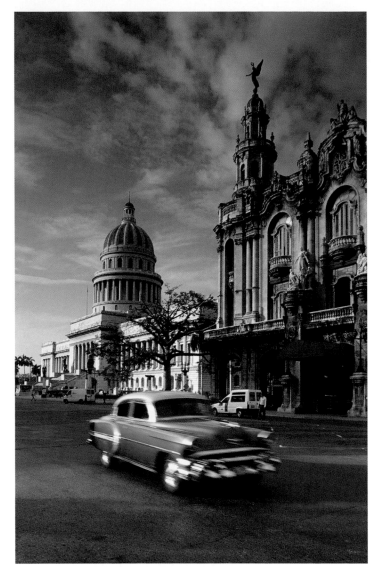

Old car passing the Gran Teatro and Capitolio, Habana Vieja, Havana, Cuba

All the icons of Havana in one shot, the Capitol, Theatre and an old car. All I need is an old man with a cigar.
• **Nikon F5, 17–35mm lens**

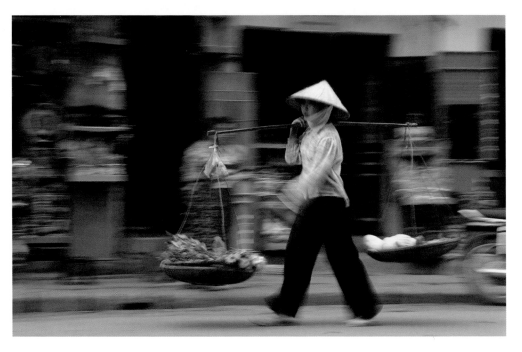

Street scene, Hanoi, Vietnam
For all the impressive monuments, it's the human interest that defines a city. This street scene of a woman carrying vegetables typifies Hanoi.
• **Nikon F5, 80–200mm lens**

Cities do have their downsides. Somehow, a tripod when erected seems a magnet for every drunk, stag night gang and hustler in the city. Pickpockets and thieves are always in the back of my mind. And don't get me on to the subject of the Tripod Police. They are a modern phenomenon, gangs of jobsworth so-called security guards hired specifically to stop photographers taking pictures from selected famous spots of their own national heritage without a permit costing a fortune applied for months in advance. Scaffolding is another bugbear. On one visit to Florence, green sheeting and scaffolding where restoration work was underway blighted every shot I tried. And while I'm at it, trying to sleep in hotel rooms not big enough to swing a cat in with the noise of late night revellers in the street outside and the amorous couple next door. And New York taxi drivers who don't know the way to Broadway … But at the end of the day all environments have their specific challenges, and cities provide such rich pickings that they're worth trudging the streets for.

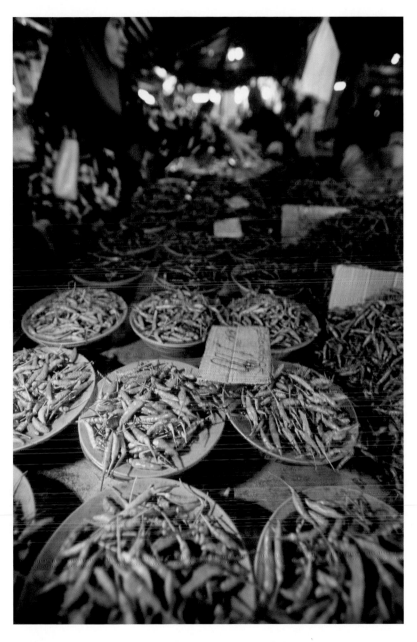

Chillies, Chow Kit market, Kuala Lumpur, Malaysia

The stall holders in Kuala Lumpur's Chow Kit market are somewhat bemused as I crouch within inches of their displays, holding the camera with one hand and a flash with the other. It's a cramped, sweltering rabbit warren of stalls displaying all the colourful ingredients of Asian cuisine; fresh fish, chillies, vegetables, live chickens, lemongrass, spices ... you name it. It's also a hellhole of mixed lighting. Hard sunlight pierces gaps in the awnings, tungsten bulbs mix with fluorescent lights; hence the fill-in flash.

• **Nikon F5, 17–35mm lens**

Pad Thai noodles being stir fried on the Khao San Road, Bangkok, Thailand

The Khao San Road in Bangkok is a Mecca for all the backpackers and travellers passing through this corner of Asia. Pad Thai has to be the best street food in the world. I had the camera virtually in the wok to shoot this as the chilli sauce went in, and balanced the ambient light with the street lights and a dash of fill-in flash.

• **Canon EOS-1Ds MKII, 24–70mm lens**

Parisian Walkways

I've photographed Paris more than any other city. I find it an endlessly stimulating subject – every time I go I get fresh inspiration for the next time. Ideas are the key to avoiding just rehashing the famous views. There's no getting away from the fact that the Eiffel Tower is a potent symbol of not just Paris but of all things French, but of course it has been done to death. There is simply no point in shooting the classic view from the Palais de Chaillot yet again. However, for icons as familiar as the Eiffel Tower it's not necessary to show it all. One leg of the famous structure amongst the foliage beneath is enough. Long lenses, fish-eyes, unusual viewpoints, black and white and infrared film: they're all useful tools in endeavouring to bring fresh perspectives to familiar subjects.

Tricolour blowing in wind at dusk, Arc de Triomphe, 17th arrondissement

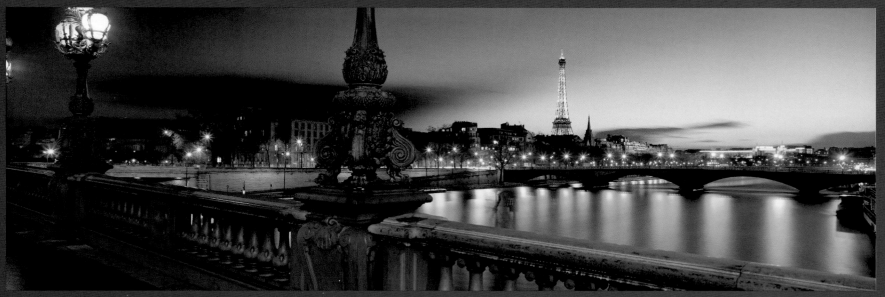

River Seine and Eiffel Tower at dusk from Pont Alexandre III, 7th arrondissement

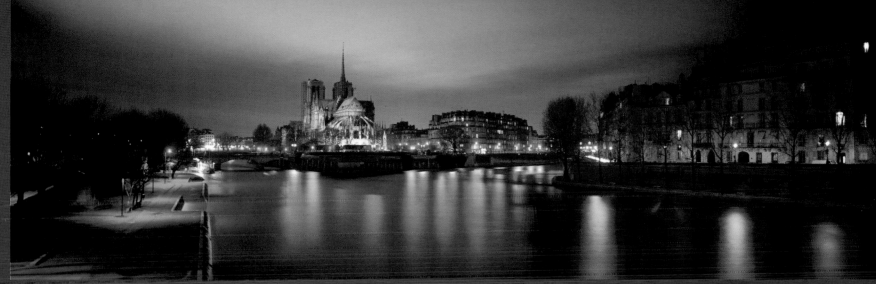

The Cathedral of Notre Dame, Ile de la Cité and River Seine at night, 4th arrondissement

The Eiffel Tower and Champs de Mars in spring, 7th arrondissement

Arche de la Défense

Skin

Much as I love to produce epic panoramas of sweeping vistas it's often the people who best capture the flavour of a place. Ideally I aim to return from a trip with a comprehensive collection of images ranging from landscapes to street scenes, portraits and details, which will form a photo essay on my website and support each other as a set. Each image is stronger as a part of that set than it is on its own, and the portraits and candid images of people in their own environments are a vital element.

Every photographer has a style and unique way of working. As I seem to spend half my life stood beside my tripod waiting for the perfect light for my landscape work, I adopt a completely opposite approach with my people shots: opportunistic, spontaneous and impulsive. I like to react to what's going on around me rather than to manipulate it; posed portraits of people staring balefully at the camera are not for me. It's all about observation, interaction with the subjects, speed and making the most of fleeting opportunities.

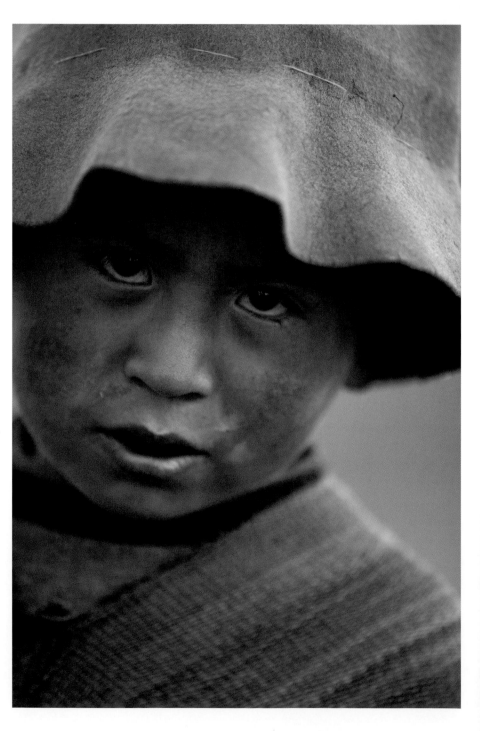

Farm boy, near Chincerro, Peru
The composition of a portrait has to happen almost instantaneously, but as with all images the arrangement of the shapes within the frame and the absence of background clutter are crucial factors. Usually for portraits I work with the lens wide open at f2.8 to drop the background out of focus, but I have to be so accurate with the focusing at that aperture and range. Usually, the eyes are the focusing point. The camera's auto-focus does a good job normally, but I have to be aware of what it is focusing on and be ready to override it quickly if necessary.
• Canon EOS-1Ds MKII, 70–200mm lens

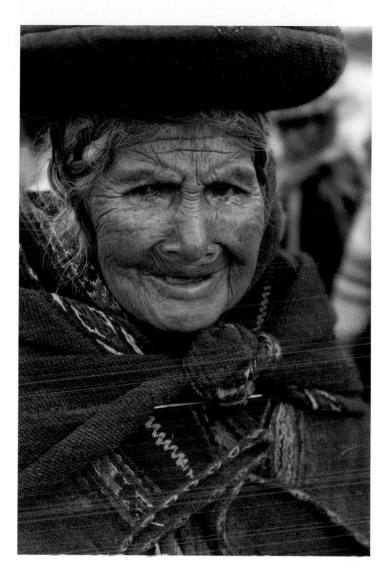

Quechua woman, Chincerro market, near Cusco, Peru
Markets are always a good hunting ground for people pictures. Here in Chincherro, above the Sacred Valley of the Incas, this Quechua woman is possibly a direct descendant of the Incas. The colours and vibrant cultures of Peru are unique; there aren't many places left in the world where most people wear native dress.
• Canon EOS-1Ds MKII, 24–70mm lens

"It's all about observation, interaction with the subjects, speed and making the most of fleeting opportunities"

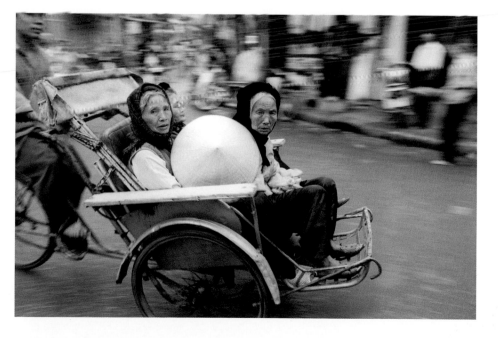

Old ladies in a rickshaw, Hanoi, Vietnam
You take your life into your hands crossing the street in Hanoi. There never is a break in the stream of bleeping motorbikes and bicycles. You just have to take a leap of faith and step out into the flow. I'm standing watching the rush of humanity pass under a heavy leaden grey sky. I've been out all day shooting the rich pageant of Vietnamese street life. A rickshaw approaches, I dial in 1/8sec with shutter priority exposure, pan and shoot, fleetingly aware of piercing stares boring into my lens as they pass. It's a moment that's gone before I can barely register it, a decisive moment only to be recognized on the contact sheet a month later.
• Nikon F5, 20–35mm lens

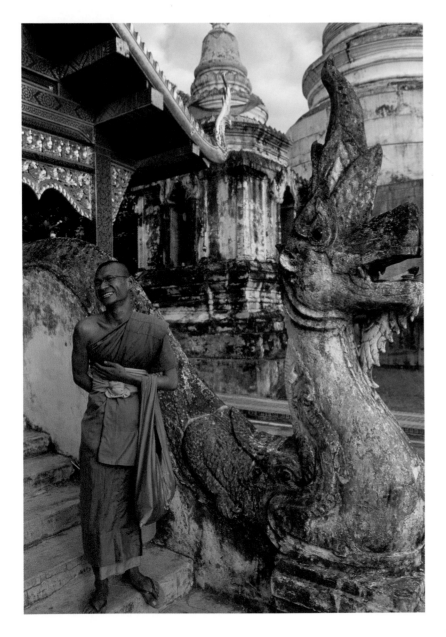

Do I always ask permission? No, for candid shots it doesn't work, the moment has passed, but sometimes it would be rude not to. People often refuse, many a time I've trudged away from an absolute classic, but what more can I do? Refusals used to be a real setback; I'd brood on them for hours. I'd seldom get back into the groove after a couple of brusque rejections, but I've become less sensitive and thicker-skinned over the years. I've had fruit thrown at me and dogs set on me, but it's my job, so I just get on with it. I'm never intrusive with my photography, but this game is all about getting stuck in, making the most of a situation, being up close, in the thick of it; sitting on the fringes with a long lens afraid of upsetting anyone just doesn't work.

Monk at Wat Phra Singh, Chiang Mai, Thailand
We make a good team, Wendy and I. People often freeze up when the camera is raised, staring woodenly into the lens, body tense; it takes some effort to loosen them up. Here in Wat Phra Singh in Chiang Mai, Wendy is off to my left, chatting to the monk to distract him from the intruding photographer. Then as they continue to talk I move in for a study of his hands clutching his scroll.
**• Nikon F5, 17–35mm lens
/ Nikon F5, 28–70mm lens**

Lijiang, Yunnan Province, China

The sun at this altitude beams down with searing clarity. I'm sitting in the square just watching the world go past, soaking up the rays and the atmosphere, feeling good. An old boy sits on the wall next to me; his face is like a historical map of China. The light is too harsh, but I've got to try for a shot, what have I got to lose? I gesture, he gestures back, I gesture again; I think it's game on. With the 70–200mm f/2.8 zoom set at about 135mm I squeeze off a few frames. We start communicating again, despite the total lack of a common language. He's pointing at my shades on the top of my head, he wants to try them on. I pass them over and raise my camera; compose, focus, expose ... he's loving it. There's a clutch of Chinese tourists now taking pictures of the two of us, the quintessential face of China wearing Oakleys and me, the westerner with a big lens. He then jumps up and makes as if to run off with my sunglasses with me in mock pursuit, and the whole square erupts with laughter. It's just one of those rare magical travel moments that leave a warm feeling. I head for my lunchtime noodles on a high.

• Nikon F5, 70–200mm lens

A sad fact of life nowadays is that people often want money for pictures. Should you pay? It's a tough question. Generally speaking I'd say no, it just ruins it for everybody else, distorts the local economy and makes the locals into photographic hustlers. In the Plaza de Armas in Havana there's a bloke with a wrinkled face, fulsome grey beard, Guevara beret and cigar who makes a living charging tourists $5 per picture. When I was judging a travel photography competition recently his mug popped up numerous times, and he's currently staring out of the window of the local bookshop from the cover of a Cuban travel guide. I must admit I shot him too, but as I walked away from that encounter I felt a fraud.

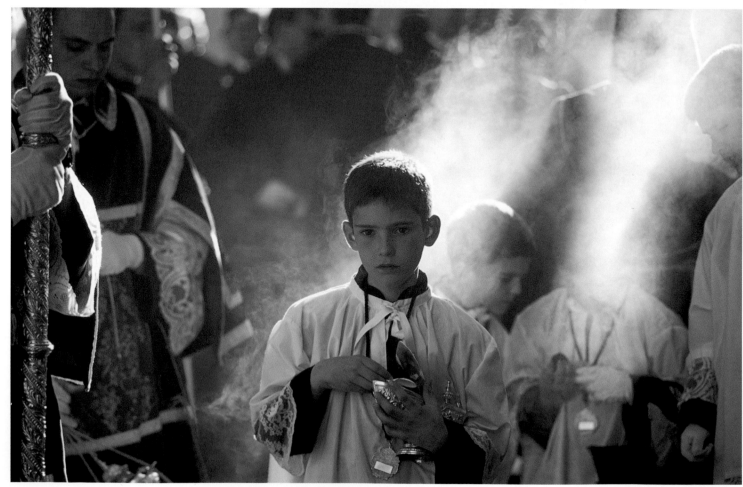

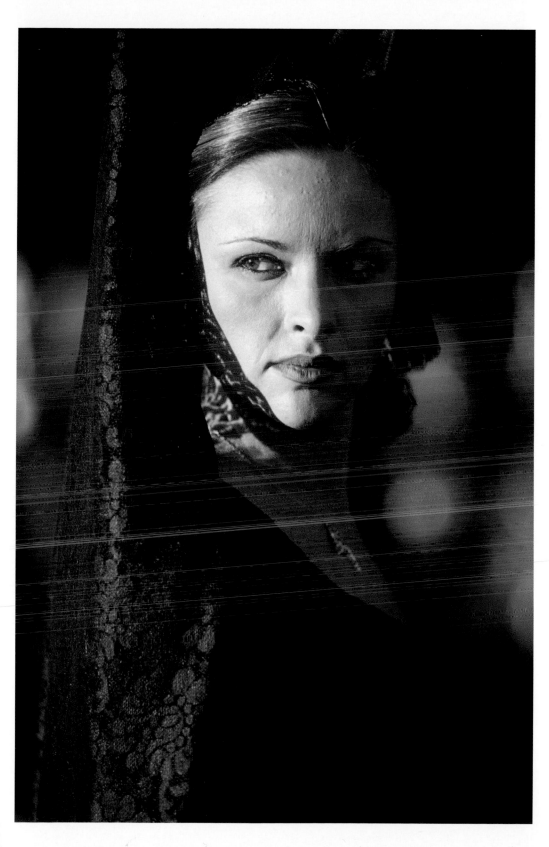

Semana Santa fiesta, Málaga, Spain

At Easter throughout Spain the Semana Santa processions parade through the streets in a display of religious devotion. I'm in Málaga pushing my way through the crowds, trying to get an angle on it all. The blokes in the tall purple hats and black robes inevitably draw my attention. I didn't expect the Spanish Inquisition. I'm treading on people's toes as I try to get the best backdrop as the procession marches past; the crowds make it difficult and there's so much going on. A choirboy is momentarily backlit, looking suitably devoted. The procession halts and I spot a black-clad widow with features so Spanish it's outrageous. I move around to shoot her cross lit by the evening sun; it's a bit harsh but what can I do? Not photograph her? She knows I'm focused on her but she loves it, striking numerous noble poses before they move on.

• Nikon F5, 70–200mm lens

Backwater scenes, Kerala, India

Five days spent being paddled along the backwaters of Kerala on a houseboat have given us a unique viewpoint on rural India. Our merry crew consists of two boatmen to pole us along and a cook to feed us unfeasible amounts of coconut curry. We just sit and watch India drift past. It's not a great trip for the fitness, this one, but we're certainly well off the beaten track and there's plenty of time for contemplation and photographic experimentation. A couple of women in their bright saris are walking along the path amongst the lush tropical vegetation and I make a slow panning exposure of them, blurring the motion to an outrageous extent. As evening settles a farmer tends his flock of ducks on the river: how does he possibly remain balanced in such a tiny craft?
- **Nikon F5, 80–200mm lens**
- **/ Nikon F5, 300mm lens**

My shot was undoubtedly no different from countless others, a worthless reinforcement of a stereotyped cliché. I have to believe that what I'm doing is unique; otherwise it's just a record. Of course, there are times when someone has genuinely put themselves out for you and in those cases some sort of donation is reasonable. Usually the further you are off the beaten track the less of an issue this is. I've had people thanking me for taking their picture in the backwaters of Kerala, and on the Tibetan plateau the kids were almost fighting to be the subject of my lens. But where legions of camera-clutching packaged tourists predominate, the locals will most likely be seeing dollar signs when a camera is focused.

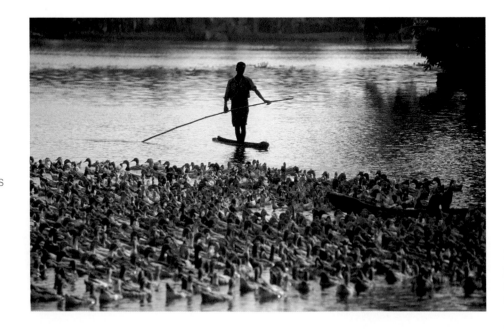

Kathmandu, Nepal

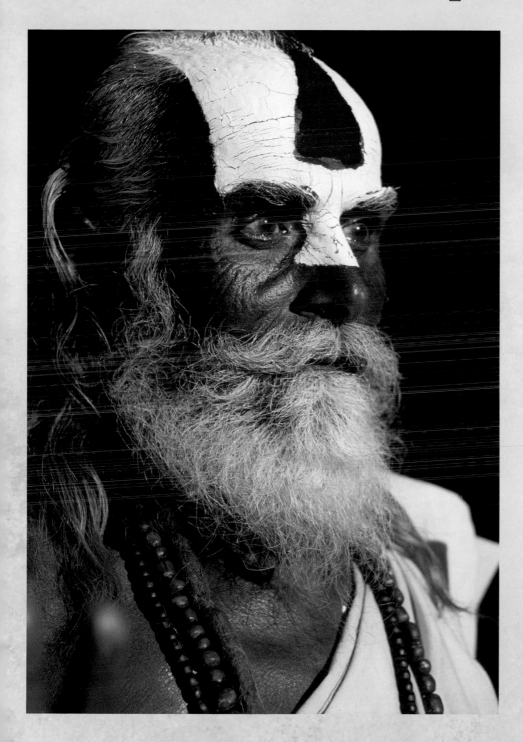

It's the last day of the Nepal trip and I've taken a walk just to see what I come across. There are a couple of sadhus hanging out in Durbar Square, holy men looking like something from biblical times. Today, with no specific location in mind I'm ambling with a body and just two lenses, a 28-70mm and 70-200mm f/2.8 zoom. I kneel next to one of the sadhus and we have a halting conversation - my Hindi is lousy. I'm buying time and trying to develop some sort of rapport while composing the shot, assessing the light and dialling in my camera settings without breaking eye contact. When an opportunity presents itself there's no time for changing lenses or messing around with camera controls, so it's important to be totally familiar with your kit. If it's a classic medium telephoto portrait such as this I'll almost always be working with the lens wide open at f/2.8 so the minimal depth of field drops the background out of focus. Even so, annoying details in the background can ruin a shot. I point to my camera, raise my eyebrows … Yes! I squat down, move around to isolate his face against a dark background, raise the camera, lightly depress the shutter, hold the focus on his right eye as I recompose, shoot. Exposure OK? No time to bracket: at aperture priority AE with +0.3 compensation dialled in to compensate for the brightness of his beard and face paint, I'm trusting to long experience of my camera's metering to get it right. The light of late afternoon is strong and directional; ideally I'd like it a bit softer, but this is the real world. Five frames exposed, I move around for a different shot, but he's had enough so I stop. Namaste. I back away with a spring in my step.

"When an opportunity presents itself there's no time for changing lenses or messing around with camera controls, so it's important to be totally familiar with your kit"

Part Three: Gallery

Ultimately a picture must stand on its own merit. All the effort that went into making it – the photographic techniques, the equipment used and the lengths the photographer had to go to – is irrelevant. Some pictures come easily, when Mother Nature smiles and all the elements come together seemingly effortlessly. More usually the strongest images represent triumphs of perseverance, or fleeting moments of perfection.

 Sometimes after waiting for the light for hours or even days, a splash of light paints the landscape for just 30 seconds, and I only manage to expose two or three frames. As the clouds close in again, I am often left wondering, did I get it? How were my exposures? It's good to be your own harshest critic, to be constantly striving to improve, but there also comes a time to trust your vision and experience, and move on to the next image.

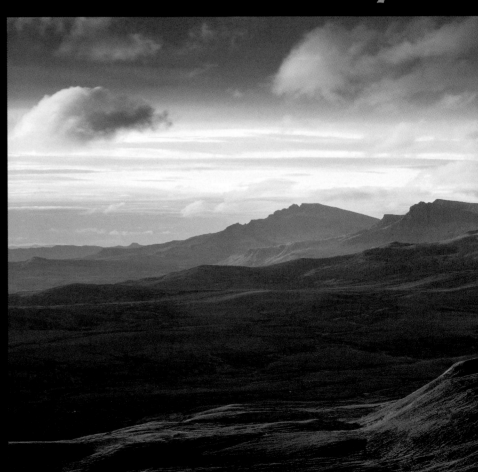

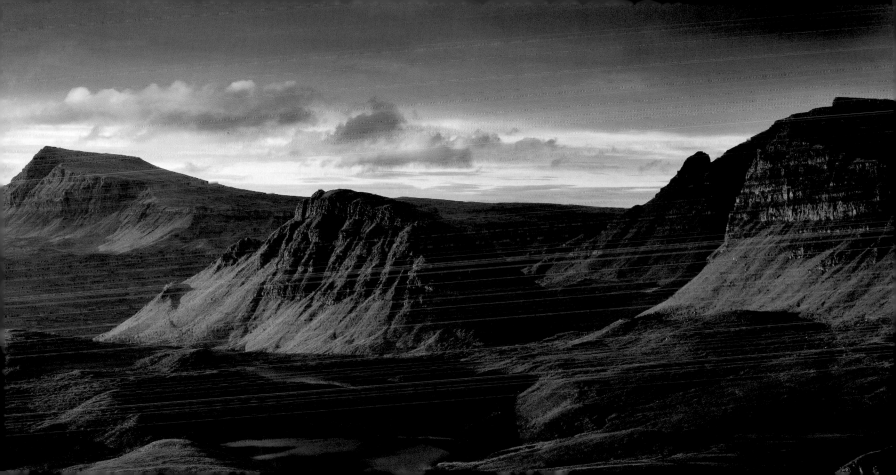

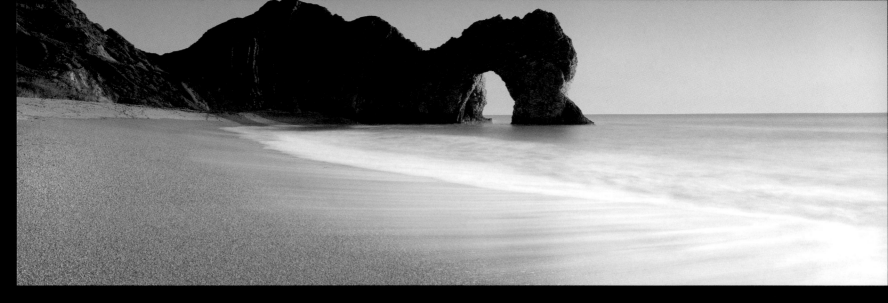

Durdle Door, Dorset, England

My grandfather used to patrol these very cliff tops in the Home Guard. At least that's what he told us; my mother reckoned they were mostly in the pub. After a lifetime of travel I've returned to my roots, here in Dorset. It's important to feel you come from somewhere. This stretch of coast, which we've always known is spectacular, is now a UNESCO World Heritage Site, the Jurassic Coast, ranking alongside the Grand Canyon and the Great Barrier Reef. This is one of my most popular images; it has sold all over the world, and hangs over many fireplaces, which, considering my photography covers all four corners of the globe, says something.

• Fuji GX617, 105mm lens

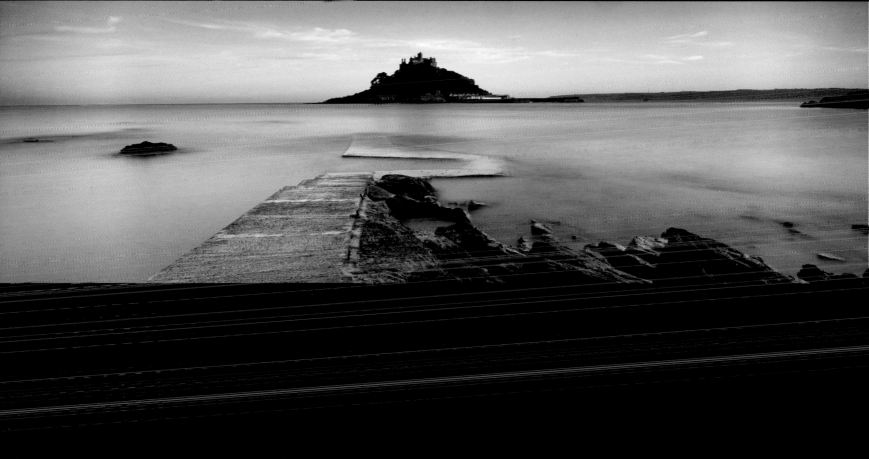

St Michael's Mount, Cornwall, England (David Noton/National Trust)

Over the course of this summer I've become a little bit obsessed with St Michael's Mount. I've visited several times to shoot in different combinations of tide and light. Here, on a long evening in June, the sun is setting way to the northwest, giving perfect cross lighting. I'm using a 0.9 ND filter to slow down the exposure as much as possible, in conjunction with an aperture of f/45, a centre-weighted 0.3 ND to even the coverage of this wide format and ISO 50 film, which all cooks up an exposure of about 15 minutes. Additionally, I've got yet another filter on, a 0.9 ND graduate to hold back the exposure of the sky in relation to the water. This is my most used filter; it's employed on probably two-thirds of all my shots. The tide is going out, gradually exposing the causeway, leading the eye towards the mount. As I idle the time away while the shutter is open, I'm pondering all these factors: the depth of field, the exposure, the filtration, the colour temperature of the light and the composition, while weighing the overall impact of the image. The making of a photograph is a fusion of science and art.

• **Fuji GX617, 90mm lens**

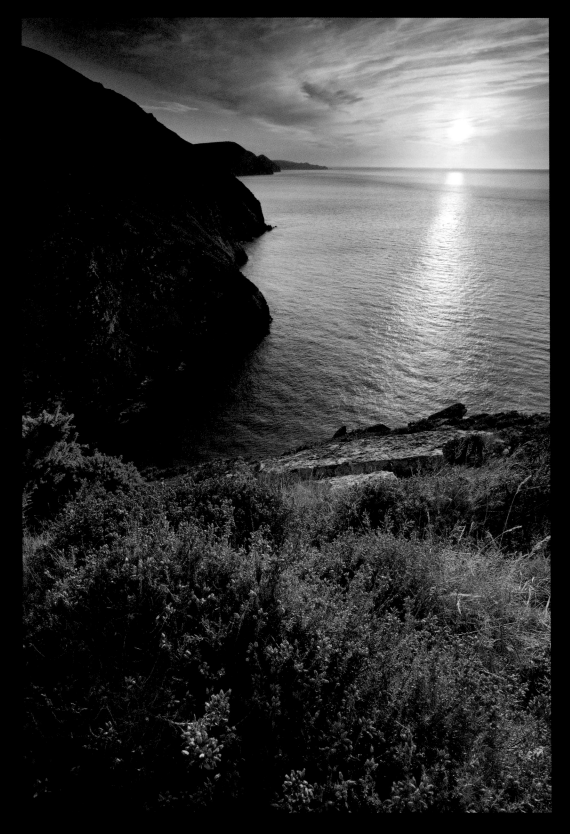

Coastal heath on the cliffs of Highveer Point above Heddon's Mouth, near Lynton, North Devon, England

In late summer on the North Devon coast the colours are incredible. Where Exmoor tumbles into the sea the coastal path is fringed with dense profusions of bell heather. I've timed my visit to coincide with this harvest of colour, but photographing a north-facing English coast in September is not easy. At this time of year, the sun rises exactly to the east, and sets bang on due west. So, on a north-facing coast at dawn and dusk I'm either going to be shooting straight into the light or have it coming from directly behind me, and during the day the sun will swing round to the south, casting the cliffs in shadow. It's hardly ideal. Purely in terms of the light the ideal time to photograph a north-facing coast is in late June, but the colours aren't at their best then. For a photographer it is vital to know exactly where the sun is going to rise and set and the effect of the seasons. So, here on the cliff tops in Devon the sun is dropping and I'm shooting straight into it. It's a scenario beset with problems: flare from the power of the sun boring straight into the lens and bouncing about between the elements, and the contrast between the light reflecting off the water and the detail in the cliffs. I wait until the sun is very low and starting to lose its punch, which solves the flare problem, but the contrast issue can only be resolved by shooting several exposures for the highlights, mid-tones and shadows and merging them later in the digital darkroom.
• Canon EOS–1Ds MKII, 17–40mm lens

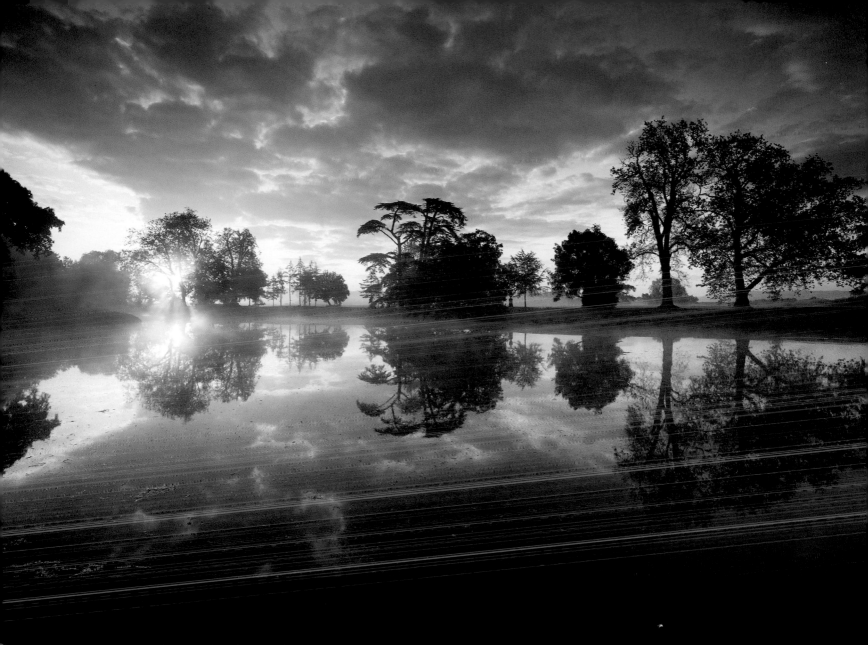

Croome Park, Worcestershire, England (David Noton/National Trust)

With perfect reflections, a dramatic sky and a trace of mist lying on the lake, conditions don't really get any better. The sun beams through the trees; at moments like this there are just too many options. If I were shooting film I'd be struggling to get it through the camera quickly enough, wasting precious time doing bracketed exposures and reloading just when the light's at its best. But I'm not, and shooting digitally in situations like this really pays off. I shoot one frame and quickly check the monitor. A blinking display alerts me to some loss of detail where the highlights are burning out around the sun, I re-adjust my exposure by -2/3 and shoot another, check highlights and histogram, it's in the can, or rather, on the card. Just two exposures. I can now move on to framing other images, making the most of this beautiful English scene at dawn.

Canon EOS-1Ds MKII, 17-40mm lens

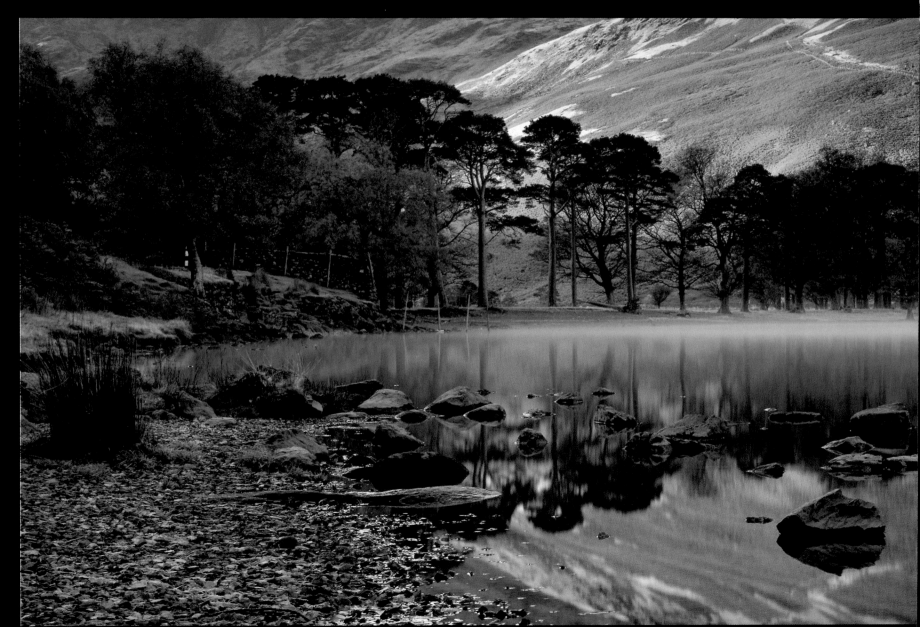

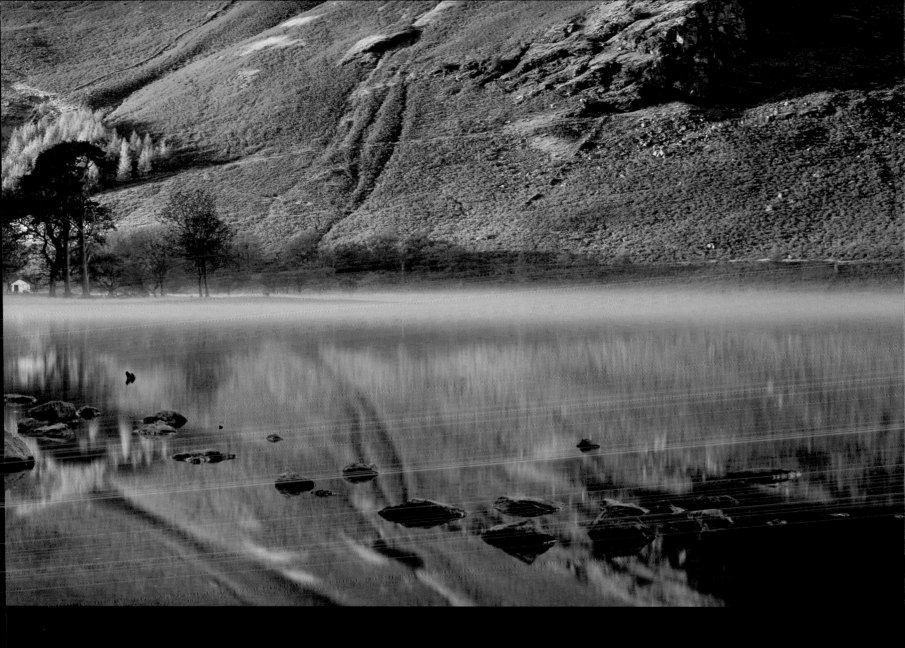

Buttermere, Lake District, Cumbria, England

It's one of those mornings when all my senses seem alive to the pleasures of autumn in the Lake District. The colours are at their prime, giving the landscape a russet golden tinge. The birdsong reverberates over the stillness of Buttermere. There's dampness in the air you can almost touch and the woods smell of autumn. This is familiar stomping ground for many photographers, for good reason. I've worked here many times (I first came here on a college field trip as a photography student back in 1983), but it's infinitely variable and I'll probably be coming back way past my sell-by date. Now the first light is slowly creeping down the fell, but it has got a way to go yet, so I'm standing by the tripod, kicking my heels, scanning the sky to the east, thinking of my next meal, waiting for the light. I think I've spent half my life in this mode.
• Fuji GX617, 180mm lens

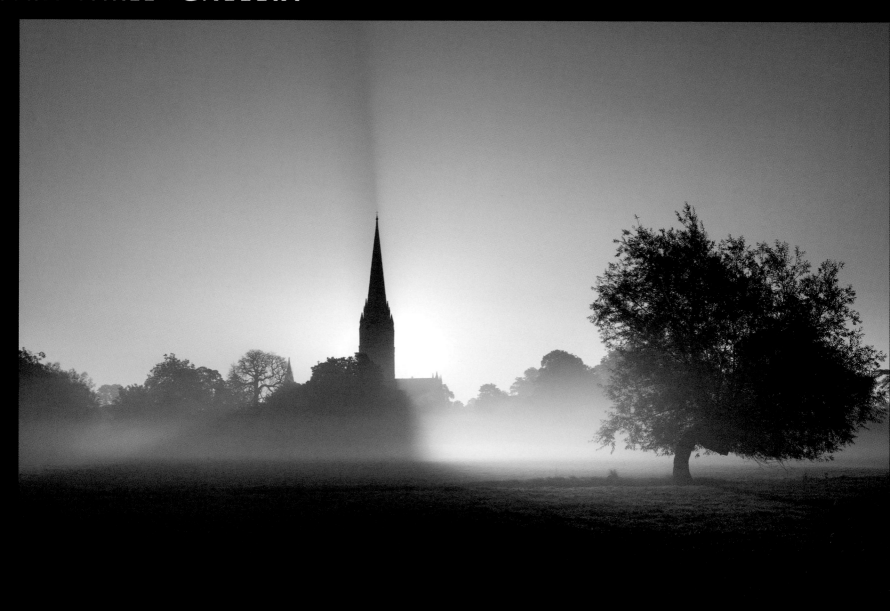

Salisbury Cathedral at dawn, Wiltshire, England (David Noton/Britainonview.com)

I waited all summer for these perfect conditions: the still, settled conditions of a high pressure
system laying mist over the water meadows around Salisbury Cathedral. Then over the course
of two subsequent dawns I turned out to do the job. On the first dawn I saw where the mist was
lying and made some reasonable images, but I left with a nagging thought that I hadn't quite
made the most of the situation. And so the following morning, a summer Sunday at 5am, I was
there again. Pre-visualization, persistence, and Being There ... it works.
• **Canon EOS 1Ds MkII, 16–35mm lens**

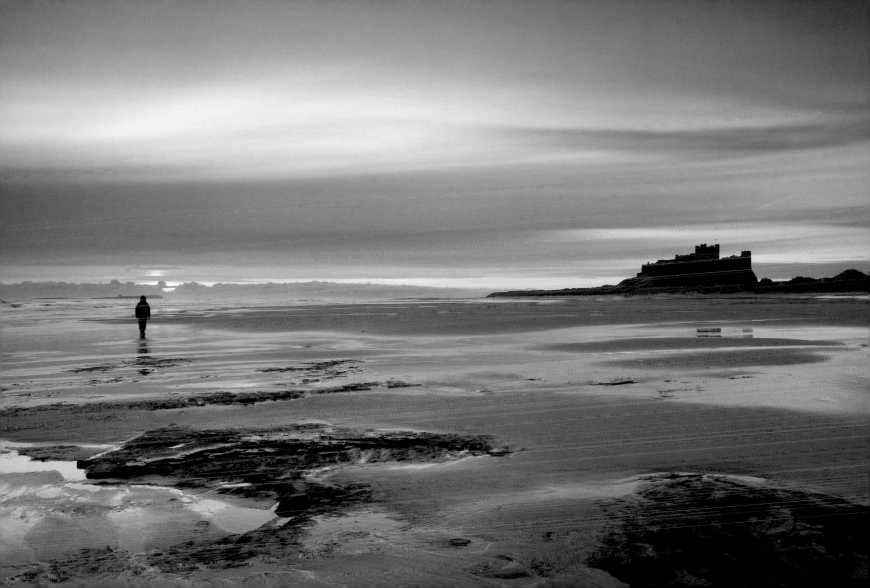

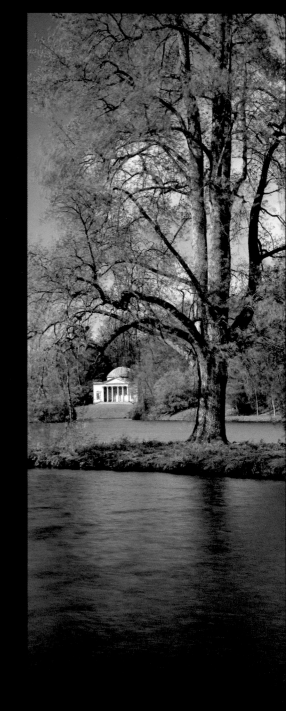

The four seasons, Stourhead, Wiltshire, England

The autumn image came first. Stourhead in the fall is glorious, and after a particularly good session here the four seasons idea came to me. Thereafter it became an exercise in persistence and planning. Finding a location that will work in the different light of all the seasons is difficult. I lost count of how many times I visited in the making of this set. Winter was the tough one; thankfully I was in the country for one of the few frosty spells we had. The direction of the light in the early morning for the autumn and winter shots was perfect, a low cross light from the southeast. Spring and summer were much more difficult: with the sun rising to the northeast I had to wait until much later, about mid-morning, before the sun had swung around to the southeast. To have shot earlier would have given me flat frontal lighting, which I hate, but this way the sun was much higher than I would normally prefer. In the end it was a compromise. Summer came last, and when I finally printed the set side by side I got a buzz of satisfaction: a year's work had come to fruition.

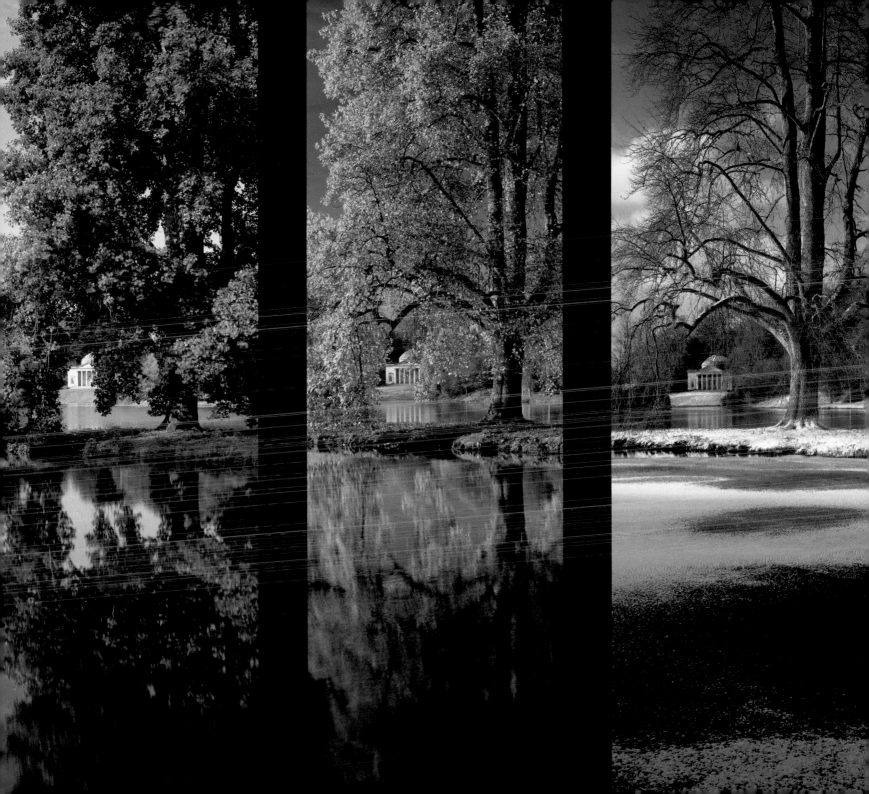

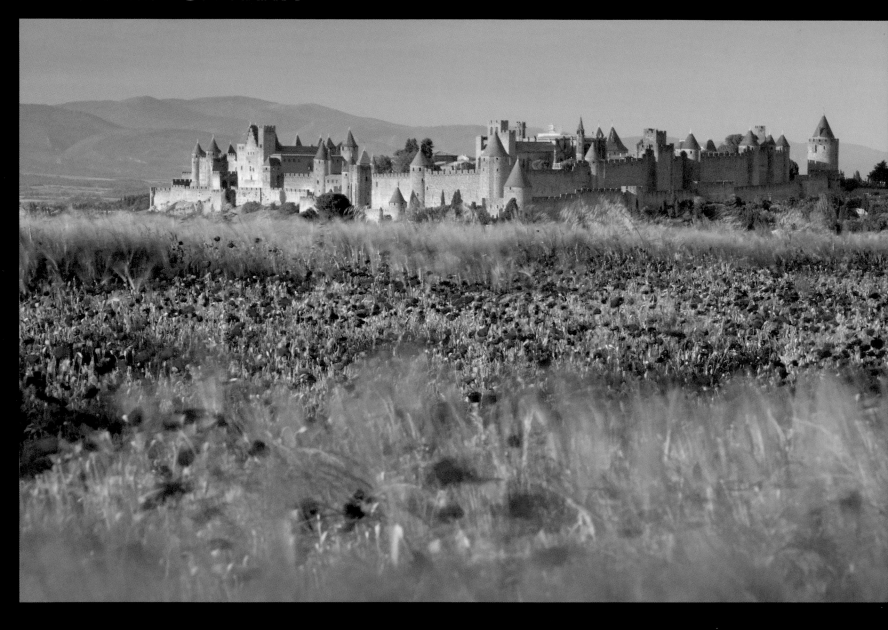

Poppies and barley blowing in the wind with la Cité Médiévale beyond, Carcassonne, Languedoc, France

Every time I check in for a flight the rules about what can be taken and how seem to have changed. It's a big problem for photographers. Obviously it's desirable to take it all as hand luggage, but that's just not possible when there are long lenses, laptops and panoramic systems to take. Not to mention all the equipment needed for living and camping in the wilds. I hate having to debate whether to take my 400mm or not, and if it's going to be a panoramic-type trip. With the change to digital I no longer have to travel with hundreds of rolls of film, but the number of chargers, cables and connectors I now need has mushroomed. Our annual timetable usually sees the winter months dominated by long-haul journeys to the tropics or southern hemisphere. In spring I often have a blitz on European cities. By May I've usually had my fill of airports and flight schedules. So when it's time for another roving trip through the lanes of France or Italy you can imagine what a treat it is to be able to load the car with what we need and just go. We've stayed in this region near Carcassonne for over a week. That's a bit longer than normal but there's so much potential around the Canal du Midi I'm loath to move on. I've got a good stock of locations scouted; some will have to wait until our next visit.

• Canon EOS–1Ds MKII, 70–200mm lens

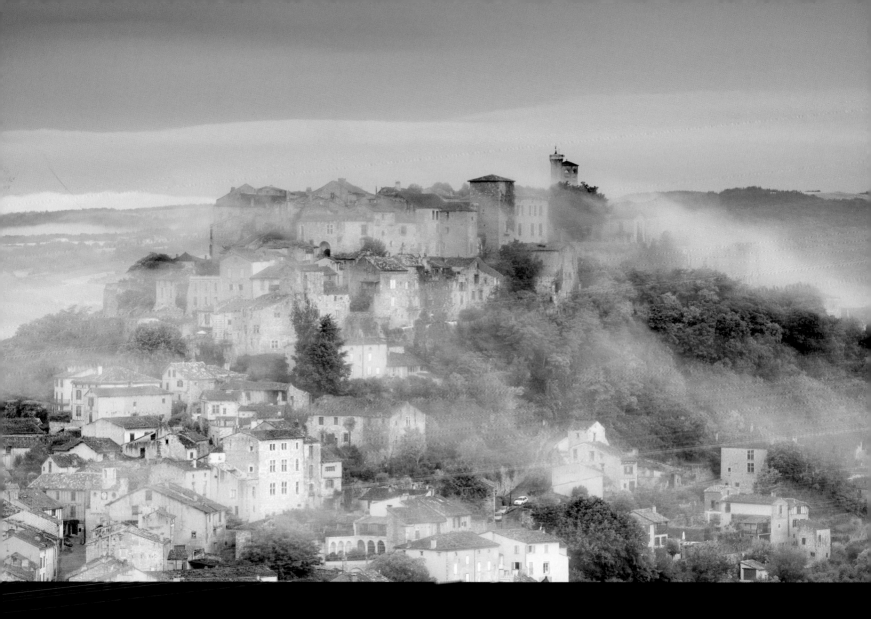

Cordes-sur-Ciel, Midi-Pyrénées, France

From the guidebooks, a friend's testimony and pictures I'd seen, the bastide town of Cordes-sur-Ciel seemed a promising location. So, after a half-day drive from the Pyrenees we're setting up camp just down the valley. After a couple of hours cycling around the periphery of the town I've sorted my morning location: an adjacent hill looking back at the quintessential French hilltop town. On my first morning there are clear skies apart from a rebel layer of cloud on the northeastern horizon, obstinately obscuring the rising sun. I hang around fruitlessly for a couple of hours, before heading for the boulangerie. The second dawn is clear, too clear. The light is low and directional, slightly hazy, and there's not a cloud in the sky. Somehow, it's just not coming together – there's no drama to the image. On the third morning it's mostly clear again, with scattered cloud – perfect – but by the time I'm in position I'm standing under leaden grey skies. It's another fruitless vigil before heading for the croissants. On the fourth morning there's broken cloud at 4am so here I go again. There's a layer of mist lying in the valley. As the rising sun struggles to make an appearance wafts of mist drape themselves over the town. This is the sort of thing I've been waiting for. The sunlight is desperately weak but it's enough; the mist makes the difference.

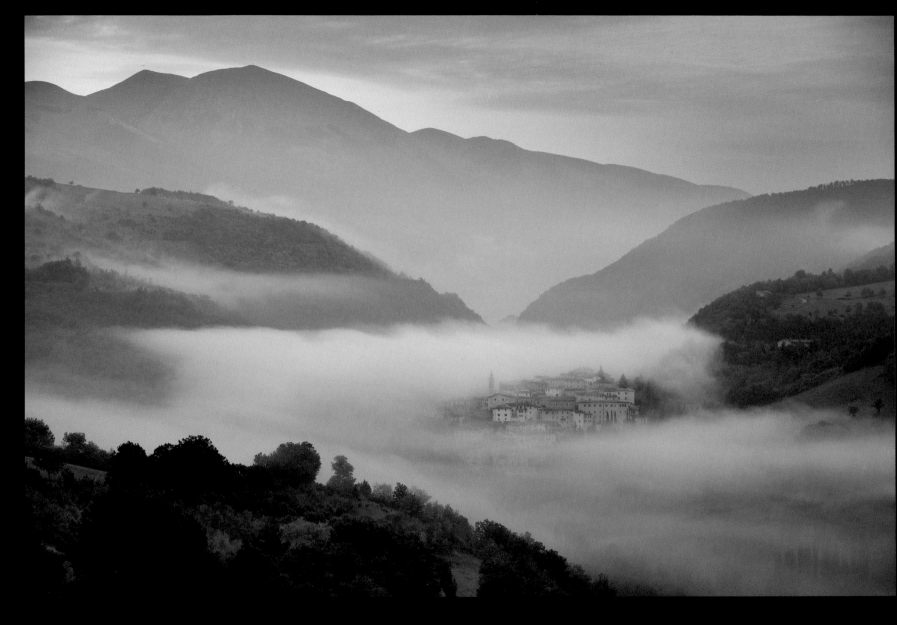

The village of Preci in the morning mist with Monti Sibillini National Park beyond, Umbria, Italy

It is a rare bonus when the view from the accommodation turns out to be a peach of a location, but so it was here on a farm in Umbria. The morning after our arrival I'm out at dawn, looking down the valley towards the mountains of Monti Sibillini with the village of Preci perched impossibly on the hillside. Except I can't see the village: the whole valley is shrouded in mist. It may or may not clear, but I'm set up with the digital SLR and framing the scene, just in case, as the subtle tones of dawn seep through the sky. Through a gap in the mist the village appears fleetingly, long enough for me to make a few exposures, before it disappears back into the mists. I check the image on the camera monitor: it looks OK, although very washed out, and it's a bit flat with a lack of contrast in the scene. I know though that low contrast is a problem I can do something about later – if all the information is there on the RAW file I can optimize it in post-production. Cheating? No way, I'm just making the most of what was there at the time. It's not as if I'm introducing any false elements; this is what I saw. Matching the tonal range of the subject to the photographic medium, be it film, paper or a digital image is what photographers have been doing since Fox Talbot's day.

• Canon EOS-1Ds MKII, 70–200mm lens

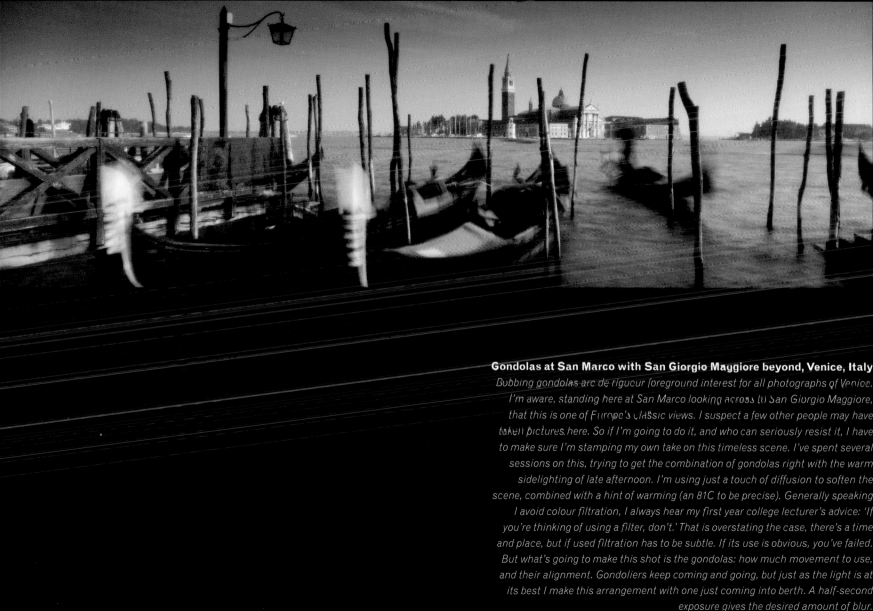

Gondolas at San Marco with San Giorgio Maggiore beyond, Venice, Italy

Bobbing gondolas are de rigueur foreground interest for all photographs of Venice.
I'm aware, standing here at San Marco looking across to San Giorgio Maggiore,
that this is one of Europe's classic views. I suspect a few other people may have
taken pictures here. So if I'm going to do it, and who can seriously resist it, I have
to make sure I'm stamping my own take on this timeless scene. I've spent several
sessions on this, trying to get the combination of gondolas right with the warm
sidelighting of late afternoon. I'm using just a touch of diffusion to soften the
scene, combined with a hint of warming (an 81C to be precise). Generally speaking
I avoid colour filtration, I always hear my first year college lecturer's advice: 'If
you're thinking of using a filter, don't.' That is overstating the case, there's a time
and place, but if used filtration has to be subtle. If its use is obvious, you've failed.
But what's going to make this shot is the gondolas: how much movement to use,
and their alignment. Gondoliers keep coming and going, but just as the light is at
its best I make this arrangement with one just coming into berth. A half-second
exposure gives the desired amount of blur.

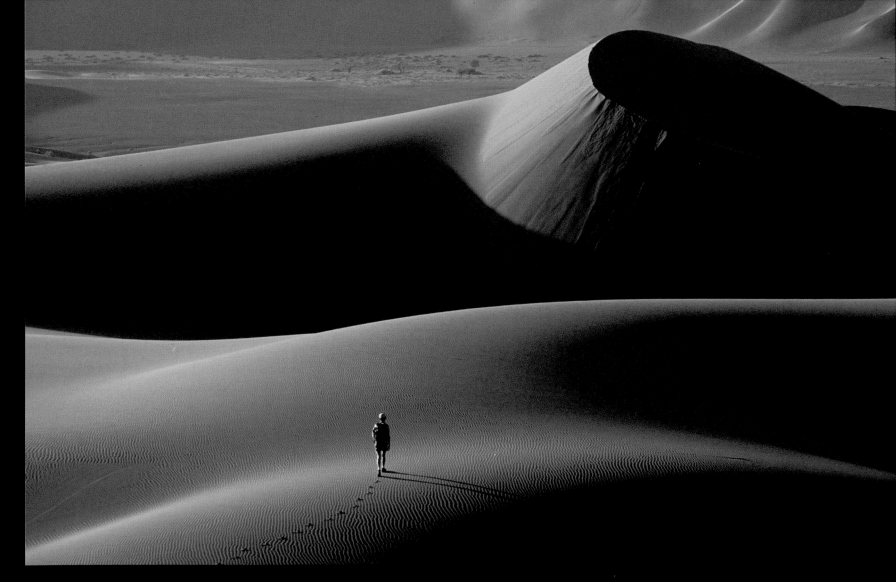

Lone figure on the dunes, Namib Desert, Namibia

Yes, it's my supermodel, Wendy, treading boldly again. In the early days I travelled mostly solo, it was the only option, but there was no way we could have carried on that way indefinitely. And so Wendy started coming on more and more trips. Now we make quite a team. Having someone to share the driving, help establish camps and carry kit, watch my back and crucially keep me sane makes a huge difference. Sharing the highs and lows makes travel a much more enjoyable venture. She can magic a meal out of nothing while camping in the snow in Patagonia, is a nurse by trade, and has evolved over a thousand uses for a sarong. Being a photographer's partner is not easy: there's the interminable waiting for the light on drafty hilltops when normal people are sitting down to dinner, and dealing with a monosyllabic photographer who's suicidal because he hasn't made a picture in five days. She thinks it's entirely reasonable that all her hand luggage allocation is taken up with photographic gear when flying. And, of course, she continues to be the lone figure in the landscape.

• Nikon F5, 80–200mm lens

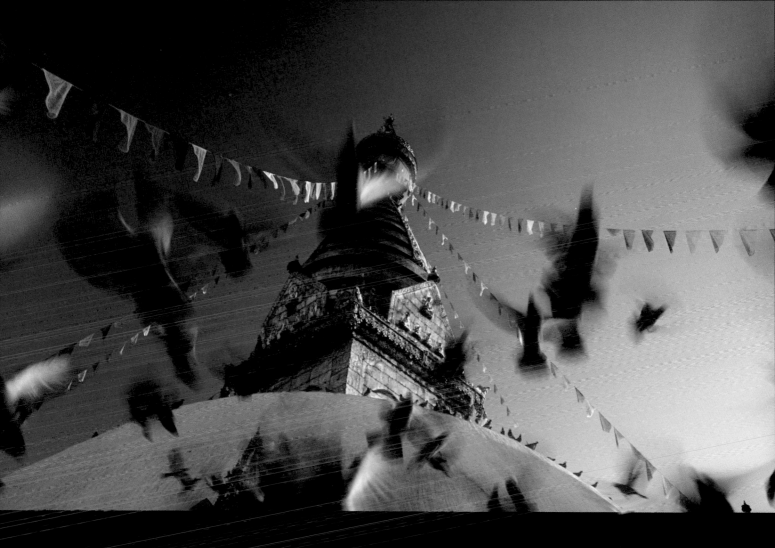

Swayambhunath Temple, Kathmandu, Nepal

The best shots always come from planning. I'd pre-visualized this image after our first visit in the heat of the day. Now it's just a case of spending a long hour craning upward, waiting for the pigeons to fly in the right spot on a late afternoon at Swayambhunath Temple. They're fluttering everywhere but where I want them. I keep stamping and clapping, trying to get them to simultaneously burst forth. There are monkeys scampering over the roof of the temple, eyeing me up suspiciously. I guess they've seen it all before. My neck and arms are feeling the strain of peering up through the camera. I think wistfully of my first SLR, a delightfully compact and light Olympus. Modern pro cameras have certainly put on weight: is that progress?

• Nikon F5, 17–35mm lens

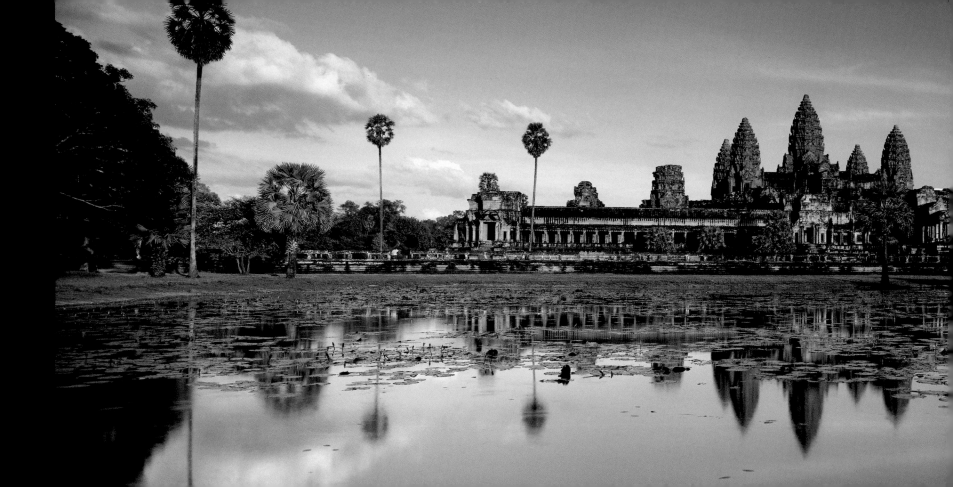

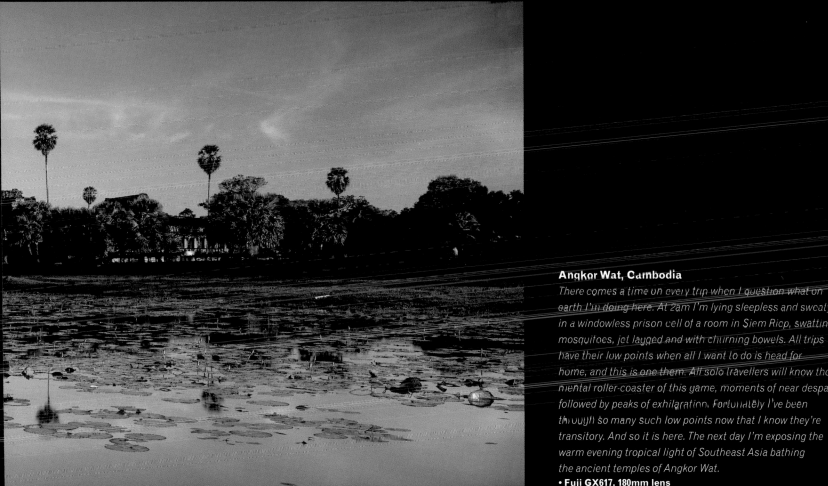

Angkor Wat, Cambodia

There comes a time on every trip when I question what on earth I'm doing here. At 2am I'm lying sleepless and sweaty in a windowless prison cell of a room in Siem Riep, swatting mosquitoes, jet lagged and with churning bowels. All trips have their low points when all I want to do is head for home, and this is one them. All solo travellers will know the mental roller-coaster of this game, moments of near despair followed by peaks of exhilaration. Fortunately I've been through so many such low points now that I know they're transitory. And so it is here. The next day I'm exposing the warm evening tropical light of Southeast Asia bathing the ancient temples of Angkor Wat.

• **Fuji GX617, 180mm lens**

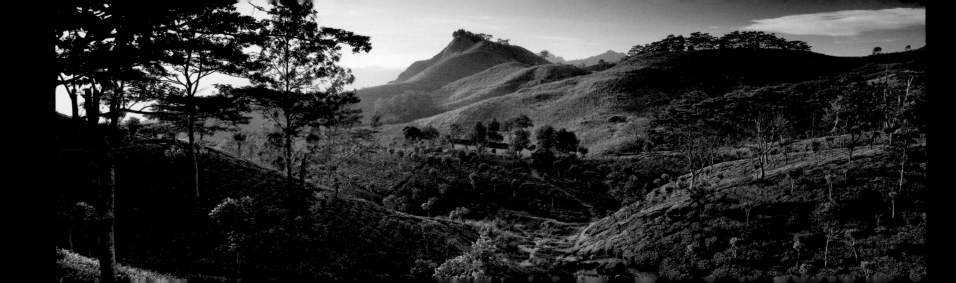

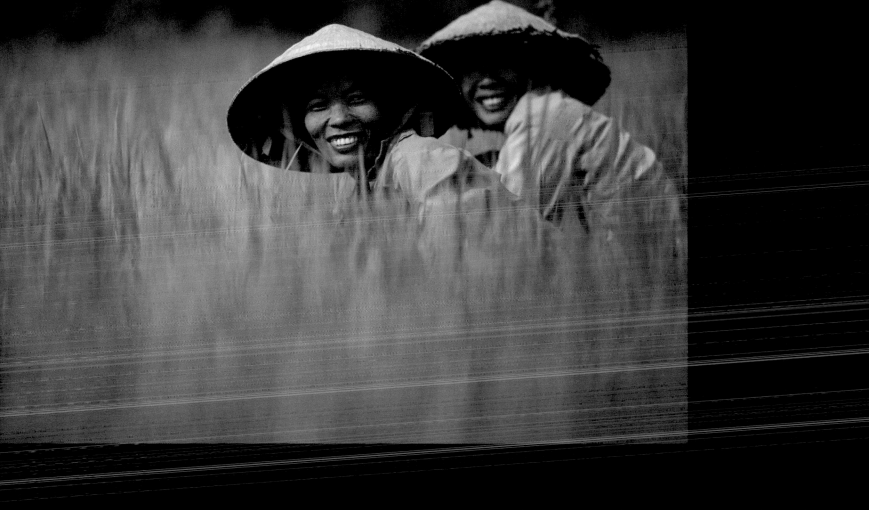

Women in a paddy field, Ben Tre Province, Mekong Delta, Vietnam

Vietnam. Just the name gives me a buzz. It's always been a must see destination for me, and I've not been disappointed. I'm in the Mekong Delta, about 60 miles south of Ho Chi Minh City (Saigon). It's a region of rice paddies bisected by a bewildering network of tributaries, flat as a pancake, and is pretty much untouched by the outside world. I'm in seventh heaven, and staying in the Communist Party hostel in Ben Tre, which has a slightly different atmosphere to a Best Western; pictures of Ho Chi Minh abound. I also have an entourage: my efforts to rent a car resulted in a driver and interpreter being thrown in. We're all crammed into a tiny Peugeot dating from the French colonial era. I just can't believe how green the rice paddies are. I shoot this image of women picking rice as my merry band sits in a farmer's hut sipping Mekong whisky (only marginally preferable to lighter fluid). I'm standing with the muddy water trickling over the tops of my boots clutching the camera and 70–200mm zoom, trying to coax the ladies to raise their heads. It's a strange way to earn a living.

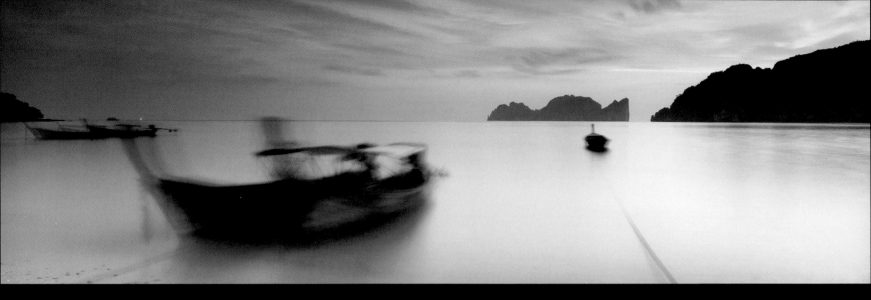

Kho Phi Phi, Thailand

I'm standing on the beach at 10.30am, the time the Big Wave struck,
wondering what I'd do in the circumstances. Where do you go? Rush
for high ground? There are some low hills about a mile inland, I guess
at full pelt I could get there in about 15 minutes. Would it have been
enough? I had to return here post-Tsunami. So many of my choicest
travel moments have come around the edge of this normally balmy
ocean, in countless beachside bars and bungalows in Sri Lanka,

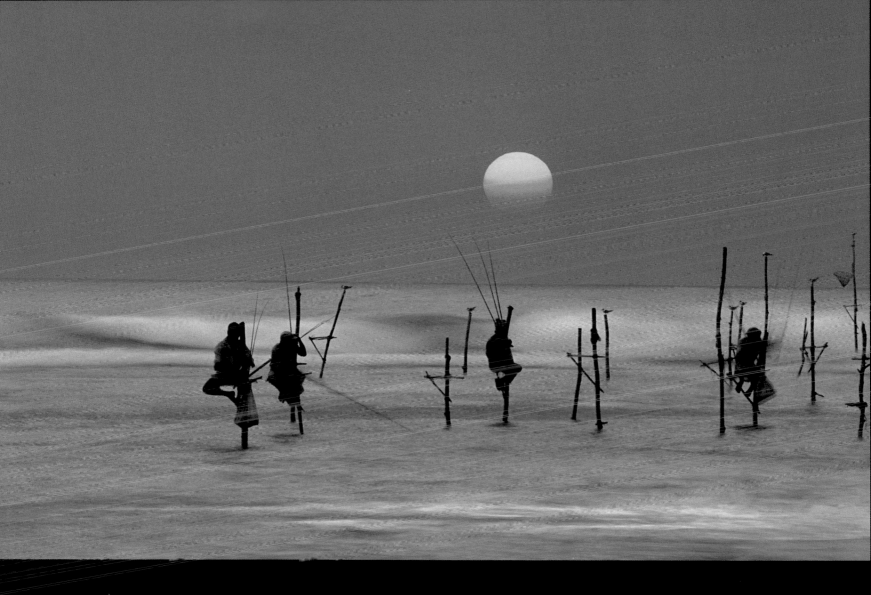

Stilt fisherman near Unawatuna, Sri Lanka

The tripod legs are slowly sinking into the soft sand. The surf is lapping around them – it's not the most stable of supports right now. I'm not sure this is going to work, but I have to give it a go. I need the tripod because I'm using a slow exposure to accentuate the movement of the surf breaking behind the fisherman. I've got the 300mm lens bolted on, which is a difficult lens to keep still at the best of times, let alone when the Indian Ocean is breaking around my knees. The sun is setting into the haze in a big fiery ball; it's Sri Lanka at its most intoxicating. This community was devastated by the Tsunami; I often wonder what happened to these fishermen.

• **Nikon F5, 300mm lens**

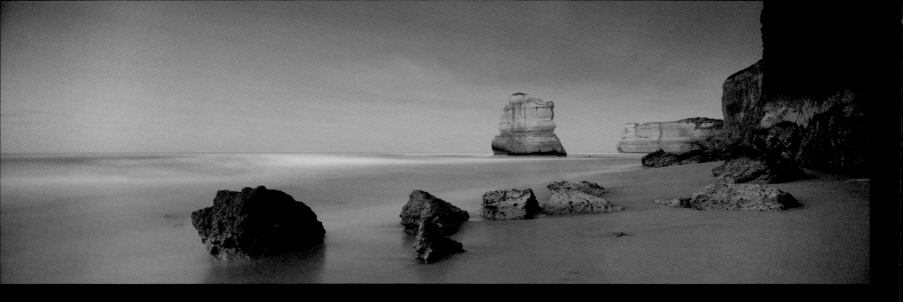

Eroded coastline of Port Campbell National Park, Great Ocean Road, Victoria, Australia

The Great Circle route between the Cape of Good Hope and Port Phillip takes you way down south, into the Roaring Forties and beyond. All the way a solitary albatross followed us, skimming the waves with apparently effortless ease. The first landfall in two weeks registered as a faint line on the radar, the coast of Victoria's Port Campbell National Park. It's a sight littered with shipwrecks from the days of sail, when trying to find the safety of Port Phillip was like trying to thread a needle in the dark. Now I'm gazing out to sea from that very coast, waiting for the dawn light. I used to spend hours watching that albatross from the poop deck, contemplating the moods of these angry seas. This morning it's more benign, there's a gentle swell lapping the beach and the light is gradually seeping through the sky giving a diffuse dash of twilight to the stacks and cliffs. It's a unique stretch of coast here, like none I've ever seen. I make my exposures in the light just before sunrise, shivering in the unaccustomed chill. It's mid-summer in Australia but here, now, you can sense Antarctica far over the southern horizon.

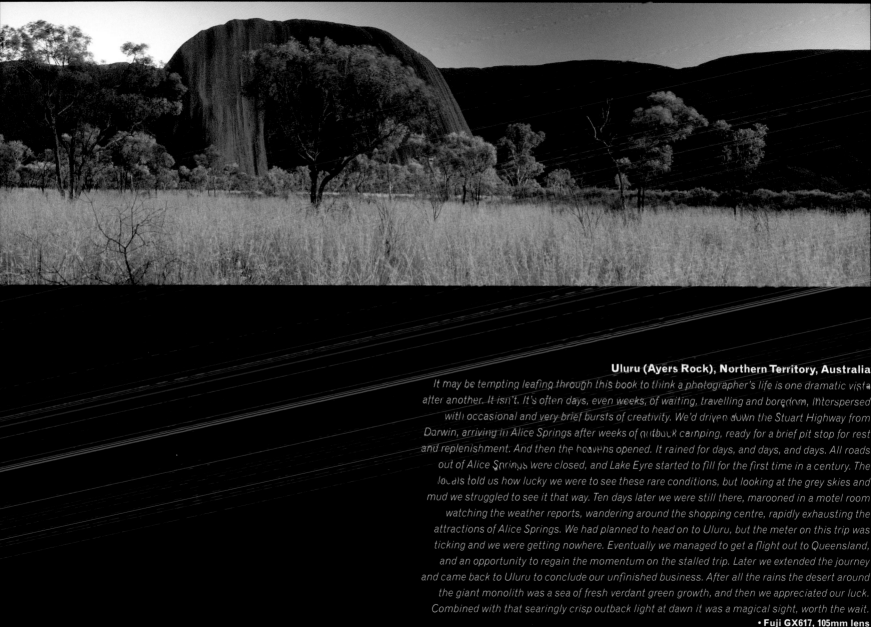

Uluru (Ayers Rock), Northern Territory, Australia

It may be tempting leafing through this book to think a photographer's life is one dramatic vista after another. It isn't. It's often days, even weeks, of waiting, travelling and boredom, interspersed with occasional and very brief bursts of creativity. We'd driven down the Stuart Highway from Darwin, arriving in Alice Springs after weeks of outback camping, ready for a brief pit stop for rest and replenishment. And then the heavens opened. It rained for days, and days, and days. All roads out of Alice Springs were closed, and Lake Eyre started to fill for the first time in a century. The locals told us how lucky we were to see these rare conditions, but looking at the grey skies and mud we struggled to see it that way. Ten days later we were still there, marooned in a motel room watching the weather reports, wandering around the shopping centre, rapidly exhausting the attractions of Alice Springs. We had planned to head on to Uluru, but the meter on this trip was ticking and we were getting nowhere. Eventually we managed to get a flight out to Queensland, and an opportunity to regain the momentum on the stalled trip. Later we extended the journey and came back to Uluru to conclude our unfinished business. After all the rains the desert around the giant monolith was a sea of fresh verdant green growth, and then we appreciated our luck. Combined with that searingly crisp outback light at dawn it was a magical sight, worth the wait.

• **Fuji GX617, 105mm lens**

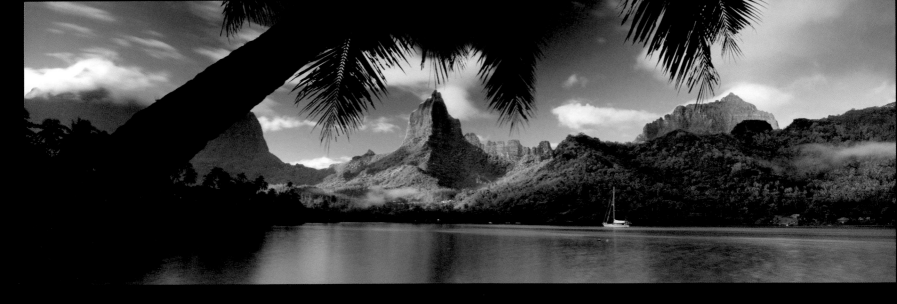

Oponohu Bay, Moorea, French Polynesia

A tropical paradise is a popular dream that's difficult to find in reality. I'm wading along the shoreline of Oponohu Bay in the first light of day, up to my hips in warm water, multi-coloured fish flitting around my knees. I'm not too keen on the idea of stumbling on the submerged rocks, as I've got the bag on my back and the tripod on my shoulder. I've got no choice though; this is the only way to get to my chosen spot, found after several days of scrambling through the dense growth and wading along this shore. Location searching has, as usual, been the key, I knew the shot I was after but finding it proved difficult. After several fruitless days on Moorea I was starting to get twitchy, here I was on an idyllic South Pacific island unable to make a decent picture. Self doubt started to creep in, maybe I'd lost it, or maybe I never had it in the first place ... Now though I'm happy, I know this is a good location, all I need is the light, which hopefully should be a bit more predictable than in Snowdonia at this time of year.

• Fuji GX617, 105mm lens

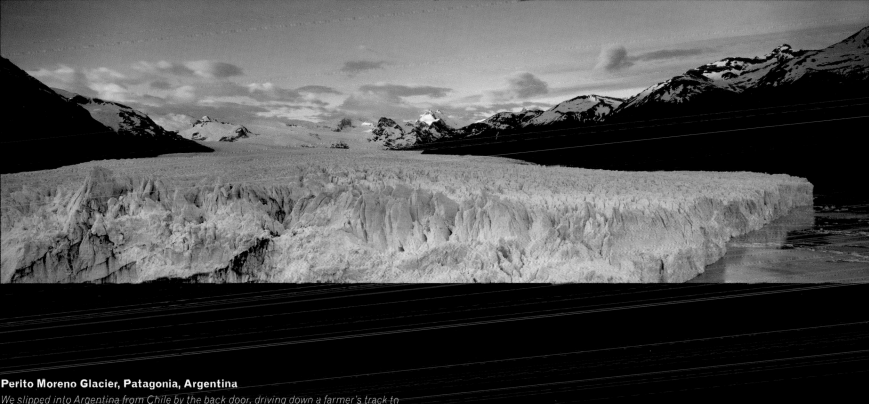

Perito Moreno Glacier, Patagonia, Argentina

We slipped into Argentina from Chile by the back door, driving down a farmer's track to a border post where a bored soldier unlocked the gate to let us in, not before stamping reams of paperwork. It must be said the driving here hasn't been a highlight; long, lurching journeys down dusty boulder-strewn roads, wondering if our rental sedan will make it as yet another rock gouges a piece out of the undercarriage. We arrived in El Calafate feeling like the marrow had been shaken out of our bones and our internal organs re-arranged. Next item on the agenda of our South American odyssey is Perito Moreno Glacier, a massive river of ice tumbling down from the Patagonian ice cap, the largest outside of the Polar Regions, and a truly jaw-dropping sight. Hopefully now this two-month adventure will start to develop some momentum. It's weird, sometimes on these long trips a week can go by without a camera being touched due to a combination of travelling days and indifferent weather. How can that be? I get decidedly twitchy until the next decent image is exposed. One of the toughest challenges on the road can be maintaining a positive attitude when things are not going well, particularly when travelling solo.

• Fuji GX617, 90mm lens

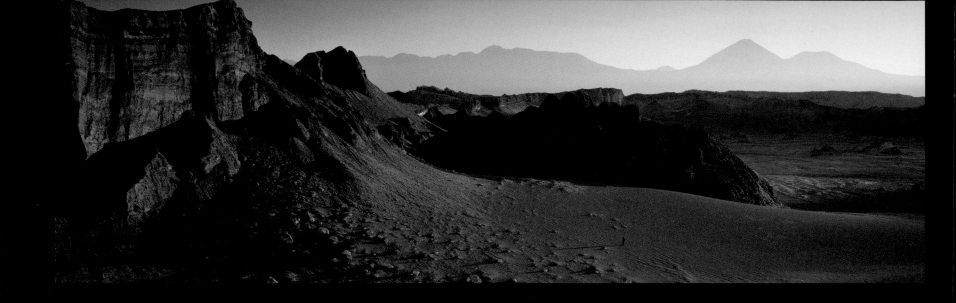

Solitary figure in the Valle de la Luna at dawn, Atacama Desert, Chile

The Atacama Desert is the driest place on earth – a rippling lunar landscape of rock and saltpans. It's dawn and Wendy is treading boldly up a rocky ridge, providing perspective again. I'm on a ledge above, looking down on her dwarfed by the harsh folds of the Atacama, stretching to the volcanic peaks of the Andes that dominate the horizon to the east. In the midday sun it's about as harsh a place as you can imagine, but in the soft light of dawn the elemental shapes

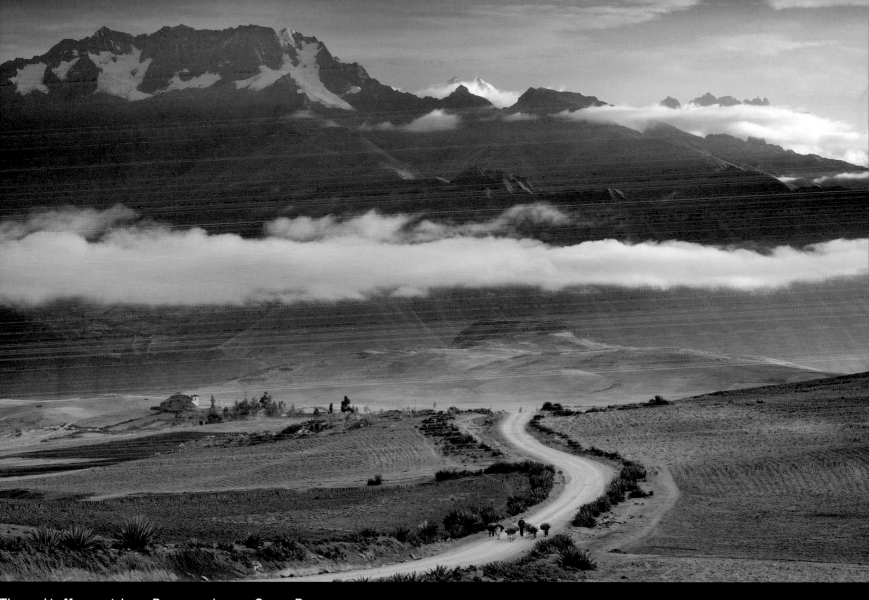

The road to Marras at dawn, Pampasmojo, near Cusco, Peru

The sun is slowly punching holes in clouds. Just as the light is beginning to lift the landscape in the foreground, a farmer drives his donkeys down the road, winding their way into frame with the Andes towering above. I use a 0.9 ND graduated filter to hold back the sky and with +0.3 exposure compensation dialled in I expose a few frames, revolve the camera and make a vertical composition. Is there such a thing as a lucky shot? Well, the donkeys appearing at the right time was a stroke of luck, no question. But I've been here on duty by the tripod in the perfect spot at the right time of day for two mornings now and that was no accident. As they say, you make your own luck. Photography is all about putting yourself in the sort of situations where you can make the most of Lady Luck when she does come along.

• **Canon EOS–1Ds MKII, 70–200mm lens**

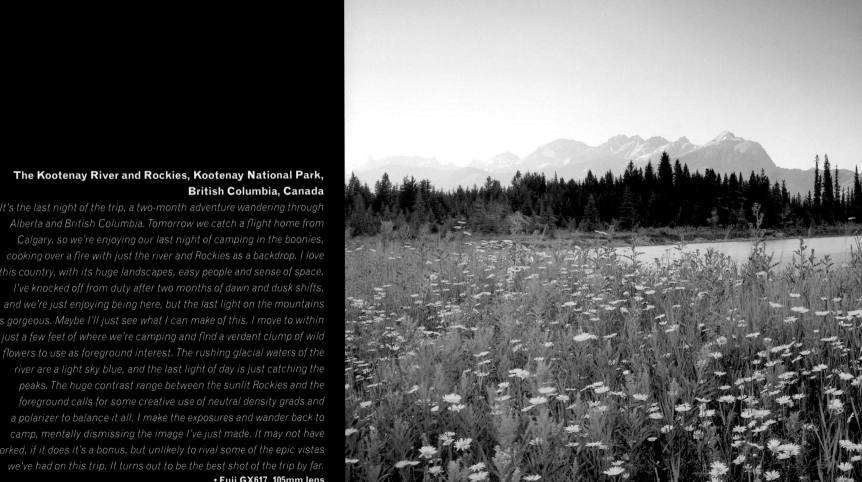

The Kootenay River and Rockies, Kootenay National Park, British Columbia, Canada

It's the last night of the trip, a two-month adventure wandering through Alberta and British Columbia. Tomorrow we catch a flight home from Calgary, so we're enjoying our last night of camping in the boonies, cooking over a fire with just the river and Rockies as a backdrop. I love this country, with its huge landscapes, easy people and sense of space. I've knocked off from duty after two months of dawn and dusk shifts, and we're just enjoying being here, but the last light on the mountains is gorgeous. Maybe I'll just see what I can make of this. I move to within just a few feet of where we're camping and find a verdant clump of wild flowers to use as foreground interest. The rushing glacial waters of the river are a light sky blue, and the last light of day is just catching the peaks. The huge contrast range between the sunlit Rockies and the foreground calls for some creative use of neutral density grads and a polarizer to balance it all. I make the exposures and wander back to camp, mentally dismissing the image I've just made. It may not have worked, if it does it's a bonus, but unlikely to rival some of the epic vistas we've had on this trip. It turns out to be the best shot of the trip by far.

• Fuji GX617, 105mm lens

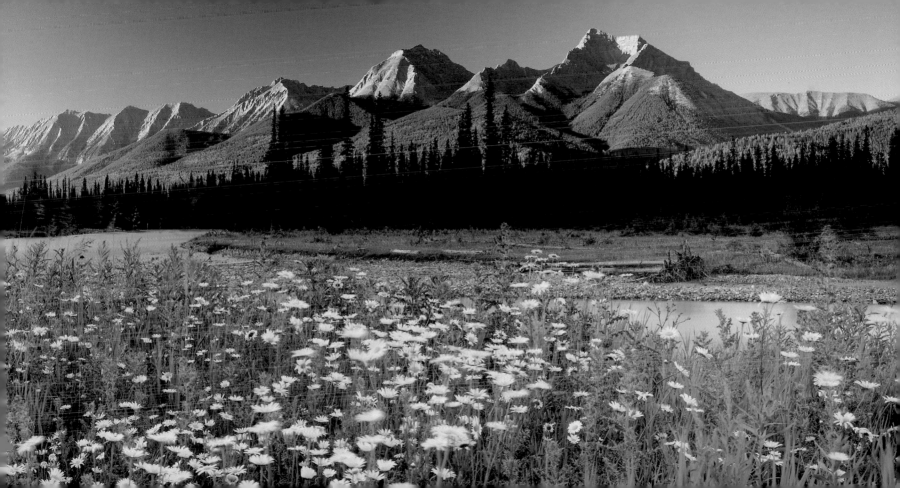

Part Four: Mechanics

And so to the nuts and bolts of the job: the hardware and software. The importance of photographic tools is usually overestimated; nevertheless how a photographer prepares and uses those implements is crucial. We are surrounded by so much techno-babble, especially in the world of photography, that it's often difficult to strip away all the technical distractions and irrelevancies to get to the nub of the task: creating strong images. Since Fox Talbot first exposed his calotypes of Lacock in the mid-19th century, the mechanics of the job have changed immeasurably, with the digital revolution of the last decade being the single biggest upheaval since his day. But the essentials remain the same: a lens, a sensitized surface and a means of development.

Corfe Castle at dawn, Dorset, England
• Fuji GX617, 105mm lens

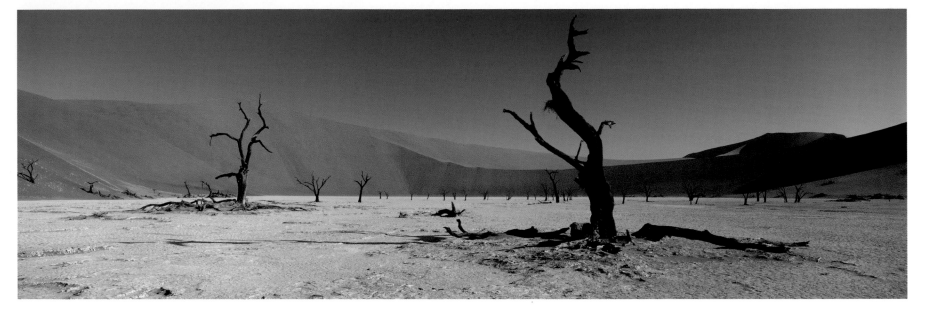

Deadvlei, Namib Desert, Namibia

It's a nightmare trying to fly with all the kit we need for a trip like this – all the photographic gear, the panoramic and 35mm systems, plus all the camping kit. Pulling together a desert expedition is a major logistical exercise, but when you're there, camping under the stars, plugging in the dawn patrols and making the images, there's nothing quite like it.
• Fuji GX617, 105mm lens

Preparation

'Don't think about it too much; just go,' is the best travel advice I've ever heard. Do I practise it? Well, sort of. It is possible to be too pedantic about researching and planning every aspect of a trip, as few plans survive their first contact with reality. But good research and planning can help you get the most out of a destination. Actually deciding where to go and for how long is the most difficult part. Reading between the lines of guidebooks and Internet sites to determine the photographic potential of a specific region is a black art, and a bit hit and miss. Pictures can help but they can also mislead. Before embarking on a recent trip to New Zealand I was researching the Hokianga region out of interest. I could find little on it and virtually no pictures on any of the major photo-agency websites. That could have meant it was a region of little interest, or the opposite but so off the

beaten track that few photographers have ever been there, in which case it would definitely warrant a visit. In the event we went, and it was moody, wild and dramatic. Conversely, I have visited many areas with glowing reports in guidebooks only to wonder what all the fuss is about. So, the key is to have a plan but build in sufficient flexibility to enable decisions about how long to stay to be made on the hoof. Ideas come as I move through a country talking to the locals and other travellers; consequently I try to avoid booking more than a few days ahead unless it's absolutely necessary. Time is the currency we're all short of and it's tough to decide how much to allocate for each phase of a journey. As a remarkably faithful rule of thumb I have a three-day rule; I never stay for less. That's because it takes time to find locations that aren't obvious, to get under the skin of a place and make

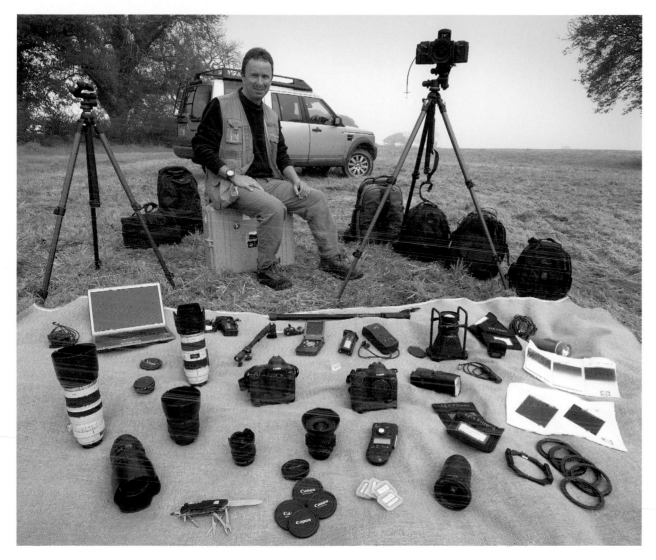

The Complete Arsenal
Of course I would never carry all of this on my back at the same time, but on a long trip with no airport restrictions this is the kit I take. We left out the kitchen sink, and I never return with as many lens caps as I left with.

the most of its photographic potential. If you're moving on every day you're travelling far but seeing little, never getting beyond a surface view. I find the days in transit are rarely productive photographically, so I often stay for more – five days, a week, sometimes more. Be wary of first impressions – after a long, tiring journey they can be very deceptive. Many a time I've been on the point of skipping a stop based on a fleeting judgement, only to wonder five days later how I could have been so wrong.

Practical considerations

Beyond those fundamental choices of where and when, the modes of travel, accommodation and what to take will vary considerably depending on the type of trip. The reason we appreciate our annual European wanderings so

much is the simplicity of them: we just load up and go. We've got a rough plan but nothing is fixed. But where flights and car rental are concerned that's obviously not practical. In fact, dealing with the hassles and restrictions of air travel is the major bugbear of my job. Planning a trip to the Namib Desert was a major logistical exercise. I can't remember how we used to do it before the Internet.

And one final top travel tip: never read the warnings about the dangers of various destinations in the front of travel guides, they'll put you off going anywhere. Bears in Canada, spiders in Australia, thieves in Peru, malaria in Malawi, Maoists in Nepal, time-share touts in Spain, all of the risks are overstated. There's nothing like a bit of local knowledge to sort the grain from the chaff. Just go.

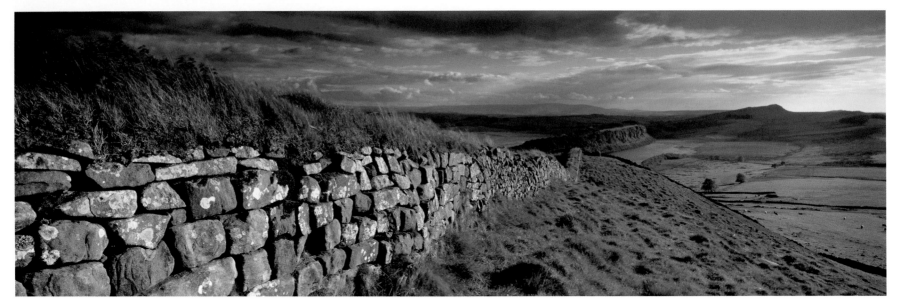

Hadrian's Wall, Northumberland, England

Nothing beats a big panoramic. As yet, there's no digital alternative. Image stitching? Fine if nothing is moving in the frame where the joins are made. Trouble is, something usually is, especially along Hadrian's Wall; clouds, cows, Centurions, Picts …
• **Fuji GX617, 90mm lens**

Equipment

The importance of the equipment in photography is usually overestimated. Many people are more interested in the gear and technology than the actual images. To listen to some it's as if the camera made the image, and the photographer merely leant support. Let's just get a few things straight. A camera is but a tool, useless in the wrong hands. Give an experienced photographer the cheapest compact and a novice a top-of-the-range model and who will make the better pictures? A photograph stands on its own; its worth depends solely on the impression it makes on the viewer. The camera or lens that was used to create it is irrelevant. A photograph is made not by a camera but with a photographer's vision and craftsmanship. Nevertheless the tools are important.

My cameras

I've used and owned many cameras of all formats over the years. I was wedded initially in the early 1980s to the Olympus OM system, which was delightfully compact with great lenses. When Olympus abandoned the professional market I switched to Nikon. For nine years my two Nikon F5s circled the world with me, never missing a beat. The F5 is in my view the best 35mm SLR film camera ever made and many of the images in this book were shot using one. A battered F5 body now sits on my desk as a memento alongside an OM1 from my student days. I think it highly unlikely I'll ever use the same camera for nine years again.

A choice of formats

I've owned various medium-format systems – a Hassleblad was my workhorse for years of commercial work – but I never really gelled with the square format. All photographers are different, and there's no right and wrong here; we use the systems that best suit our approaches. For me that's been a combination of the 6x17cm panoramic format and 35mm. I find the two offset each other well. The panoramic format delivers incredible quality and allows a unique view on the world, particularly for landscape work. With 90mm and 180mm lenses, it's a rugged, simple

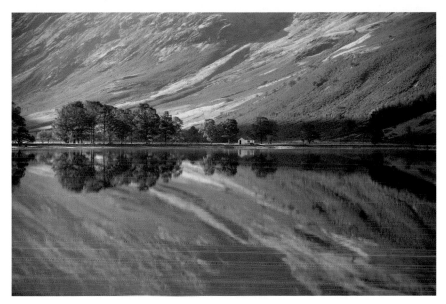

Buttermere, Cumbria, Lake District, England
Perfect reflections on Buttermere, shot with the Canon EOS-1Ds MKII with a
70–200mm f2.8 lens with Image Stabilization. In the early days I used to lust
after optics such as this lens in the mistaken belief that their possession would
improve my photography. It doesn't. No equipment does.
• Canon EOS-1Ds MKII, 70–200mm lens

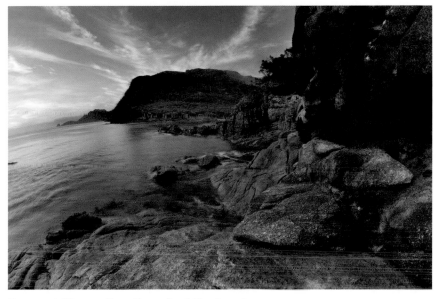

Dawn at Sleepy Bay, Freycinet Peninsula,
Freycinet National Park, Tasmania
The beauty of working on 35mm, and now with a full-frame DSLR, is the option of
using lenses of extreme focal length. Here in Tasmania, a 15mm fisheye gives a
180-degree view of Sleepy Bay, without getting the tripod legs in shot.
• Canon EOS-1Ds MKII, 15mm fisheye lens

and relatively portable system, but not exactly compact. And 35mm has provided the flexibility and spontaneity, with the ultimate choice of lenses. The 5x4in large format is not for me; it delivers impressive quality but at the price of flexibility, but I respect my photo-mates who make this format work for them. A photographer's choice of format will be inextricably linked with their vision and way of working, and, ultimately, it's the pictures that matter.

The digital switch-over

Now it's all change with the switch to digital capture. I still use the big panoramic film camera, as there's no digital alternative for that yet, but the 35mm Nikons have been replaced with digital Canons. I defected from Nikon to Canon because of the fundamentally important issue of sensor size and now I've got an extensive system built around two Canon EOS-1Ds MKII bodies with lenses ranging from the 15mm fisheye to 400mm.

The set-up back in the digital darkroom is just as important. Time was when I thought we were high-tech with just a fax machine; now we've an office stuffed with computers, monitors, scanners, printers … and a kettle. A lot of people get worked up about the Mac v PC debate; personally I don't believe it makes much difference. We use PCs, three of them plus a laptop, with loads of RAM for handling large images. What are of crucial importance are the monitors – you have to be able to trust what you're looking at, so they have to be colour calibrated. My advice is to ignore the techno-babble, and just go for the best monitor you can afford with a dedicated colour calibration system. All our PCs are networked and each has two monitors, one LaCie for the critical colour work and a smaller one for the tools tablets when working in Photoshop. Also in constant use is our Imacon 646 for scanning big transparencies. And being able to produce professional art prints now with the Epson 2100 is such a rewarding kick. Somewhat less exciting is the constant necessity of backing up images, both RAW and processed. For that we use a combination of dedicated hard drives and two DVD libraries, one stored remotely. Other vital bits? Well, a graphics tablet is handy … as is a packet of ginger biscuits.

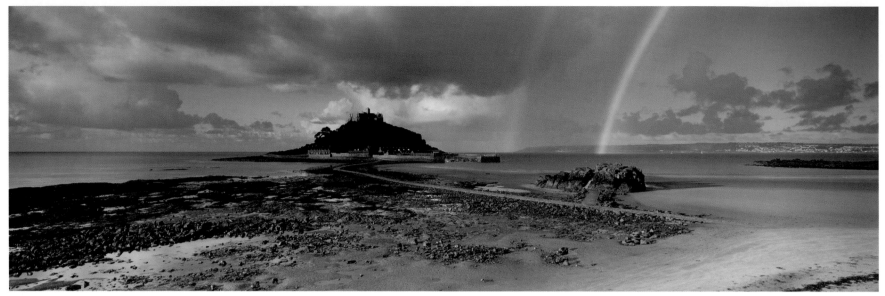

**Rainbow over St Michael's Mount, Cornwall, England
(David Noton/National Trust)**
*The panoramic camera is low tech and basic, the complete opposite of
the state of the art Canon.*
• **Fuji GX617, 90mm lens**

Digital v Film

In March 2005, I had a mid-life crisis. I terminated a long-term relationship with my Nikons, switched to digital, and ran off with a younger camera system. Like all such momentous changes it was traumatic and expensive, but it had to be done. Now, several years later I'm ruminating over the changes, weighing up the pros and cons. What do I love about my new life? Freedom, flexibility, quality. What do I hate? The fact that I now feel wedded to a computer. Still, in all honesty, I've got no regrets – the timing was right.

The big debate

I'm looking back at a magazine article I wrote five years ago, when the debate between film and digital was in full flow. The digital revolution was perhaps the biggest seismic shift in photography since the evolution of the negative. Pixels were replacing the light-sensitive emulsion, and photographers were wondering if and when to make the change, and how it would affect them. Back then I decided to stick with film over issues such as power, quality, and compatibility with my existing system. If it works, don't fix it was my ethos. But things moved on quickly and just a year later

I couldn't ignore the fact that the latest generation of digital SLRs were producing images of superior quality to my 35mm film cameras. A jump in available quality was enticing, not to mention all the other advantages of working digitally. There was, though, a big problem for me and many other Nikon users delaying my decision: sensor size. Nikon's DSLRs use a half-frame sensor, suitable for press work maybe, but not my game. For a full-frame sensor I'd have to switch to Canon and change my entire system. This was a painful decision to make, but the writing was on the wall.

Now the debate has moved on, shooting digitally is the norm and most photographers have a foot at least partially in the pixel camp. I have to admit I'm a convert. The digital revolution has rung the death knell for 35mm film; the quality and versatility available from most DSLRs is far superior. As for medium format it's a tougher call. I've done comparisons between my Canon and a Mamiya RZ67 and not only is the DSLR way more flexible and portable, it delivers superior image quality. Surprised? So was I, but the EOS-1Ds MKII produces a crisper image. The ability to vary the ISO setting to suit the conditions is so useful, not to mention a digital camera's

Mrs Wendy Noton on location in the Atacama Desert, Chile

Marlna, a Quechua shepherd girl, Peru

Outback driving off the beaten track in the Flinders Ranges, South Australia

"The digital revolution has rung the death knell for 35mm film; the quality and versatility available from most DSLRs is far superior"

flexibility when dealing with mixed lighting. Before the change, among a throng of swirling dancers in a village hall on the Tibetan plateau, Wendy was making images with her digital compact that I couldn't – that said it all.

A personal choice

Still, many will disagree with me, and let's never lose sight of the fact that it's the pictures that matter. Ultimately in this big debate intangibles creep in. A photographer friend of mine insists he prefers the feel of film, he doesn't like 'metallic' digital images, and another questions their evenness of tone. These are issues that are impossible to quantify. Ask ten different photographers their feelings about a particular film and you'll get ten different opinions. I know what I think though: that's all nonsense. Using those two crucial tools wisely, the Curves and Levels controls at the RAW conversion and Photoshop stages, I have far, far more control over all aspects of my images than I ever have done. Each to their own, but I think the flexibility offered by a DSLR system is a priceless asset that translates into better pictures.

Maintaining discipline

Conversely, shooting digitally can foster a looser approach, a more laissez-faire attitude; blast away and sort it out later, if you shoot enough one is bound to work. In fact, I think to get the best from my DSLR I need to be even more meticulous behind the camera, but undoubtedly the flexibility of digital capture allows me to explore more options, to extract more from any photographic opportunity. To avoid that condemning me to endless computer hours I have to hone in on the best. I'd rather produce one great picture than 50 average ones. So, and here's the rub, the great challenge of the switch to digital has been firstly ensuring a tight, disciplined approach to shooting while making the most of the possibilities opened up by the flexibility of the kit, and secondly learning a whole new way of editing to avoid spending the rest of my life in Photoshop.

And large format? Well you can't beat a big piece of film, which is why I still use my 617 panoramic monster. That will change eventually when digital alternatives evolve, but for now I think I've got the best of both worlds, and I'm revelling in it.

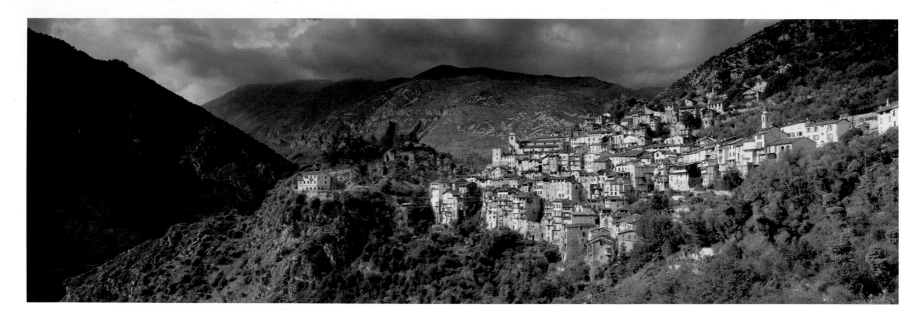

Accessories

Tripods

You can spot serious photographers by their tripods. It is the most important piece kit you'll purchase. Perhaps news, sports and fashion photographers wouldn't agree with me, but for the kind of images in this book, steady legs for your camera are crucial. I'm always amazed to see someone who has spent a fortune on a camera and lenses using a cheap plastic tripod that wouldn't keep a mobile phone camera steady in a gentle breeze. A tripod is not as tantalizing a possession as a camera, but it's a false economy to skimp on one.

As with all gear, compromises have to be made – rigidity versus portability, it's a tough choice. All kit has to be portable to be practical, but a tripod also has to be able to support long lenses, extend up to head height and enable you to get down low. I now use a carbon-fibre tripod, which is significantly lighter than alloy legs without sacrificing rigidity. The actual weight of the tripod does contribute to its stability, but this can be aided by hanging your camera bag from the undercarriage. The head is important too; all photographers have their own tastes on these. Ball heads are popular but I can't stand them – I prefer a geared head for precise framing adjustments.

Camera bags

When I first started in this game dinosaurs roamed the planet, leg warmers were in, and the options for carrying photo gear over the hills and far away were limited. You could use a shoulder bag guaranteed to induce numerous visits to the osteopath and that was it. I used to wrap my lenses in sweatshirts and stuff them in rucksacks. Now there is a multitude of options, with photographic rucksacks devised for every imaginable combination. I've got about five; in fact, I've lost count. One big sack the size of a coffin for when I'm carrying virtually everything, the pano and DSLR systems. One for when I'm just working with the DSLR. One for when I need to fly with a laptop. One small one for lightweight forays into crowded markets, and one for carrying camera kit and lunch, waterproofs etc. for day-long hikes. I think they're fantastic, with one proviso, to get to your camera you have to put them down in the mud, dust and grot. But I can't imagine life without them.

Trying to keep the flies off, the Outback, Australia

Mid-exposure in the rainforest, Costa Rica

Winter backpacking in the Cairngorms, Scotland

Filters

The importance of filters can't be overstated. The need for colour filtration when shooting digitally is obviated, but I would never be without a set of Lee neutral density graduates for holding back the exposure on the sky, a polarizer for saturating the colours in vegetation and deepening the blue in skies, and a neutral density for slowing down exposures to optimize the motion in an image.

Miscellaneous items

In the depths of my bags all sorts of stuff lingers. The usual essentials: remote release, spare batteries, filter holder and rings, a spot meter, a hot-shoe mounted spirit level, an extension ring and memory cards. And other stuff: toilet paper and matches, a Swiss Army knife, shades for peering into the sun, and sometimes a book for those endless vigils. On my wrist I have a solar-powered watch with a compass. Whenever I can take it, the mountain bike is so useful for location searches and collecting the baguettes. And on the roof of my Land Rover I have a photographic platform, big enough to get a tripod up there above the level of the hedgerows and look down on the world. Boys and their toys? Yeah, I'll admit that one. But I can vouch for the practicality of all of them.

"All kit has to be portable
to be practical"

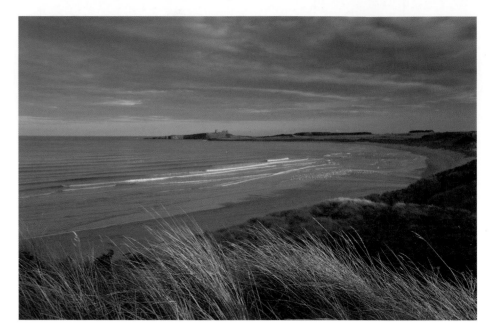

**Dunstanburgh Castle and Embleton Beach at dusk,
Northumbria, England**

*I try and get as perfect a shot in-camera as possible. I'm not one for
complex manipulations anyway – the best shots are the simplest
and you can't improve on nature. Here I gave a slightly warmer tone
to the reeds in the foreground in post-production. I'll often tweak
the contrast or brightness of selected parts of the image such as the
sky. Upping the contrast can have the appearance of accentuating
the colours, but it is so easy to go over the top. Subtlety is the key.*
• **Canon EOS-1Ds MKII, 17–40mm lens**

Post-Production

Sometimes in our office I sit back and reflect. The three of us are here, tapping and clicking away in front of our monitors, dust busting, tweaking Curves, attaching metadata, converting RAW files, copying, scanning, updating the database, backing up etc. etc. etc. … it's endless. Wendy and Sharyn, our office manager, are beavering away; I haven't a clue what they're doing, is it anything to do with me? The office is stuffed full of computers, monitors, printers and scanners: how did this happen? Just 12 years ago I had a typewriter, a light box, a filing cabinet and a fax machine, and that was about it. The trannies would come back from the lab, they'd be edited, mounted, captioned and submitted – a deliciously simple workflow. Granted, sending off precious originals was always a leap of faith; thankfully that's not an issue any more. But what is an issue is the sheer amount of time that needs to be spent in post-production. Shooting digitally it's easy to expose a lot of pixels, all of which need sorting. I still think the editing process was much better with just a sheet of trannies on a light box, but that's tough, I've just got to deal with it.

From a shoot of say 200 images I'll go through and weed out the obvious also-rans, bringing it down to maybe 40 images. Where a shot obviously has worked there will most likely be multiple variations of it, and picking the best isn't always straightforward – often it's necessary to process several of the options to choose the best. It's easy here to get sidetracked into spending a lot of time on a shot that doesn't warrant it; there comes a time when I have to say no, and hit the delete button. The flip side of the coin is that sometimes an image that looked lacklustre straight out of the camera can sparkle with just a few basic adjustments at the RAW conversion stage. In a nutshell a fine balancing act is needed to avoid wasting time on the dross without missing out on the jewels. I'm still learning with this, but hopefully getting better and quicker at homing in on the winners.

I groan in exasperation at one popular misconception – the notion that shooting digitally means less work. If only. In fact the digital workflow has meant the photographer's workload in post-production has mushroomed. For me, this is the huge downside of the digital revolution. Clients, publishers, agencies and printers all now expect to be supplied with a digital image ready to go to print, website or repro. It would be nice if the image that came off the memory card was the finished article but it isn't. Even if it were it would still need to be copied, backed up, stored in a database, submitted and tracked in its journeys. But before that it needs to pass through the digital darkroom.

Backing up images on a campsite in Languedoc, France

Exposing RAW files

When I expose a digital image the picture is just a bunch of information still in the camera as a RAW file. I think of it as a sort of digital negative, a means of recording an image that needs processing before it's of use to anyone. If you're serious about your photography then shooting RAW is the only way to go – forget about TIFFs and JPEGs. If you aren't shooting RAW you're letting your camera's software make important decisions about your images that it has no business doing, and you're throwing away information in the process. When I expose a digital image I am trying to maximize the amount of information recorded, in particular the range of tones and colours. I don't want highlights burning out but I do want as much detail in the shadows as possible, and a RAW file has huge exposure latitude compared with transparency film. That has two big implications for the way I expose in the field. Firstly, bracketing exposures is a thing of the past, which saves much time and allows me to get on with making the most of the situation. Secondly, I'm trying to give the maximum exposure possible without losing highlight detail, known as exposing to the right, referring to the resultant histogram display. If you look at the monitor display and JPEG preview it may appear that I have an overexposed image, but by exposing to the right I'm maximizing shadow detail and minimizing noise. But beware of those highlights – perform a preliminary test exposure and check the highlights alert and histogram display in-camera. Basically, I'm exposing a RAW file not to give me the best display on the camera monitor but to produce the best 'digital negative', with the greatest scope in-computer later.

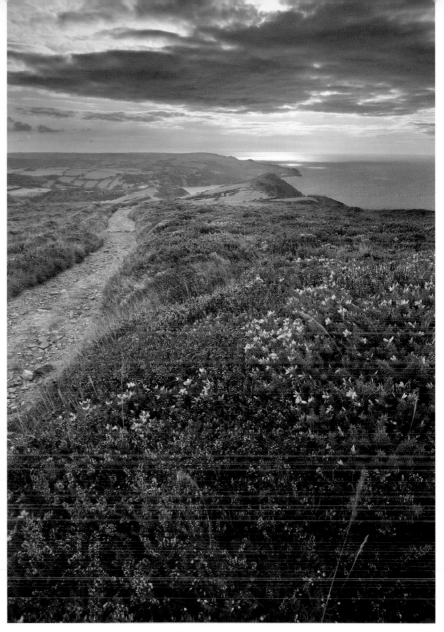

Heather lining the coastal path in late summer on the Great Hangman, North Devon, England (David Noton/National Trust)

The range of tones from the sky to the foreground detail is so high here that even a RAW file couldn't cope, so I've made three different exposures and merged them. It's a handy technique, but doesn't work if there's anything moving in the frame where the different layers merge, which is why I still need to carry neutral density graduated filters.
• Canon EOS-1Ds MKII, 17–40mm lens

RAW conversion

So, we're back at base and have copied the RAW files to a computer ready for processing. The next step is the RAW conversion. To do this we need specialist software. Adobe RAW is the most common, but I use Phase One C1 Pro. At this stage, important decisions about colour balance, density, tonal range, saturation, sharpening and output are made – indeed the whole look of the image can be finalized here. If you understand nothing else about the digital darkroom the two key displays to understand are the Levels histogram, which represents the tonal range of an image, and the characteristic Curve, which controls the distribution of those tones. It's beyond the remit of this book to go into too much detail, but working with Levels and Curves you can control the brightness, tonal range and contrast of an image. This is where we take that RAW file we 'exposed to the right' in-camera and pull back the Levels to give the density we desire. The net effect is an image with more shadow detail than if we'd 'exposed to the left'. Then we output the image as a 16-bit TIFF, to hold on to as much information as possible through all the stages of post-production.

The Baptistry (1196), Piazza del Duomo, Parma, Emilia-Romagna, Italy

Often a picture needs minimal input. If it has a perfect range of tones and density it will go straight through the digital darkroom with no alterations. I always check the Levels and Curves, but try to avoid tweaking for the sake of it.
• **Canon EOS-1Ds MKII, 70–200mm lens**

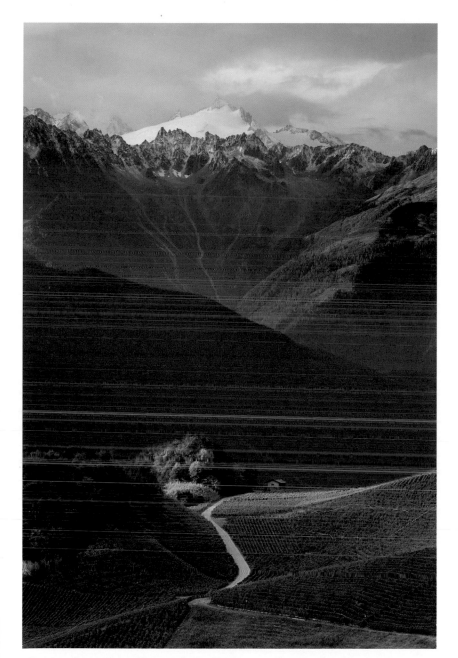

Photoshop adjustments and archiving

The last stage of post-production is to import the image into Photoshop for its final adjustments. There's no way I can even start to talk about all the options for sorcery at this stage. Quite often, I do nothing. If it works, don't fix it. Sometimes I do complex composites merging multiple exposures. Most often in Photoshop we dust-bust the image, checking for tiny imperfections resulting from grot on the camera sensor at 100 per cent magnification, and take out cables, masts, people and aerials where necessary. We routinely deprive whole

towns of their TV reception at this stage. I say 'we' because now the creative decisions about an image have been made, I've handed it over to the crew. Caption and keyword information is embedded in the image's metadata, the finished image is converted to 8-bit, low-res JPEG copies are made for emails and quick searches etc., the image is entered into our database, copied to a dedicated hard drive and backed up twice to DVD libraries both on- and off-site. Finally, the image is done; ready for submission, or deletion if, as happens, I subsequently decide it's no good.

I think we've gone full circle. In the old days we shot and processed our own black and white work in dark stuffy corners of lofts smelling of fixer. We made decisions about exposure in-camera based on the contrast in the scene and how we were going to develop the negative, and then we used all sorts of ruses with our hands and paper under the enlarger to maximize the tonal range and impact of the final print. The analogies with the digital darkroom are obvious. For decades I worked predominantly with colour transparency film where we had no such input, it all had to be done in-camera. Now, again, we're controlling every aspect of an image's processing and final impact. I rue the time it soaks up, but revel in having such control.

Vineyards on the hillside above Saillon, le Valais, Switzerland

This one took hours. When you're standing by the tripod making the exposure, it's important to think through what is going to be necessary to optimize an image. Here in Switzerland, I shot three exposures of this composition with a 400mm lens, flattening the perspective of the vineyards and mountains. The trouble was the distant mountains looked washed-out in the haze. I knew I could reintroduce contrast into the distance using Levels and Curves, but getting a join that wasn't obvious between the layers took hours with the Eraser tool. I'd much rather be out in the field, but that's life. For every hour I spend behind the lens I spend the same in the digital darkroom. It feels all wrong but if I've gone to Switzerland, got up at dawn and spent hours waiting for the light to make this one shot I have to make the most of it, and that means time hunched in front of the computer.

• Canon EOS-1Ds MKII, 100–400mm lens

MILFORD SOUND,
NEW ZEALAND

2am:

Eight meters of rain a year, and it's all falling on our tent. I now know what it would be like to camp at the base of Victoria Falls. I'm not sure where the Official Wettest Place on Earth is, somewhere in India? But Milford Sound must be up there in the Top Three – it's seriously soggy. I lie in the tent listening to the sheets of water deluging us, wondering how the young German backpacker in his NZ$30 supermarket special is faring; this really could be the winter of his discount tent. New Zealand's fjordland is a spectacular corner of the world with famously atrocious weather. The combination of deep fjords, jagged mountains and lush temperate rainforest is inspirational, when you can see it. Only two rocky

promontories interrupt the Roaring Forties tour of the southern latitudes, the tip of South America and here, with predictable results. From Britain, it's a long way to come for a few sodden camp nights; I can do that in North Wales.

4am:

Incredibly, we've slept well. I awake to a strange sensation: silence. It has stopped raining, and I can see stars through gaps in the cloud – game on. I still get a real buzz in these situations, there's a distinct possibility of a shot here, a chance I hadn't dared entertain in the past few days. We scramble down to the flood plain at the head of the fjord, our chosen location. For the first time we see the full

splendour of Milford Sound, uncloaked by rain clouds. The walls of the fjord are almost vertical, and the night's precipitation is cascading down the cliffs in multitudinous waterfalls, as if the landscape is weeping – totally epic. The sky is still heavy with rain, but there are breaks and the first indirect dusk light is just starting to filter through. What's more there's not a soul around, we have one of the world's most beautiful views all to ourselves.

4.40am:

I'm running now, trying to get to a piece of driftwood lying on the flats for foreground interest. Tripod up while we're on the move, bag on a rock, the driest option. Camera on the quick release head, compose,

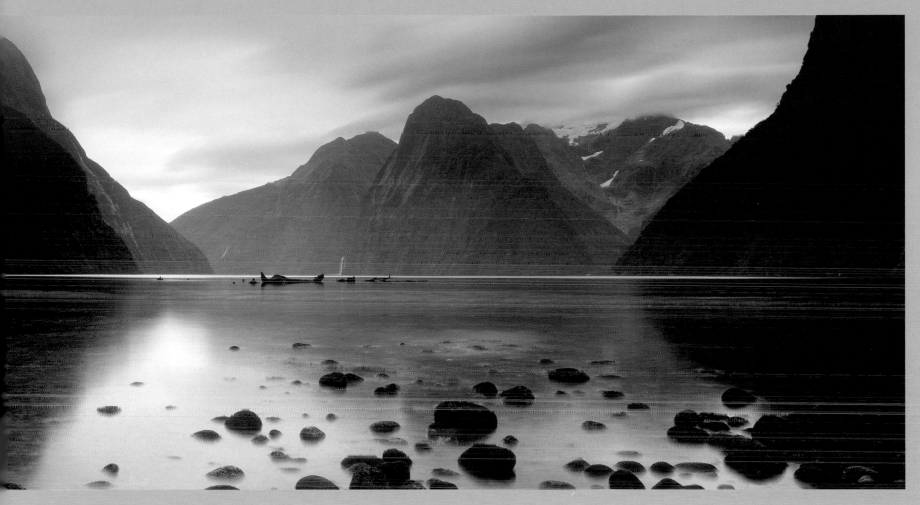

level horizon, cock shutter, focus, set aperture, cable release in, position grad. Double check everything, then open the shutter. Then I take an exposure reading, while exposing. I know from experience at this time of day the exposure is going to be measured in minutes, so I might as well start on the first exposure immediately while I'm calculating how long it's going to be. I don't want to miss a thing, all sorts of wonderful things can happen to the light at this time of the day.

5am:
The first exposure is about 15 minutes. Wendy serves coffee from a flask as we contemplate the advancing tide. By the end of the first exposure the tripod legs are underwater and we're perching on rocks, forcing a retreat to dry ground. This is going to be a problem. I want the shoreline in the shot, the semi-submerged rocks breaking the reflections of the fjord, but the tide is coming in at such a rate I can only make one frame before having to move and re-compose. Also, with long exposures like this the light levels are changing as I'm making the exposure. I open the shutter after taking a reading that gives four minutes: two minutes later that's down to three minutes. I end up exposing for about three minutes 20 seconds. How do I come to that figure? A combination of mental arithmetic with wet feet and experience. It's not rocket science but it works.

5.30am:
The twilight is spreading a palette of mauves and hues across the landscape, incredibly subtle and far more atmospheric than a clear sky and direct sunlight. The sun is coming up to our rear, giving diffuse front lighting to the scene. I hardly ever work with front lighting; generally I prefer side or backlighting. In this case though it's indirect, the first tones of dawn striking the pregnant clouds and reflecting down into the image. Keeping ahead of the advancing tide we move up the fjord, exposing all the way like retreating skirmishers. The damp atmosphere keeps fogging the filter, just another of nature's little reminders, and the sand flies are on their dawn missions. But this is very special. It has made waiting for the light worthwhile.

About the Author

David Noton was born in 1957 and split his childhood between England, California and Canada. After leaving school in 1976 he spent four years as a deck officer in the Merchant Navy, before trying his hand a number of different professions, including working in a glue factory, as a motorcycle courier, a window cleaner and a gardener, before finally returning to college in Gloucester in 1982 to study photography.

Graduating in 1985, David turned freelance and has concentrated primarily on landscape, nature and travel photography ever since, winning the landscape category of the BBC Wildlife Photographer of the Year Award in 1985,1989 and 1990. He married Wendy in 1987, and together they run their successful photography business from Milborne Port near Sherborne on the Somerset-Dorset border, and travel the world in search of picture opportunities.

Today David's work is published around the globe. Every month he licenses in excess of 100 images to publishing, advertising and the news media. During the last 20 years he has photographed much of the National Trust's landscape and coastline, which has featured in many high-profile publications and several highly acclaimed photographic exhibitions. Additionally he sells art prints and writes on travel and photography themes for magazines worldwide, including a monthly column in *Practical Photography*. This is his first book.

Acknowledgments

Many thanks to the following who have, in one way or another, influenced this book:

My father, for his forbearance with a headstrong 20-something-year-old son who seemed intent on wasting his education in search of adventure.

Sharyn Meeks, our stalwart office manager, who holds the fort with such reliable efficiency while we're treading boldly.

Charlie Waite, fellow photographer and friend, who provided the initial advice and impetus to getting this project off the ground.

All my photo-mates, who drink my whisky every year, but especially Peter Adams, Jeremy Walker and Jon Gooding; we keep each other vaguely rational while navigating our way through this strange profession.

Freya Dangerfield, Emily Pitcher and Martin Smith at David & Charles, and editor Ame Verso, all who have been such a pleasure to work with on this book.

My wife, Wendy. We make quite a team. I couldn't do half of what I do without her.